THE BetterPhoto Guide to
Creative Digital Photography

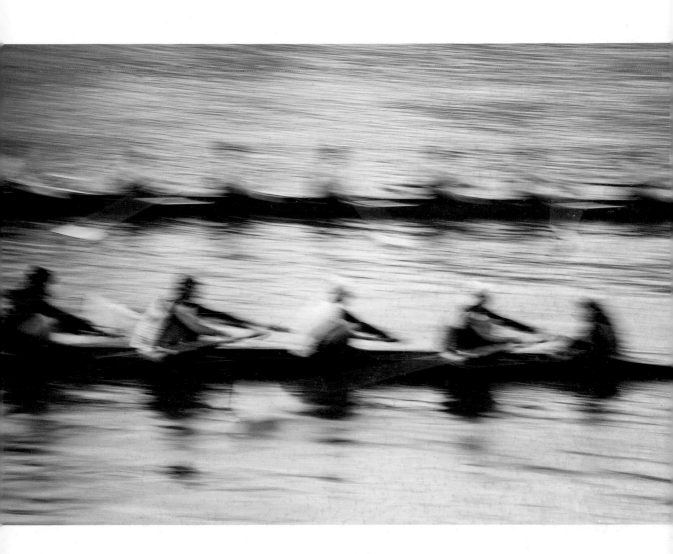

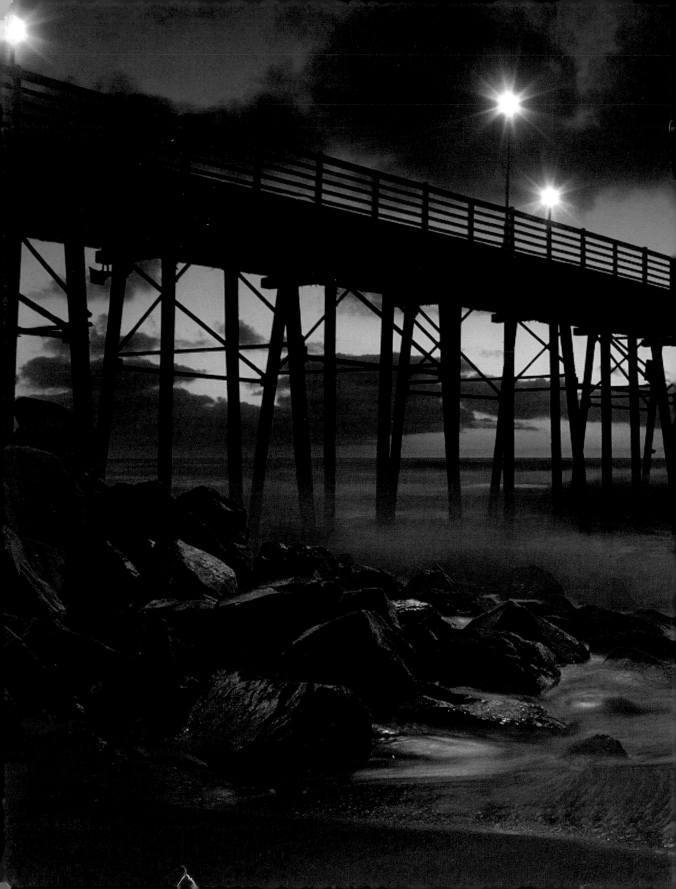

THE BetterPhoto Guide to
Creative Digital Photography

LEARN TO MASTER COMPOSITION, COLOR, AND DESIGN

JIM MIOTKE AND KERRY DRAGER

AMPHOTO BOOKS

an imprint of the Crown Publishing Group
New York

Front cover photographs by Jim Miotke (top); Kerry Drager (bottom left and bottom center); Marcie Fowler (bottom right)

Copyright © 2011 by James C. Miotke

Published in the United States by Amphoto Books,
an imprint of the Crown Publishing Group, a division
 of Random House, Inc., New York
www.crownpublishing.com
www.amphotobooks.com

AMPHOTO BOOKS and the Amphoto Books logo are registered trademarks of Random House, Inc.

Library of Congress Cataloging-in-Publication Data

Miotke, Jim.
 The BetterPhoto guide to creative digital photography : learn to master composition, color, and design / Jim Miotke and Kerry Drager.
 p. cm.
 Includes bibliographical references and index.
 ISBN 978-0-8174-2499-2 (alk. paper)
 1. Composition (Photography) 2. Photography—Digital techniques. I. Drager, Kerry. II. Title.
 TR179.M56 2011
 775—dc22
 2010044809

Front cover and interior design by veést design

Printed in Thailand

10 9 8 7 6 5 4 3 2 1

First Edition

p. 1 A high camera position and a telephoto view helped fill up the picture frame with these rowers. When photographing motion, freezing the movement is frequently the choice for many photographers. But, at times, a slow shutter speed—in this case, 1/8 sec.—can convey a nice sense of motion.
Photo © Jim Miotke. 1/8 sec. at f/16, ISO 100, 28–135mm lens at 135mm

pp. 2–3 The lights and colors of twilight lit up this Southern California coastal scene in a glorious way. With the extreme lighting contrast range, photographer Donna Pagakis decided to use the HDR (high dynamic range) technique. She says, "I had my camera set to autobracket the exposures at 2/3-stop intervals. I blended two exposures in Photoshop—one exposed for the sky, one for the foreground." *Note:* Two exposures, both set at f/7.1 (and 1.3 seconds for the sky exposure and 2 seconds for the foreground exposure), were combined for this image.
Photo © Donna Pagakis. ISO 100, 18mm lens

p. 5 This barrel-cactus scene is all about shape and texture. Photographer Leslie McLain used a close composition to fill up the picture frame with just the pattern. In addition, the photographer chose a camera angle that helps emphasize the scene's lines and curves.
Photo © Leslie McLain. 1/3 sec. at f/16, 100 ISO, 100mm lens

pp. 6–7 Colorful subjects always seem to catch my eye, such as this old boat with a fresh coat of red paint. The low-angled, late-day sun—hitting the subject from the side—cast a nice shadow, too. For this telephoto close-up, I zeroed in on the graphic design of strong lines and colors.
Photo © Kerry Drager. 1/2 sec. at f/22, ISO 100, 105mm lens

pp. 8–9 (left to right)
Arriving on the scene early one morning in northern England, I saw clouds, light, and color come together perfectly. A wide-angle approach seemed natural. For landscapes, and many other scenes, I always check both formats—horizontal (landscape) and vertical (portrait). For this scene, I felt that a horizontal view best fit my vision.
Photo © Jim Miotke. 1/125 sec. at f/5.6, ISO 100, 16–35mm lens

Photographer Susana Heide specializes in children's photography. "I find it extremely refreshing to be able to capture so many genuine expressions of a child or baby during a session," she says. For this image, she used a telephoto lens, a tight composition, and a huge hat that colorfully frames the subject's expression.
Photo © Susana Heide. 1/250 sec. at f/7.1, ISO 100, 28–70mm lens at 70mm

These shadowed garden sculptures stand out against a bright pond background at sunset. I was attracted by the distinctive shapes. I wanted to include the cat's outline as a soft-focused "secondary" subject that I knew would still be interesting and identifiable. Otherwise, the cowboy and frog stand front and center while "framing" the cat beyond.
Photo © Kerry Drager. 1/4 sec. at f/8, ISO 100, 105mm lens

Photographer Katarina Mansson has a passion for shooting architecture in a semi-abstract way. It's not a surprise, then, that this Frank Gehry–designed building in Germany caught her attention. "I played with my wide-angle lens and lots of different compositions. In this one, I was after a good Rule-of-Thirds composition, together with the flowing shapes and the beautiful blue versus white."
Photo © Katarina Mansson. 1/250 sec. at f/8, ISO 200, 10–22mm lens at 10mm

A steady camera (on a tripod) and a slow shutter speed (to blur the movement of the walkers) combined to record this holiday scene in Boise, Idaho. "I had been shooting the city Holiday Tree and turned around to see this couple," says photographer Becky J. Parkinson. "I thought the scene looked very festive."
Photo © Becky J. Parkinson. 1 second at f/8, ISO 250, 24–120mm lens at 55mm

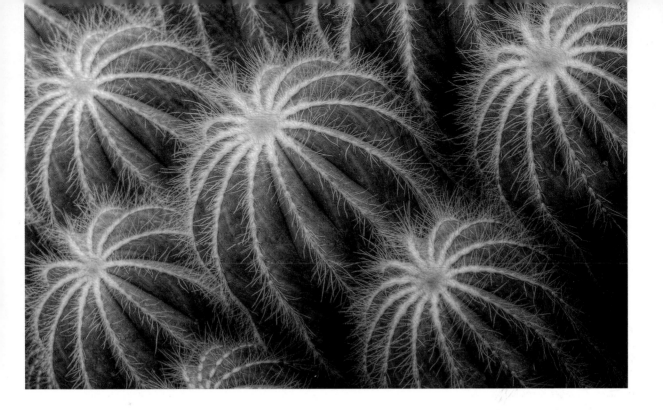

ACKNOWLEDGMENTS

We are very grateful to the many people who have helped us produce this book.

First, we would not be anywhere without Team BetterPhoto—thank you all for your amazing support.

Next, Jim would like to thank his family—wife, business partner, and best friend, Denise; and children Julian, Alex, and Alina—for their loving support. He is also very grateful to Brian and Marti Hauf for their prayerful and practical support.

And Kerry would like to thank his family—wife and best friend, Mary, and his stepchildren, Dan and Kristin—for their great love and never-ending support.

A special thanks goes to the great team at Amphoto—Victoria Craven, Julie Mazur, Autumn Kindelspire, and Jess Morphew.

We feel deeply honored to work with the amazing photographers who teach at BetterPhoto.com, including Tony Sweet, Jim Zuckerman, Vik Orenstein, Lewis Kemper, George Schaub, Kathleen T. Carr, Susan and Neil Silverman, Deborah Sandidge, Peter K. Burian, William Neill, G. Newman Lowrance, Paul Gero, Rob Sheppard, Jim White, John Siskin, Charlotte Lowrie, Simon Stafford, Jennifer Wu, Ibarionex Perello, Jenni Bidner, Doug Johnson, Kevin Moss, Lynne Eodice, and Doug Steakley. You all rock!

We also would like to thank Art Wolfe, Dewitt Jones, Jack Hollingsworth, Dane Sanders, Rick Sammon, Bob Krist, Jack Warren, Kevin La Rue, and Laurie Shupp at Nik Software; Gabriel Biderman, Tana Thomson, Jonathan Yudin, and Hershel Waldner at B&H Photo; Sam Perdue at Lensbaby; Neal and Chris at Photographer's Edge; Gary Farber at Hunt's Photo in Boston; Kathleen Davis at Popular Photography; Ben Willmore, Colin Smith, Joe and Casey at Really Right Stuff; the team at Singh-Ray Filters; and the team behind the software: Adobe Lightroom and Photoshop.

On page 216, there is a list of the many contributors from BetterPhoto, including those involved in the Masterpiece Membership, who shared their wonderful images. We would like to say to each of you, Thank you and congratulations!

Last, we extend our thanks to all of the dedicated members of BetterPhoto, who have helped make it such an awesome and joyful photographic community. Keep it up!

We dedicate this book to all photographers
who dream of following their own creative vision.

CONTENTS

 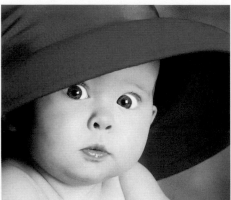 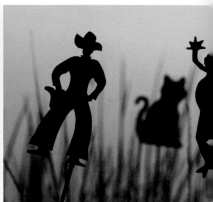

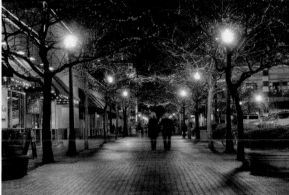

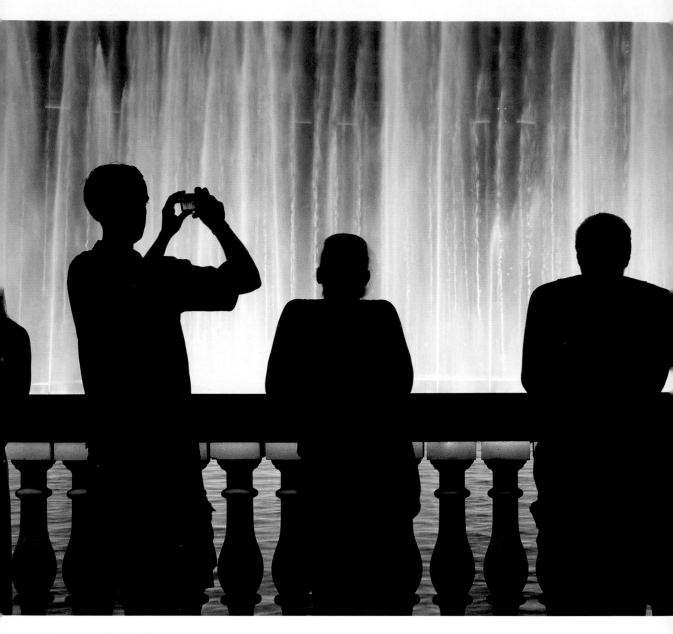

The Las Vegas Strip is always a treat for night photography. One evening, my goal was to photograph the Bellagio's awesome fountain performance. As spectators started lining up along the sidewalk, I took a few quick grab shots (photos in which you pick up the camera, point, and shoot with little regard to composition) to check the highlight warning on my LCD monitor—i.e., to make sure my exposures weren't blasting out in any important bright areas. Otherwise, I used the extreme lighting contrast to show the shadowed figures as striking silhouettes.
↑ Photo © Kerry Drager. 1/15 sec. at *f*/11, ISO 400, 50mm lens

INTRODUCTION

"Is creativity something that can be learned?"

We hear this question all the time, and the answer is short and satisfyingly sweet: Absolutely yes! This book is intended to reject the mistaken belief that you either have it or you don't. In fact, it's easier than you might think to boost your creativity and improve your skills. With some time-tested techniques and innovative approaches, you can start making memorable photos that stand out from the crowd of forgettable snapshots.

Anyone can develop talent by learning and practicing. Take it from both of us. When we started out in photography, we had the artistic skills of a log or a rock (or any other lame inanimate object). It's really true. We chopped off heads (feet, too), and we wound up with annoying shadows in all the wrong places. We cluttered up some images with too many subjects and shot other pictures with no clear subject at all. When we each reached the final straw—just one too many images that failed to meet our great expectations—we took it upon ourselves to learn to take better pictures.

The thoughts and insights we share on these pages worked for us in the development of our own photography and proved successful for students who have taken our classes and attended our workshops. These hundreds of students—of all ages and abilities—have dramatically expanded their photographic vision and have taken their work to new levels.

In *The BetterPhoto Guide to Creative Digital Photography* we discuss—in words and images—such topics as getting motivated, finding subjects, exploring the world around you, becoming more creative with lenses, discovering unique points of view, working with inspiring light, identifying the key elements of design, understanding the basic rules of composition and then learning how they can be broken, zeroing in on depth and balance, and pulling it all together with personal projects. We cover the many ways to capture motion—from freezing the action with a fast shutter speed to "painting" with long exposures. Thinking outside the photographic box and experimenting with new ideas are overriding topics that come up throughout the book.

A fascinating part of the creative process is that no two photographers see the world in the same way. This has been reinforced so many times in field workshops. We've watched photographers shooting the same scene in the same light yet all interpreting the scene in their own individual styles. During group reviews of the attendees' photos later, there's a string of "Wow, I was right there, but I didn't see that!" comments.

If you're a beginner, the techniques and exercises we share are designed to take you beyond the snapshot stage and into the world of capturing well-conceived photographs. If you're an advanced shooter, you'll find insights and motivation for fine-tuning your creative vision and for taking your photography to the next artistic level.

Don't assume that you must travel to exotic locales to make exciting photographs. Possibilities for dynamic images exist anywhere, and we'll share our tried-and-true techniques for finding subjects and visual satisfaction wherever you happen to be—including in and around your own hometown. This book is for people who have other jobs, who are busy with families or school, and who may have limited financial resources. What's really required is a desire to learn, and since you're reading this book, you already have what you need start taking your photography to new artistic heights.

ABOUT YOUR CAMERA

You might ask, "Will I get better pictures if I buy a better camera?" The answer—"Maybe, maybe not"—has more to do with your artistic vision and less to do with your equipment. Sure, the excitement of a new camera can motivate you to get out shooting more and trying new things. But it's really the eye behind the viewfinder—or the eye in front of the LCD monitor—that turns scenes with potential into pictures that matter.

Most of the tips and techniques in this book can be utilized with any camera. Both of us choose DSLR (digital single-lens-reflex) cameras—rather than compact digitals—for our pro work. Although relatively big and awkward compared to the sleek compact models, DSLRs offer the ultimate in image quality while providing more features and options that are easier to use. They also allow you to use a variety of lenses.

Still, today's high-end compacts are very sophisticated, with advanced modes that allow you to move off autopilot. Whether you shoot with a compact camera or a DSLR camera, if you use good technique with an artistic vision, you can get good pictures. A good DSLR simply makes it easier for you to consistently capture great photos.

In any case, if you think you need to buy a new camera, our best advice is make the most of what you already have, unless it's totally broken—or until you can no longer stand the limitations of your current model and are ready to upgrade. You'll then know what features you want and will be better able to make the choice that's right for you.

Seeking out a unique viewpoint, rather than shooting everything from a standing position, is a great way to increase your visual creativity. In the California Gold Country town of Coulterville, I liked the color and character of this old building. I then chose a low camera angle—positioned close to the colorful flowers—to create visual energy that extends from down low to up high.
← Photo © Jim Miotke. 1/180 sec. at *f*/6.7, ISO 100, 16–35mm lens at 16mm

ABOUT THE DIGITAL DARKROOM

It's true that all digital images require at least some optimizing—particularly if you're shooting in raw—such as color correction, contrast, spot removal, and so on. But the idea of this book is to focus on the shooting perspective—to work with our vision and camera handling in order to capture things in-camera.

The digital darkroom does offer a level of the control over the final image that was once just the domain of black-and-white film photographers. Nonetheless, the goal is to make well-conceived and well-executed images in your camera and to avoid the I'll-fix-it-later-in-Photoshop mentality. Image-editing software can't always successfully salvage major composition or exposure issues, or salvage images that fall short of a sparkling vision.

Of course, we realize you may wish to later apply special digital filters to an image, make photo composites, or make use of other digital art techniques. But even then, coming up with the best picture possible will make the entire process more enjoyable and efficient. In many cases, the work you do behind the camera will pay off—quality-wise—in the final photo.

ABOUT THE ASSIGNMENTS

You can't go wrong by reading about photography. Still, there's nothing quite like getting out there and doing it. Putting into practice what you've read will help you learn the concepts faster and help make them more of an instinctive part of your shooting workflow. There are motivating assignments throughout the book, and we urge you to give them a try. Keep in mind that, in most cases, the main idea is to nail down the concept or technique. If you also come up with a great photo, that's a bonus. But don't let an uninspiring setting hold you back. Practice, experiment, study your results, and enjoy the process!

ONE LAST NOTE

It's easier than you might think to sharpen your skills and your creative eye. The tips, tricks, and techniques outlined in these pages will get you started on your photographic journey. You're in for a fast, fun, and exhilarating ride. You can do it. We know you can. Now fasten your camera strap, and let's get started on the exciting road to visual creativity!

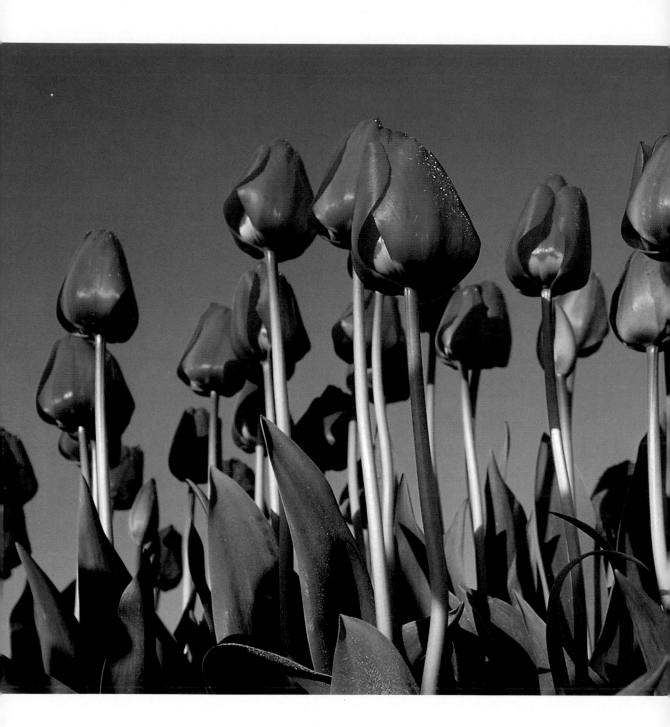

Unique perspectives always seem to catch the viewer's eye. Here, I chose a low-level position and then pointed my camera upward. At the same time, I wanted to take advantage of the wonderful color contrast at work by placing the bright red tulips against the bold blue sky.
↑ Photo © Jim Miotke. 1/125 sec. at *f*/6.7, ISO 100, 28mm lens

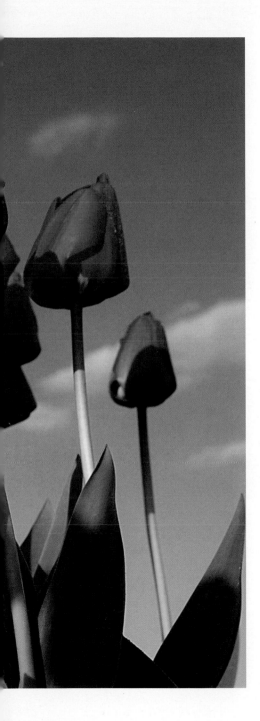

GETTING STARTED: GOING FROM ORDINARY TO EXTRAORDINARY

Legendary photographer Edward Weston was known for his distinctive images of landscapes, plants, and the human figure. But he was equally famous for his close-up studies of seashells and vegetables—particularly peppers. With the innovative use of graphic design, he proved you can turn run-of-the-mill objects into top-of-the-line works of art.

Now this doesn't necessarily mean that you must shoot shells and photograph peppers, too, although you could. But it does mean that you should strive to find visual value wherever you happen to be. The idea is to start looking beyond what casual observers see and start developing your own unique ways of seeing and recording the world around you. In these pages, we want to help you broaden your thinking and stretch your vision so you can start to consistently capture extraordinary, not ordinary, images.

CREATIVE VISUALIZATION

Most photographers benefit greatly by shooting more. Getting out and doing it is a key step in taking your photography to the next level. Periodic outings will help tune up your vision and hone your camera skills.

What's important is that you don't have to travel far and you don't need exotic subjects to photograph. But this concept is not always easy to grasp. We are surprised how often students say they live in places where there's little to shoot. Of course, if photographers were always grateful for where they were, there would be no reason for the phrase, "The grass is always greener on the other side of the fence." For many people, familiarity can be a creative stumbling block.

Certainly, new places can inspire and motivate. But exceptional photography really starts at home. This can be in and around your own backyard, neighborhood, hometown, or surrounding countryside.

The whole idea is to give your shooting eye a visual workout. Plus, photographing close-at-hand locations is not only easy but is also enjoyable—and you may find that you come up with some worthwhile images, too.

In his book *Photo Impressionism*, noted Canadian photographer Freeman Patterson wrote, "Learning to see subject matter well, learning to design image space well, and learning to use your tools effectively takes discipline—and discipline is something you rarely develop on a trip. You acquire it before you go, and then you take it with you."

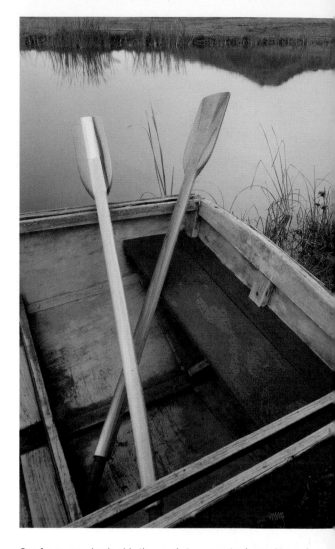

One foggy morning beside the pond at my country home, I turned my attention to this old and newly painted wooden boat. The soft light helped to enhance the colors and details. With a wide-angle zoom lens set at almost the identical focal length, I shot two very different images of the same scene. One technique was switching the format (horizontal and vertical orientations). The other was to change my camera position by moving physically closer. Also note my camera angle in these images, which emphasized the boat's graphic-design quality—particularly the strong diagonal lines formed by the boat and paddles.

↑ Photo © Kerry Drager. 1/6 sec. at *f*/16, ISO 100, 12–24mm lens at 22mm

↗ Photo © Kerry Drager. 1 second at *f*/22, ISO 100, 12–24mm lens at 24mm

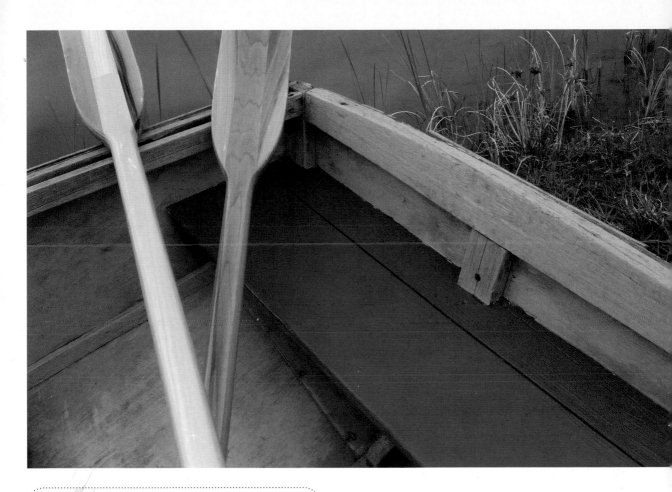

🔆 TIP: CONQUER YOUR FEARS

Digital photography makes experimentation so much easier than film, since you have instant feedback via the camera's LCD screen. Best yet, you don't have to pay for your mistakes. So there's really no reason to have a fear of failing. It's all about trying out new things, putting your imagination to work, and analyzing why your hits made the grade and why your misses fell short. You'll experience pure enjoyment when that off-the-wall approach you weren't sure about actually results in a gratifying photo.

"I CAN'T FIND ANYTHING TO SHOOT"

So many students have shared this frustration with us. We certainly understand how irritating it is when absolutely nothing seems photogenic. We've both been there, we've both said that. But there's hope. Really.

The first step is to identify your goals and interests. For example, you may want to preserve memories, share experiences with your family and friends, use photography as a creative outlet, become a professional photographer, or document a special place. Photographing subjects you love will help you hang in there when the creative going gets tough. Over the years, we've developed a host of tricks to get our own creative juices flowing. Whenever you feel stuck or uninspired, read the following suggestions. By the way, many of these topics are covered in more depth later in the book, but this serves as a quick-start guide.

• Good light can be a motivating factor. The truth is that almost any location offers plenty of photographic material. It has more to do with *when* than *where*. That's because most subjects simply look better in the dynamic sunlight of early morning and late day.

• An overcast day? Don't get depressed. Soft light can be perfect for working on a small photographic canvas— colorful details and people portraits.

• Start making a habit of being more observant. Look for bold colors, subtle tones, eye-catching shapes, interesting shadows, cool reflections—anything that strikes your fancy.

• Are you shooting subjects only from the standard eye level? Don't forget: Sometimes the best vantage points require going lower or getting up higher.

• Revisit the scenes of your past photo successes. Then try a change in camera angle, a different lens, or another time of day.

• Revisit the scenes of past photo disappointments, too. Do whatever it takes to improve on your previous attempts.

• Still having subject challenges? This may be the best go-to solution for busting out of the inspiration doldrums: Look closer, really closer. Close-ups—via either regular lenses or specialized macro gear—offer a brave and creative new world. You'll soon find yourself lost in a world of fine details and intimate scenes.

◉ TIP: GO SOMEWHERE DIFFERENT

Yes, familiar places do offer visual rewards, but at times you just need to get away to get inspired. This doesn't have to be a major undertaking. Take a day trip to a garden or park. If you haven't been to the zoo or the nearest tourist attraction in a while, do it now. Go to a local sporting event or festival. A fresh location can "force" you to be inspired and motivated. Everyone likes to experience new places—especially photographers.

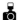 ASSIGNMENT: SEEING THE POTENTIAL

Getting a handle on your own photography involves more than having close friends and family members cheer you on. Their words will make you feel good, but they aren't quite objective evaluations. Sign up for an online course or a field workshop for valuable instruction and feedback from pros. Consider joining a camera club.

But there's more, too. Study the work of top photographers. This can be in books and magazines, in websites and online galleries, in professional programs or seminars, and in gallery exhibitions. For images that catch your attention, note how the photographer made use of composition, light, subject, color, and viewpoint. Ask yourself, What do I like and why?

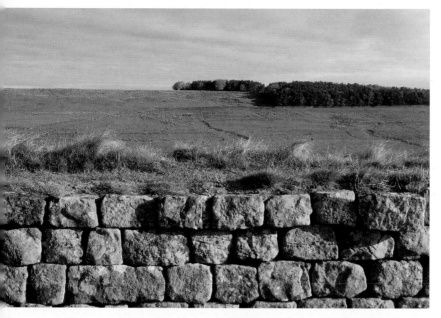

While I enjoy photographing near my home in the U.S. Pacific Northwest, new places always inspire me. In this case, working the subject was my goal while visiting Hadrian's Wall—the ancient Roman structure in Great Britain. In the first image, I used a wide-angle lens to compose a near-to-far scene. After that, I turned my attention to the wall's graphic-design pattern by moving physically close and filling the frame with the lines, angles, and textures. Slanting the camera created diagonal lines for additional visual energy.

← Photo © Jim Miotke. 1/20 sec. at f/22, ISO 100, 28–105mm lens at 28mm
↓ Photo © Jim Miotke. 1/180 sec. at f/8, ISO 100, 28–105mm lens at 28mm

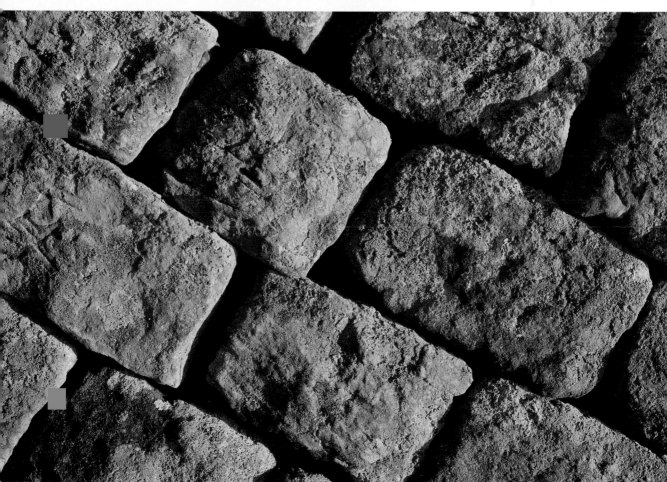

PATIENCE IS A VIRTUE

Here's a great approach to getting more eye-grabbing images and fewer mind-numbing snapshots: Don't be in too much of a hurry. Simply put, slow down. The following drive-by, been-there-seen-that shooting scenario may be a bit of an exaggeration, but we think it emphasizes our point: You arrive at a scenic overlook, whip out your camera, fire off some speedy shots, and head to the next view. No wonder those images almost certainly disappoint.

The fact is, many aspiring photographers—and not just beginners, either—work far too quickly. They get their shot and are eager to dash to the next spot. One photo? After only one photo, they haven't even gotten started! Whenever possible, take the thoughtful, more deliberate approach by dropping the ready-aim-fire attitude.

Certainly, not every scene or subject can involve a leisurely approach—such as candids or fast-changing light. Or you may be heading for an appointment, and there's only time to shoot one image. But when the light's right, the scene's inviting, and there's no need to rush it, slow down and make the most of a photogenic setting.

Here's a quick tip: Once you begin using a tripod for *every* nonaction subject, your photography will start to improve immediately. Yes, immediately. Using the accessory that photographers love to hate forces you to slow down and carefully design your photo so that you can get it exactly the way you want it. (See page 134 for more on tripods.)

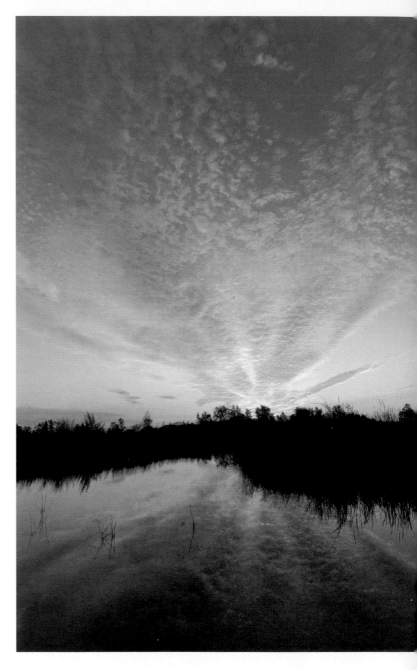

This pond is one of my favorite go-to spots for sunset. I've captured the great streaks of colors and clouds with my wide-angle zoom (as in the image above), and on other evenings, I've armed myself with a telephoto zoom and zeroed in on the details. Note that for the telephoto close-ups I placed the main subject off-center in the composition, often more visually dynamic than a perfectly centered placement.
↑ Photo © Kerry Drager. 1/3 sec. at *f*/16, ISO 100, 12–24mm lens at 12mm
↗ Photo © Kerry Drager. 1/4 sec. at *f*/5.6, ISO 100, 80–200mm lens at 80mm
→ Photo © Kerry Drager. 1/8 sec. at *f*/13, ISO 400, 70–300mm lens at 220mm

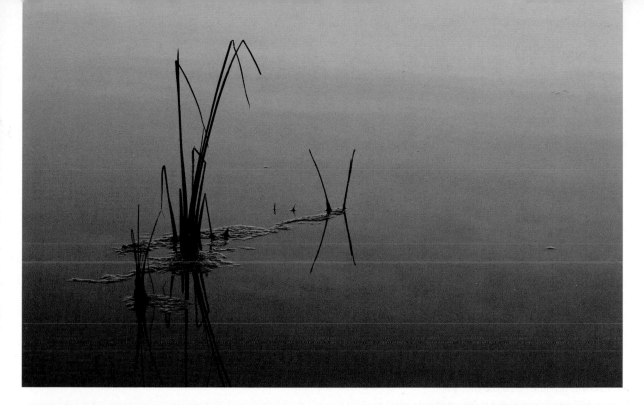

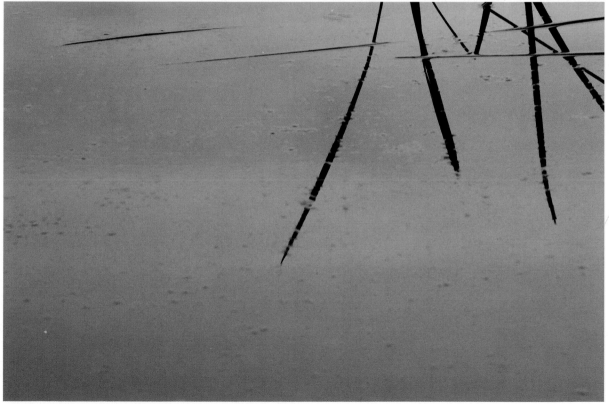

PLANNING YOUR STRATEGY

In photography, luck definitely has its place—a rainbow popping up here, a wild animal suddenly appearing there, another decisive moment occurring now. But the best photographers avoid relying solely on chance. They go out of their way to put themselves in opportunity's way. After all, for luck to happen, you must be on the scene with your camera. And that's no accident.

The concept of visualizing—often called "previsualizing"—was popularized by the great Ansel Adams. So, whenever possible, instead of simply responding to events or scenes as they present themselves, the idea is to consider your visual goals ahead of time. Part of this is thinking in advance about the subjects you would like to shoot and how you would like to capture them. You might think in terms of lens: Wide-angle for a sweeping view? Telephoto for a tight shot? Or you may try some of the motion studies described in chapter 5. Lots of possibilities to consider, but advance consideration can be so valuable.

This mind-set certainly applies to faraway destinations, but it also applies to weekend trips. And it relates to sports, family outings, festivals, holiday happenings, and special events.

It pays to plan your day carefully. Preparations for photo excursions must be well thought through and well organized. Even a quick shooting trip around town should involve a plan of action, although it can be scaled down.

Brainstorm about what you would like to record and how you can photograph those subjects in unique and attention-grabbing ways. Think about the expected shots, yet also think outside the box. Such creative visualization is both fun and rewarding. Especially for major outings, guidebooks, Internet research, magazine articles, and tourist materials can help you find your way. See if you can also determine the best times for shooting.

Preparation and planning also continue once you arrive on the scene. If it's a new place, try to take a quick get-acquainted tour to get a handle on the area, the park, the fairgrounds, the historic site, whatever. Along the way, shoot whatever captures your attention. If the subject is in the wrong light, and you'll be able to return later, make a note. This is a good reason to carry a small notebook on every photo shoot.

🔆 TIP: FIRST THINGS FIRST

The reason photographers often feel stress on a trip is the self-imposed pressure to capture the definitive images. Celebrated tourist spots, world-class cities, and popular national parks all feature justifiably famous views that have been photographed over and over again. But at the same time, there's also the desire to come up with innovative photographs. This shoot-the-classics-vs.-strive-for-originality disparity is always a challenge.

Our best advice: Attack the top spots as soon as possible. That way, you get them out of your system. After recording these definitive images, you'll be surprised how that reduces the anxiety, lifts the spirit, and makes you mentally prepared to be imaginative.

↑ Photo © Kerry Drager. 1/180 sec. at *f*/11, ISO 200, 20mm lens
↓ Photo © Kerry Drager. 1/8 sec. at *f*/13, ISO 200, 20mm lens

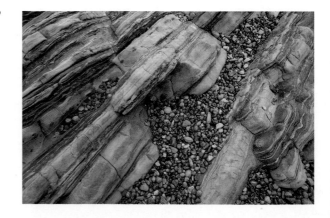

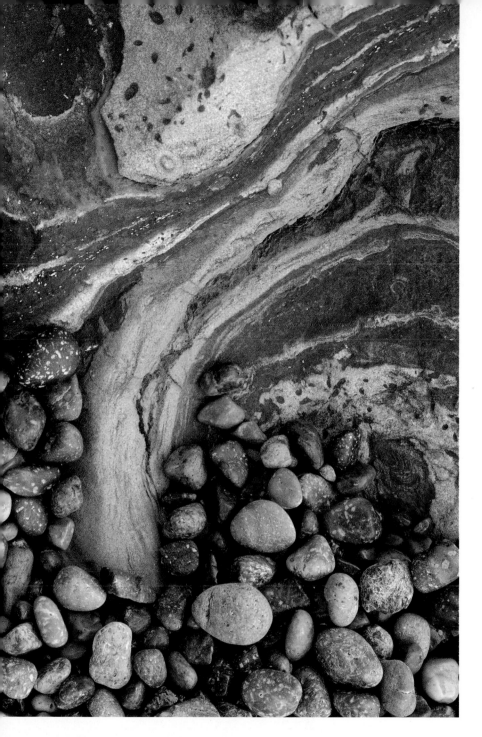

An overcast day along the California coast altered my shooting strategy—no sweeping seascapes in the warm and dramatic late-day light. So instead of a sweeping view with a dull sky (as in the image opposite), I turned my attention to capturing more intimate scenes in the softly beautiful light. As I walked the shore at Point Lobos State Reserve, I thought about possible pictures in advance—tight shots that focused on the details and designs of the park's renowned rock formations. Sure, I was ready for any visual surprises that might pop up, but I found that previsualizing helped me recognize photogenic scenes.

↑ Photo © Kerry Drager. 1/4 sec. at *f*/16, ISO 200, 105mm lens

PLAN TO BE FLEXIBLE

A photographic plan of attack is good, but always be willing to switch gears. An open mind is especially critical when things just aren't going your way. For instance, the monument you were looking forward to shooting is covered by scaffolding. The beautiful low-angled sunlight never—ever!—hits the cathedral. The historic site doesn't open until mid-morning, long after the good light has come and gone. The distant landscape looks downright dull under a gray sky. The museum is closed. The rain gates have opened.

Being in the right mind-set is so critical to success. You want to avoid tossing in the towel and calling it quits at the first (or second) hint that things aren't going your way. Being ready to let go of your preconceived ideas can be a winning formula for creativity. After all, those who expect the unexpected seem to be the recipients of happy surprises more often than those locked in rigid agendas.

WHEN NO PLAN IS A GOOD PLAN

Generally, you'll want to develop a strategy to make the most of your photography time. But at times, heading out with no particular destination or no specific photo goals in mind is another effective tactic for "uncluttering" your mind and unleashing your artistic vision. Without a schedule, you'll be more receptive to photo opportunities that can pop up unexpectedly.

This unstructured approach can be used anywhere. It can be a short escape close to home, or it can be a longer trip. For example, you might follow an uncharted (but safe) road or trail, and see what it passes and where it goes. The idea is to let your photographic eye be your guide. You never know what you'll find, and that's the attraction of a no-plan tactic. So even if you don't uncover any unanticipated gems, you'll enjoy the hunt.

In a seaside town one foggy morning, I decided to head out to see what I could find. I soon discovered this row of rental surfboards lined up along the sidewalk. I chose a telephoto perspective to give the appearance of compressing space while also heightening the graphic repetition. A slight slant of the camera afforded a more dynamic diagonal look. Tight framing put the emphasis precisely where I wanted it—on the lines and colors.

↑ Photo © Kerry Drager. 1/5 sec. at *f*/22, ISO 100, 80–200mm lens at 185mm

See a Shot? Take It—Now!

Both of us have learned this the hard way: Never pass up a good photo opportunity to get to another scene.

There are all sorts of good reasons to bypass a potential picture with the thought of returning later. You're in a rush to get to the restaurant. You just can't wait to get home. You have another—preplanned—picture-taking stop. But it's a very good bet that the photo simply won't be there when you go back to get the shot. Even if it's a stationary subject, lighting or any other conditions can change.

A don't-pass-up-a-shot approach is always a smart move. You'll be glad you made the effort to capture fine photos when you see them. Missed opportunities leave you not only without the photo but also with a depressing memory. Don't let that happen to you!

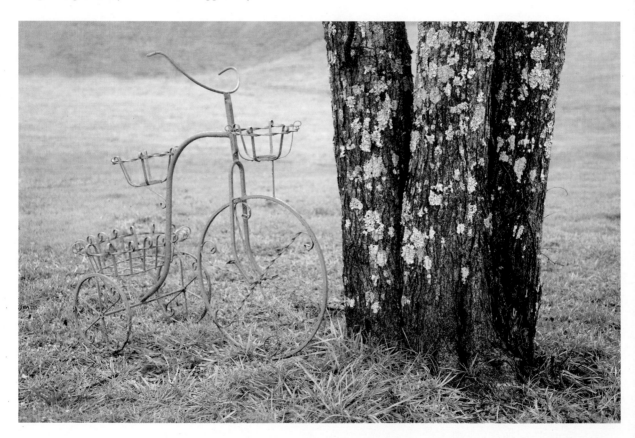

Bold colors, soft overcast light, and fun subjects always make an intriguing combination. This sure applied to a trip to Tennessee, where off-and-on rain provided ideal conditions for capturing a hot pink bicycle and an outstanding cluster of tree trunks. However, I originally had another scene in mind. Still, I forced myself to follow our take-it-now advice and shoot this photo first. I'm glad I did. The sun came out a short time later, creating an unappealing hodgepodge of highlights and shadows. I'm glad I photographed this scene when I did—in the right light!
↑ Photo © Kerry Drager. 1/30 sec. at *f*/4, ISO 200, 50mm lens

THE WOW FACTOR: POINT OF VIEW

Too many people are locked into a standard shooting stance: pointing the camera straight ahead from a standing height. An eye-level perspective is so easy to fall back on—almost the automatic choice, since it's just so convenient. Sure, that standing position ultimately may be the best viewpoint, but you really won't know unless you search the scene for other, potentially better, viewpoints.

Playing with point of view is a surefire way to put more pizzazz in your photography. Go ahead. You have our permission to unleash your artistic—if not your wild—side. Whenever and wherever you can, seek out those attention-grabbing camera angles that most photographers fail to notice.

Photography is about discovering the best position to capture your subject or scene. It's about choosing a lower or higher viewpoint—a perspective that most people just don't see in their everyday life—to create more innovative images. Gaze toward the sky and point the camera upward. Get down low to capture short subjects. The only limit is your curiosity.

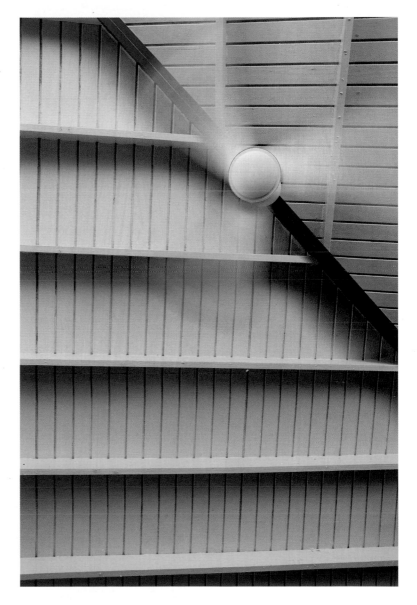

So often, it pays to explore the world around you. Look down, and look up. In this scene, I loved the pattern of colorful lines on this ceiling. The fan caught my eye, too, and I placed it in a strong off-center position in the composition. Pointing upward was awkward enough, even with a tripod, but I chose a fairly slow shutter speed to convey the motion of the whirling fan.
↑ Photo © Jim Miotke. 1/30 sec. at f/7.1, ISO 100, 24–70mm lens at 32mm

HOW LOW CAN YOU GO?

Looking for a good way to raise the photographic bar? If possible, get down low. It's often just that simple. Shooting from a near-to-the-ground perspective is a surprisingly quick and effective method for making your pictures jump out from everyone else's.

For example, most children are photographed from a typical grown-up height. For more emotionally engaging pictures, kneel, sit, or even stretch out to catch kids at their eye level. For youth sports, you can make young athletes look taller, leap higher, and perform more impressively.

All this goes for pets, too, as well as flowers and any other short subjects that can be captured low to the ground. For some subjects, you can combine a low perspective with getting close. This can further heighten the importance of small subjects by making them appear large in relation to their surroundings.

Outside on a nice day, include a bold blue sky as the background. For instance, get as low as you can go and then aim up at a subject such as a flower. This will let you include the sky as a colorful backdrop while treating your viewers to something new. We guarantee your viewers will appreciate your fresh take on things.

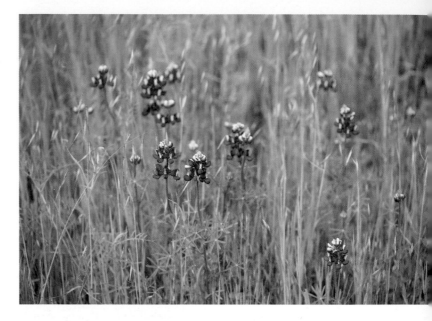

An overcast day provided the ideal soft light for shooting spring wildflower close-ups in Northern California. Since there were only scattered lupines (as in the wider view, above), I decided to concentrate on a single bloom nearby—with some yellow flowers in the background—using my macro lens. For a low perspective, I stretched out along a pathway next to the flowers for a ground's-eye view (using a tarp I carry in the car for just this purpose). Since macro photography demands precise focusing and composing, I also used a tripod that permits low-level angles. In addition, I included a blurred hint of lupine in the left background to balance out the main subject on the right of the image. Extremely close focusing and a wide aperture (low f/number) resulted in an extra-shallow depth of field, so the sharp foreground subject jumps out in contrast.
↑ Photo © Kerry Drager. 1/250 sec. at *f*/4, ISO 200, 105mm lens
↓ Photo © Kerry Drager. 1/180 sec. at *f*/5.6, ISO 400, 105mm lens

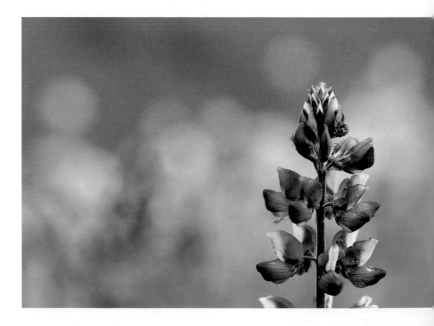

LOOKING UP

After getting down and dirty with a low-angled viewpoint, now it's time to turn your attention elsewhere. Specifically, we want you to start gazing upward and onward. Glancing skyward, unfortunately, isn't an intuitive thing, especially when searching for the typical photographic subjects. Still, this point of view is so different that it can produce very surprising—if not downright stunning—perspectives. Try it in a forest, inside a building, at a festival or amusement park, or right in the heart of a city. Sometimes you might even want to lie on your back to look up.

You can give human subjects an impressive look by aiming up from a low position. You can make statues look more statuesque, too. Get right up low and close to the monument, and aim upward with a wide-angle focal length for an unusual viewpoint. Inside a capitol dome, a cathedral, or another impressive building, zero in on the graphic designs. Watch for strong lines, curves, patterns, and angles to exploit.

Also point the camera skyward to catch the tops of skyscrapers. Take aim at a spiral stairway from the ground floor. In a stand of trees, pointing straight up can give a unique perspective—a captivating take on autumn foliage. A high overhead sun might not be the best time for many outdoor subjects, but with a tiny piece of the sun just peeking out from behind a branch, this pointing-upward technique can be quite an eye-catcher.

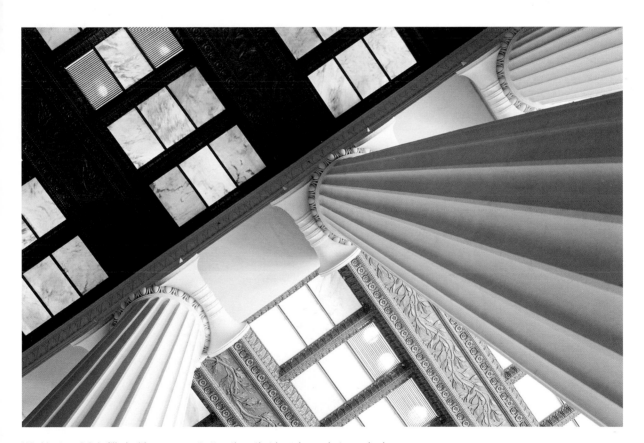

Washington, DC, is filled with many great attractions that have been photographed countless times. It takes perseverance to find a unique view. But photographer Wanda Judd stuck with it. She says, "I spent a great deal of time shooting this grand memorial while trying to line up the lines perfectly, but it simply was not working for me. At one point, though, I started angling my camera upward, and it all popped. This view worked so much better than lining and squaring everything up."
↑ Photo © Wanda Judd. 1/45 sec. at f/4, ISO 400, 28–70mm lens at 28mm

LOOKING DOWN

How often do you look down from up high? Probably not enough. Yet, this can't-miss approach will expand your portfolio of fresh perspectives. Peer down from the top of a stairway, coastal bluff or mountaintop, from a hotel's upper floor or balcony, or even from a plane. Look for vantage points from high up in a lighthouse tower or observation deck. Gaze straight down from a bridge as boats pass underneath.

A compelling image doesn't always require being forty or fifty floors above the city. Sometimes you can get a sufficient aerial view just a couple of stories up. This, of course, is great news if you hate heights or live in an area with no skyscrapers!

You don't always have to shoot from an elevated viewpoint, either. It can simply be a location where you happen to be higher than the subject or surrounding scene. Climbing higher provides a unique point of view when photographing scenes like fields, with any crop rows producing strong and compositionally valuable lines.

Ansel Adams believed so much in the value of getting above it all that he mounted a shooting platform atop his station wagon. He shot some of his most famous landscapes from that unique point of view.

For small ground-level subjects, a standing or kneeling position may work fine, by pointing the camera directly downward. Garden scenes, tile patterns, coastal tide pools, or your own feet often yield artistic results.

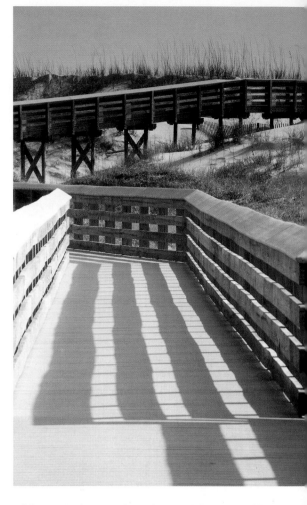

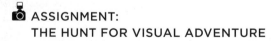

ASSIGNMENT:
THE HUNT FOR VISUAL ADVENTURE

Here are two worthwhile exercises to give your creativity a nice workout.

First, choose a subject, and then move around and view it from as many different positions as possible. Go low, go high, move to the right, move to the left, get really down and dirty. Ask yourself which points of view are working best for this particular scene.

Second, find a close foreground object and a distant scene. Move closer to your foreground, back up, move to the side. See how the relationship between foreground and background changes dramatically just by changing your position.

While scouting locations for a photo workshop in and around St. Augustine, Florida, I discovered an awesome boardwalk along a sandy beach. Atop the boardwalk, the low-angled sun was casting fine shadows of the railing. But it was when I looked downward—over the railing—that I saw scenes that excited me. The fence, sand, and angled sun resulted in great interplays of light and shadows. A favorite subject is always a time to "play" with your composition and shoot different versions.
↑ Photo © Jim Miotke. 1/40 sec. at f/22, ISO 200, 70–300mm lens at 300

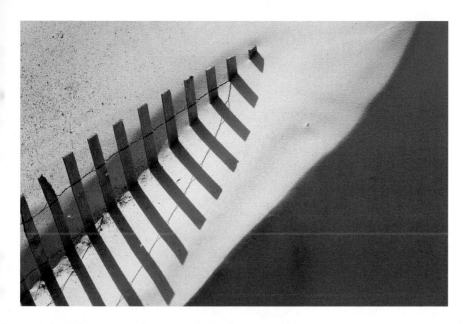

← Photo © Jim Miotke. 1/1000
sec. at f/8, ISO 200, 24–70mm
lens at 70mm

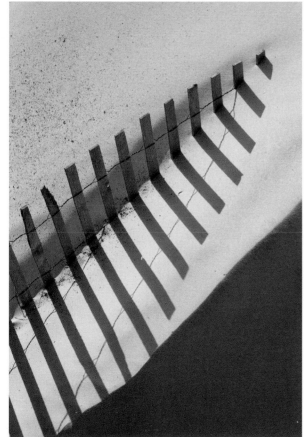

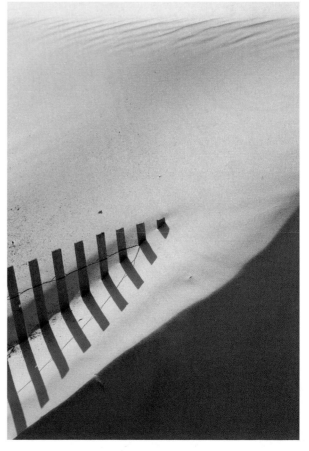

↑ Photo © Jim Miotke. 1/800 sec. at f/8, ISO 200, 24–70mm
lens at 70mm

↑ Photo © Jim Miotke. 1/1000 sec. at f/8, ISO 200, 24–70mm
lens at 50mm

GET CREATIVE WITH LENSES

Are you pushing your lenses to the outer limits of creativity? If you aren't, you should be. Lens focal length has more of an impact on artistic design than you might imagine, since your selection of lens greatly alters the way you view the world.

Good news, though: You don't need to be armed with an arsenal of lenses, since it's the big vision—not the big budget—that matters most. An everyday zoom lens, which generally extends from wide-angle to telephoto, provides a lot of picture potential.

The key is to understand how lenses see. This may sound like a difficult—if not confusingly esoteric—challenge, but it really isn't. Best yet, with a little insight and a little experimenting, you'll immediately start coming up with fresh outlooks that will result in more photos that have the wow impact.

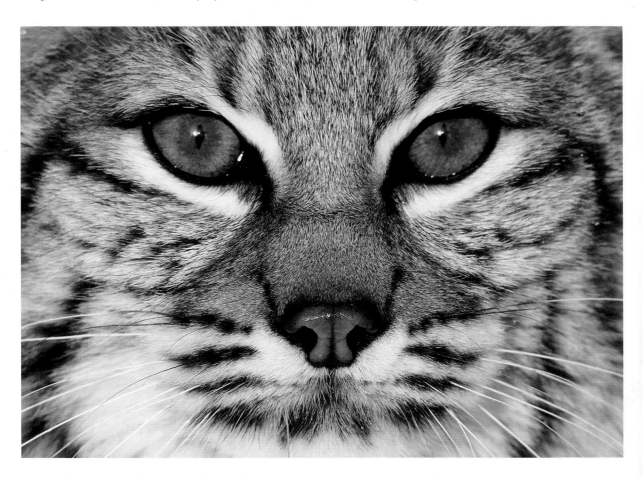

Wildlife photography and telephoto lenses just seem to go together. In most cases, you just can't get close enough to a wild animal, and even if you could, you may not want to! And at zoos and in natural but captive environments, such as what I had here, the long telephoto lets you zoom in tight—beyond the enclosures. A 300mm lens let me fill the frame for this bobcat portrait.
↑ Photo © Jim Miotke. 1/200 sec. at f/11, ISO 100, 300mm lens

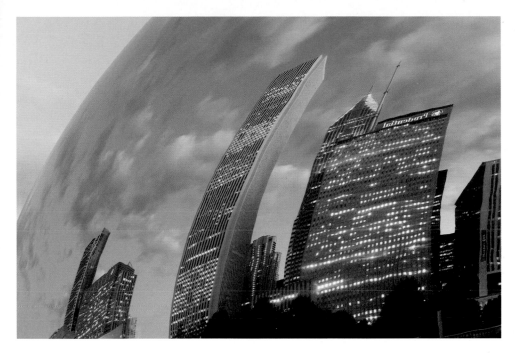

Chicago's must-see photographic icon, the mirrorlike Cloud Gate sculpture nicknamed the Bean, reflects the city's skyline in such a multitude of eye-grabbing ways. This Millennium Park attraction is absolutely incredible at any time, but it's downright dramatic at twilight. As with any good subject in dramatic light, I shot the scene in as many ways as possible. My first shot was with the "normal" 50mm (above). Then I moved physically closer with a wide-angle 20mm. As more clouds moved in, I decided to include more of the sky—both real and reflected—while also including the sculpture's graceful curve. I met my goal: same subject, two focal lengths, and two very different photos.

↑ Photo © Kerry Drager. 5 seconds at *f*/10, ISO 100, 50mm lens
↓ Photo © Kerry Drager. 5 seconds at *f*/10, ISO 100, 20mm lens

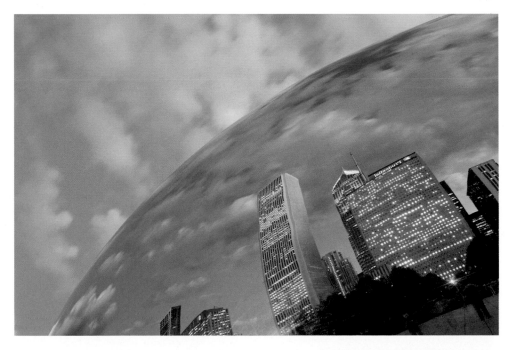

Deciphering Focal Lengths

Focal length, expressed in millimeters (mm), measures the magnifying power of a lens—i.e., how closely you can enlarge the image or how much you can increase the angle of view. A 50mm lens, for example, has a focal length of 50mm and sees things at roughly the same size as the unaided eye sees them. A 300mm telephoto focal length mimics binoculars, with things far away being greatly magnified. A 20mm wide-angle lens allows you to capture a sweeping vista.

Focal lengths fall into three main categories: wide-angle, middle range (or normal), and telephoto. The precise focal lengths that constitute each category, though, vary from format to format—i.e., from DSLRs with smaller sensors (the majority of cameras) to DSLRs with larger sensors (the upper-end or pro models known as "full frame"). The smaller sensors have the effect of magnifying your lens, usually by a factor of about 1.5 times, but for most practical purposes, this isn't an issue.

- Wide-angle: Often known as *short lenses*, DSLR wide-angles generally run 28mm or less, even down to 10mm or thereabouts. With a full-frame DSLR, the "official" wide-angle territory extends up to 35mm. In any case, the smaller the number, the wider (or more expansive) the view.
- Middle range: The middle range of focal lengths—often referred to as *normal*—roughly duplicate the vision of the human eye. Typical focal lengths run from 40mm to 50mm but can run slightly below or above those numbers, depending on the camera.

- Telephoto: Telephoto focal lengths run from 60mm or so on up. The longer the lens (the higher the "mm" number), the greater the magnifying power and also the narrower the view.
- DSLR zoom lenses: These offer a range of focal lengths in one lens. With a popular "street" zoom lens (such as a 24–105mm or 18–200mm), for instance, you can zoom from a big wide-angle view to a narrow telephoto view—or vice versa—with a simple twist of the zoom ring. Other zooms take in only wide-angle focal lengths (such as 10–22mm or 12–24mm), while others are totally in the telephoto range (i.e., 70–200mm or 100–400mm).
- Fixed, or *prime*, lenses: These cover just a single focal length, with popular fixed lenses being the 50mm "normal" lens, the 100mm or 105mm macro (capable of close focusing but also great for regular shooting, too), or any of several fixed long telephotos.

These painted milk cans appear to be about the same size in each composition, due to my change in camera position—closer for wide, farther back for telephoto. Now, this may sound counterintuitive, but remember: Wide-angle pushes things back (to show a more expansive view), while telephoto pulls things forward (as it narrows the view). Note how the wide-angle (top) reveals more of the surroundings and background. Also, the subject nearest to the camera looms much larger than the ones farther back in the frame. The telephoto shot (bottom) shows the tele-traits of isolating subjects and compressing space. Note, too, that I changed the angle of view for the two photos, since I wanted to get as good a composition as possible for each image.
↗ Photo © Kerry Drager. 1/500 sec. at *f*/8, ISO 200, 20mm lens
→ Photo © Kerry Drager. 1/500 sec. at *f*/8, ISO 200, 70–300mm lens at 100mm

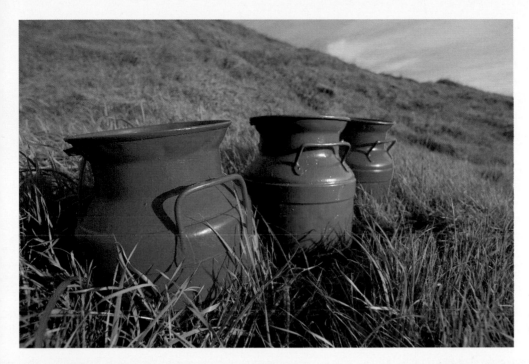

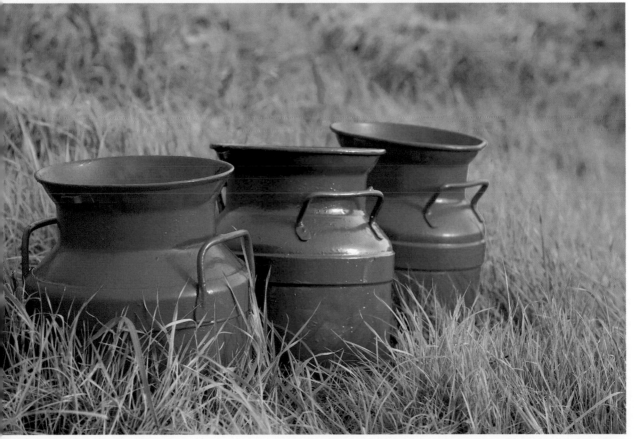

TELEPHOTO PERSPECTIVE

Telephotos offer a perspective that records the world with great visual power. In short, telephotos work like binoculars or telescopes to enlarge faraway and otherwise inaccessible subjects.

However, besides the magnification factor, another interesting thing happens when you zero in tight with a long lens: The distance between your foreground and background appears more compressed. It's almost as if landscape or cityscape features have been squashed together right before your eyes.

Use this effect to "stack" a row of cottages or sailboats, to compress a lineup of fence posts, to tighten up a repetition of architectural features, or to make mountains loom over horses or trees. The more telephoto the lens (the higher the "mm" number), the more compressed the distance will appear.

At the same time, telephotos also offer another desirable trait—a limited depth of field (DOF). This helps force the viewer's attention right where you want it. With a telephoto, your sharply focused foreground subject will be isolated against a blurred background. (See chapter 4 for more on depth of field.) Portrait photographers often shoot with short to medium telephoto (100mm being a popular focal length) for this purpose as well as for delivering portrait shots in the most natural, undistorted way.

Along with a shallow depth of field, the telephoto helps you simplify images in other ways, too. A long lens can make your composition cleaner. In other words, you can zero in tight to leave out extra elements in a scene, such as a blank foreground or sky, and unwanted objects to the left or right of your subject. After all, cutting through clutter can be just as important as making faraway subjects bigger.

A balloon festival near her home brought photographer Beverly Burke out to catch the early-morning ascension of the hot-air balloons. "While watching and shooting some of the balloons ascending," she recalls, "I turned and saw this very colorful grouping of balloons still on the ground. I decided to get a different perspective of the festival, so I used my telephoto lens to zoom in and create a more abstract and colorful image." Note how the telephoto perspective "squeezed" the balloons together, creating a graphic design of lines, curves, and colors.
→ Photo © Beverly A. Burke. 1/80 sec. at f/8, ISO 400, 70–200mm lens at 126 mm

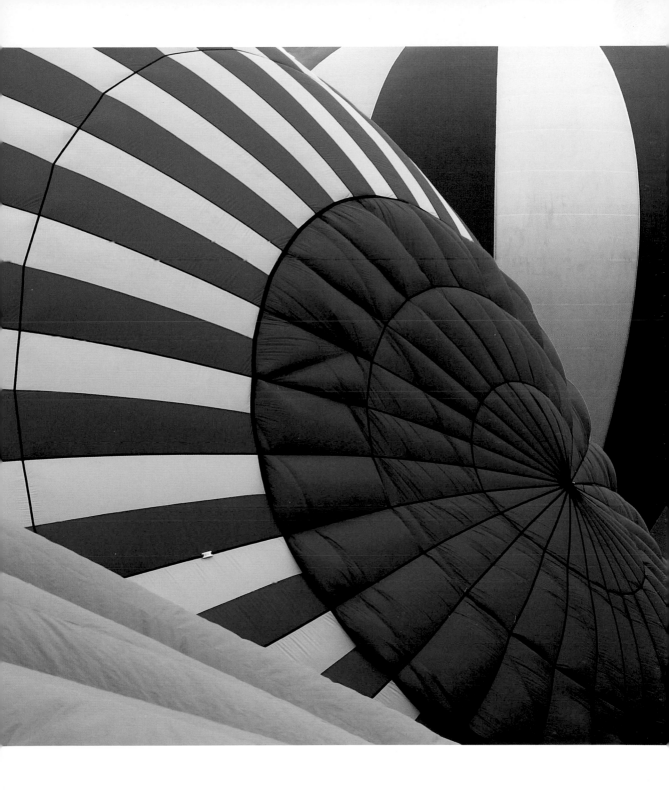

A SHARPER IMAGE

Lack of image clarity is a frequent complaint of telephoto and zoom shooters—not surprising, given that long lenses magnify any blurring from camera shake. Plus, big telephotos or zooms can be big and heavy, requiring extra care in handling.

Use a tripod whenever possible, along with a cable shutter release to eliminate any possible vibrations from pressing your finger on the shutter button. For stationary scenes, you may want to add mirror lock-up (if your camera has this feature) or even the camera's self-timer, assuming a precise instant isn't required to catch the subject. In regard to mirror lock-up: The mirror inside a DSLR camera lets you see through the viewfinder, but when you snap the shutter, the mirror instantly flips up and out of the way so that light coming through the lens can make the image. After the shutter closes, the mirror drops back down. The lock-up feature on some cameras lets you lock the mirror up after composing the photo to eliminate any possible vibration that might occur from the mirror's movement.

The general guideline when handholding the camera is that the shutter speed should be at least the reciprocal of the lens's focal length. So with a 300mm telephoto, use a speed of 1/300 sec. or more. With a 70–200mm zoom, go with 1/200 sec. or faster (consider the zoom's highest mm number when choosing the shutter speed).

If you are shooting from a tripod, this guideline doesn't apply, although a faster shutter speed might be necessary to stop the motion of a moving subject. Also, stabilized lenses (often designated as IS for *image stabilization* or VR for *vibration reduction*) are designed to reduce the impact of camera movement when handholding while allowing slower shutter speeds to be used successfully.

> ### ASSIGNMENT: GET TO KNOW YOUR TELEPHOTO
>
> This two-part exercise will help you explore the tele-world, where what you see with your eyes can be totally transformed by your lens.
>
> **1.** Pick a subject, any subject: The best choice would be a friend or family member with plenty of patience. Start with a short telephoto focal length—say, in the range of 70mm to 100mm. Then shoot a tight portrait shot—just head and shoulders. Next, back up (don't zoom) and, with the same focal length, shoot a full-length portrait. Try this same series again (close-up and full-length) with a longer focal length. When analyzing your results, be sure to note the subject's relationship to the background.
>
> **2.** Compress a distant scene: Here, the idea is to find subjects that are at different distances from the camera and then zoom in tight on them with your longest telephoto (i.e., biggest mm number). The subjects can be a row of fence posts, buildings, or whatever. Note how the telephoto not only compresses space but also can create graphic-design patterns. For extra credit, repeat the exercise several times, with each image using a different *f*-stop (a great way to see the impact of depth of field).

The downtown area of any major city offers so many visual possibilities. All you need are enticing subjects that are of varying distances to the camera. For this image, I zoomed in tight with a telephoto to compress the buildings into an urban architectural pattern.
↑ Photo © Jim Miotke. 1/50 sec. at *f*/22, ISO 100, 28–135mm lens at 125mm

A WIDER ANGLE OF VIEW

Photographers learn very quickly that a wide-angle lens lets them fill up the viewfinder with more things. That wide-ranging capability is part of the wide-angle's charm. Unfortunately, it's part of the wide-angle's frustration, too.

The urge is to back up to get more elements into the picture, but this approach commonly leads to a "busy" look with lots of subjects competing for the viewer's attention, or it results in a photo with vast empty spaces. It's no wonder so many emerging photographers lament the wide-angle.

For the creative photographer, though, the wide-angle's unique perspective means great artistic potential. In particular, the wide-angle can provide an unreal look of depth—an almost three-dimensional quality—in which a close-up foreground appears disproportionately large in contrast to the distant background. This technique has been used by landscape photographers, photojournalists, fine-art photographers, and even fashion shooters.

For visual impact, you must move in physically close to the foreground—sometimes as close as your lens will focus. In any case, think about moving to within a couple of feet of the nearest object. In fact, if you start considering your wide-angle as a close-up lens, you'll be well on your way to wide-angle artistry. The result is an exaggerated or exploded perspective that gives your photo a sense of the scene sweeping away from front to back. At the same time, you'll often want to use a high f/number (small aperture) to ensure a deep depth of field—sharpness from close up to far away.

Quite simply, our eyes don't see the world in a wide way. But if you start thinking of your wide-angle as more of a close-up lens than a get-everything-in-your-picture lens, you'll have another valuable tool in your bag of creative tricks.

> ### 🔘 TIP: OTHER TIMES TO GO WIDE
>
> Although we're concentrating on the wide-angle's near-to-far depth, there are other important reasons to go wide at times, too. One approach is to emphasize a sweep of dramatic or colorful sky, while just including a narrow slice of landscape. Another use is a very practical one: the ability to catch the entire scene when the photographer is cramped into tight quarters.

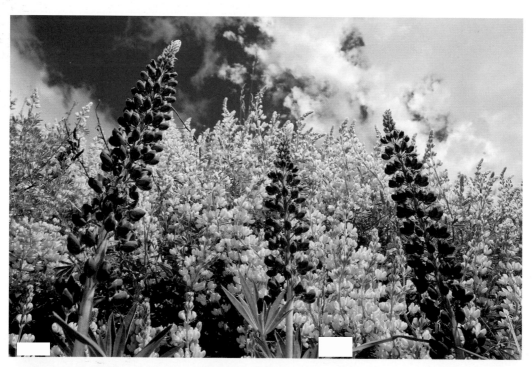

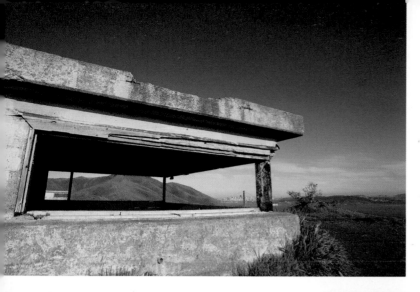

In the Marin County hills high above the Golden Gate Bridge, old military buildings and batteries dot the landscape. With wide-angle, it's all about foreground, so I used this lookout to help frame San Francisco in the distance. For the horizontal view, I'm close, but not nearly close enough, with the result being too much extra sky. For the vertical view, I set up my tripod within an arm's length of the nearest point to take full advantage of the wide-angle perspective.
↑ Photo © Kerry Drager. 1/250 sec. at *f*/16, ISO 200, 50mm lens
→ Photo © Kerry Drager. 1/90 sec. at *f*/22, ISO 200, 20mm lens

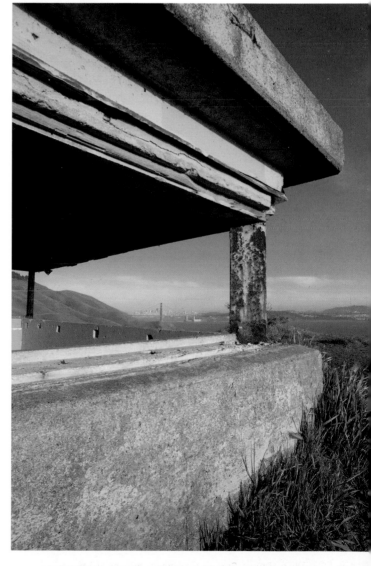

With flowers, a macro lens may seem a natural. But a wide-angle focal length can create such a unique perspective. The trick is to think of a wide-angle as a close-up lens, since it lets you move in very physically close to a subject—often well within an arm's length of the nearest point. Also with a wide-angle, pointing upward will cause vertical lines near the borders to bend inward—an effect called *keystoning*. My intent here was to take advantage of that distortion by placing one lupine in the center, so it remained straight up and down while the outside ones leaned toward the center, creating a natural symmetry.
← Photo © Jim Miotke. 1/500 sec. at *f*/14, ISO 400, 28–135mm lens at 28mm

Make Distortion Work for You

A side effect of wide-angle photography is distortion—also known as *keystoning*, as previously mentioned, or *converging lines*. When you point your camera upward to show the entire stand of tall trees or all of the multi-story building, the result will be vertical lines that lean inward toward the center of the composition. Sometimes this works; other times it doesn't. Because wide-angle focal lengths distort what our eyes see, many people avoid the wide-angle altogether.

One solution is to make sure the camera's back is parallel with the plane of your subject. But unless you have a great foreground scene to incorporate into the composition, then you'll end up with a distant subject and a great expanse of empty space in front. Another solution is to skip the wide-angle altogether and instead switch to a telephoto and shoot the building from a distance; with more of a long-distance straight-forward angle, distortion won't likely be an issue.

But consider a more artistic technique with your wide-angle. In fact, the creative use of major distortion can transform a straightforward world into an interpretive and compelling one. How? Move in tight with a wide-angle and aim upward to convey a sense of movement or visual energy. With the wide-angle, you can also emphasize distance, depth, or height.

Remember this key point: A little distortion can make a picture look clumsy, so for extreme creativity, go for a lot of distortion. Make it perfectly clear that distortion was indeed your creative objective and not just an oversight.

On the bluff above the beach at St. Augustine, Florida, I set up my camera very close to this blue building. I pointed the camera sharply upward to intensify the wide-angle perspective. I selected a vertical format to emphasize the diagonal lines. My camera was mounted on a tripod to keep things steady but also to fine-tune the composition and to hold things in place while waiting for shorebirds to fly into a position that I liked.
↑ Photo © Kerry Drager. 1/180 sec. at *f*/13, ISO 200, 20mm lens

At times, your goal will be to shoot a straight-forward—or documentary—shot of a building. Simply keep the camera level and make sure the back of the camera is parallel to the building, which diminishes—if not eliminates—the bending-line syndrome. *Note:* This straight-on, level-camera approach may not work with a wide-angle, since the lens's broader view will incorporate a big expanse of sky or foreground. Try backing up and shooting from a distance with a telephoto, which makes it much easier to fill the frame with little distortion. Photographers who shoot architecture regularly, incidentally, frequently opt for a specialty tilt-shift or perspective-control lens, which helps keep vertical lines straight up and down.

📷 ASSIGNMENT: DEVELOP YOUR WIDE-ANGLE EYE

Your mission today: Train your eye to see wide.

Start with your widest focal length. If you have a wide-to-telephoto zoom or an all-wide-angle zoom, then set it as its lowest mm number and leave it there. Don't turn that zoom ring.

Next, go out and put it to the test. Point the camera upward and downward, then move in closer to your subject—any subject. A tree trunk, flowerpot, or car works, or anything else you choose. Keep moving closer. Try to determine the nearest point at which the lens can still focus. We bet this exercise will be an enlightening experience.

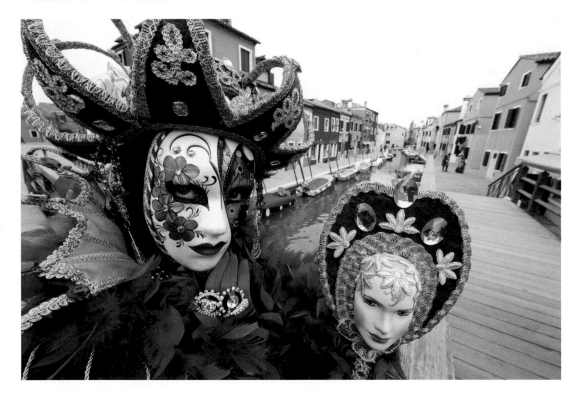

Soft overcast light is ideal for capturing colors, details, and people. This photo—shot during Carnival on Borano Island in Venice, Italy—demonstrates the artistic use of a wide-angle lens in portraiture. The key is to get close to the foreground, which photographer Jim Zuckerman did while photographing this masked Carnival model.
↑ **Photo © Jim Zuckerman. 1/80 sec. at *f*/14, ISO 400, 14mm lens**

QUALITY OF NATURAL LIGHT

Do your pictures tend to elicit more "ho-hums" than "ahas"? One reason may have to do with the quality of light. In short, fine light adds visual impact. When planning workshops and our own personal outings, we think about the light just as much as we do about the subject.

Here's a basic rule of outdoor photography: An average subject in great light looks better than a great subject in average light. In other words, get out during the right hours, and you'll capture better pictures. Period. It really is that simple.

For many photographers, however, the urge to shoot seems to hit only at high noon under a brilliant blue sky. Yet, at midday, the intense sunlight washes out subtle colors, flattens distant landscapes, creates harsh light-vs.-dark contrast, and for portraits results in squinting, contorted faces, and unflattering "raccoon" eyes (dark shadows under the eyes).

An easy solution is to limit your shooting primarily to certain hours—specifically, early morning or late afternoon. The edges of the day are often the most exhilarating times for photography. Yes, you may have to rearrange mealtimes to get the memorable shots, but unless you're willing to take advantage of great light, your photography will never live up to its potential.

A South Pacific seascape is always something special, but just as in other areas of the world, there's nothing quite like a sunset. Here, the boats seemed perfectly suited to occupy the foreground and middle ground, and groupings of three make very strong graphic designs. At the same time, the cool blues of the scene complement the warm tones.
↑ Photo © Jim Miotke. 1/640 sec. at *f*/3.2, ISO 100, 50mm lens

⬡ TIP: A VERY VALUABLE CAMERA ACCESSORY

Don't forget the start of the day. As with evening twilight, dawn can look magical, too—right after nighttime starts turning toward daytime. The freshness, light, and color at the beginning of the day are big reasons why we consider an alarm clock to be a very valuable piece of equipment for the outdoor photographer.

The Early Photographer Gets the Shot

Is there a more satisfying outdoor pursuit than sunset or sunrise photography? Maybe so, but we can't think of one! However, it's easier to prepare for a sunset than a sunrise, because you can track the sun's progress from late afternoon to evening. In the morning, the darkness turns into a soft early light, but as the sun nears and then clears the horizon, things happen so quickly. Plus, for early-day shoots, you'll want to have a photographer friend or two along, as well, for the companionship and for any safety considerations.

For sunrise, the trip actually begins the night before, when you gather everything together for the morning shoot. You'll need to factor in how much time you need to get up, get ready, and arrive at your destination. Know the weather forecast and have all clothing and gear packed up and ready to go. Check your camera settings so they're ready for action. Make sure you gather up your tripod, memory cards, extra battery, and jacket. A flashlight can be a worthwhile accessory as well. In addition, for our early morning adventures, we never leave home without some snacks tucked into a pocket or camera bag.

Whether you're photographing at dawn or dusk, though, remember that the sun moves fast and dips below—or rises above—the horizon in a matter of minutes. Allow more time than you think you'll need to get there.

Looking across the bay toward the Seattle skyline can be quite a sight at sunrise, as this image proves. "I liked how the silhouette of the fishermen mirrored the buildings and how the sun was emphasizing the outlines," says photographer Anne McKinnell. "I wanted to capture the starburst of the sun just as it rose above the buildings to portray a combination of the calmness of the ocean and the sunrise with the excitement of the beginning of a new day and the joy of the fishermen's early catch." She used a small aperture to catch a sun-star effect while keeping the outlines of the fishermen, the pier, and the buildings in sharp focus.
↓ Photo © Anne McKinnell. 1/15 sec. at f/29, ISO 100, 18–55mm lens at 40mm

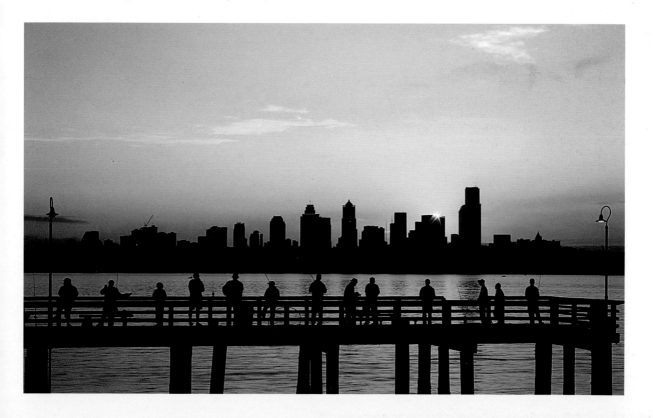

ISO and the Exposure Triangle

There's a three-way relationship going on in photography, and it's known as the *exposure triangle*. The amount of light that strikes the camera's sensor is regulated by these three factors: the size of the lens aperture (*f*-stop), the length of time the shutter remains open (shutter speed), and the ISO (whose initials derive from the International Organization of Standardization).

ISO measures the sensor's sensitivity to light. A less sensitive ISO (lower ISO number) means that the sensor must receive more light (either with a larger aperture opening, a longer shutter speed, or both) to get the same exposure as a very sensitive ISO setting (higher ISO number).

While a high ISO setting can mean faster shutter speeds, the downside is that higher ISOs can cause *noise*, where the image looks grainy or mushy with color blotches. The precise ISO at which noise kicks in at a detectable level varies from camera to camera, and newer DSLRs can handle higher ISOs better than older models.

Here's a good guideline: Use a high ISO only when necessary. So, unless your subject is moving or light is very low and you don't have a tripod, use your camera's lowest ISO setting (usually 100 or 200), since that will mean the least amount of possible noise.

But here's more: If a high ISO is the only way to get a fast-enough shutter speed for a sharp picture, then go for it. It's better to have a noisy photo that's sharp than a noiseless picture in soft focus. You can often fix noise in the digital darkroom—at least to some extent—but a blurred image is, well, blurred.

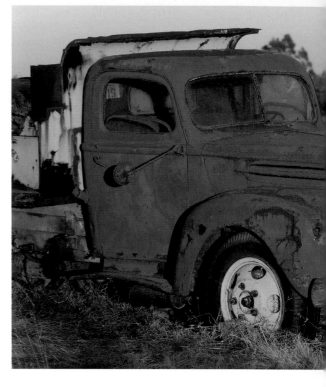

This old 1942 Ford dump truck sits in a field at my rural home in California. Both of these photos were recorded with the sun at my back while striking the subject head-on—in other words, frontlight. The low-angled sunlight definitely pumps up the warm colors of this truck. For the close-up, I set up my camera very low to the ground and, with a wide-angle lens, very close to the front wheel. Then, with the self-timer, I captured my shadow. I took a series of images, checking each result on my camera's LCD monitor, to make sure I got what I wanted.
↑ Photo © Kerry Drager. 1/125 sec. at *f*/8, ISO 200, 70–300mm lens at 145mm
→ Photo © Kerry Drager. 1/60 sec. at *f*/13, ISO 200, 20mm lens

DIRECTION OF SUNLIGHT

In low-angled sunlight, ask yourself, Where is the source of light in relation to my subject? Your answer could make or break your picture. Exploiting the angle of sunlight has such a great impact on a scene or subject. Let's consider the specifics:

Frontlight occurs when the sun is behind you and hits the front of your subject. This has been called flat lighting, due to its straight-on illumination. The lower the sun in the sky, however, the more intriguing the frontlight becomes. At sunup or sundown, it can be awesome, although we admit that turning your back on a sunset or sunrise sky just doesn't feel natural. But sometimes it is simply the right thing to do, since the scene behind you may pack as much—or more—photographic punch as the sunset or sunrise scene in front of you, thanks to the beautiful golden light. So, even though the visual drama unfolds at the end of the day, periodically look around, as you may see captivating subjects illuminated by warm, glowing light. After all, when the sun hovers just above the horizon, amazing things can happen—anywhere you look.

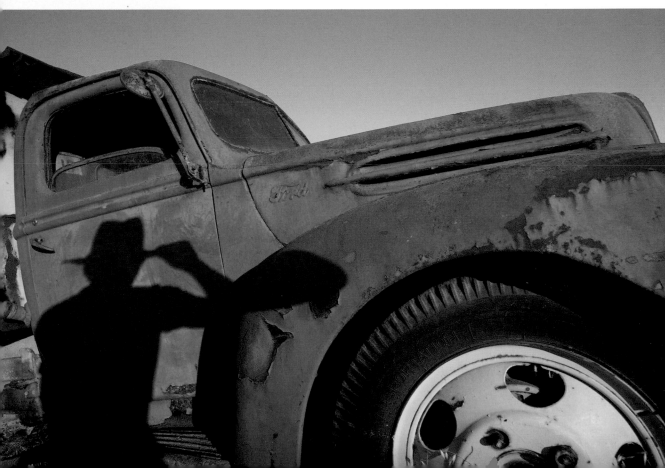

Sidelight results when the sun is off to the side, not in front of or behind you. Sidelight can add form and texture, and it accentuates the three-dimensional look and depth of a scene. In early or late day, expect long and striking shadows.

For portrait subjects, sidelighting brightens only one side of the face. Sometimes this can be a very artsy effect. Most times, you'll want to minimize this by bouncing or reflecting light onto the shaded side of your subject with a portable reflector.

Long shadows are one of the great benefits of low-angled sunlight, particularly sidelight. Photographer Donna Moratelli explains how she set up this eye-catching scene: "It was late afternoon on a clear, cloudless sunny day when I arrived at a local scenic overlook. I was with an assistant. After seeing the perfect spot, I asked my assistant to sit down, open the umbrella, and hold it over his head. I then went upstairs to the deck of the overlook on the second floor. I set up a tripod, set up my camera, and looked through the viewfinder. I saw a nice graphic pattern with a brightly colored subject as the star, with shadow play adding to the design."
→ Photo © Donna Rae Moratelli. 1/6 sec. at *f*/22, ISO 100, 15–30mm lens at 28mm

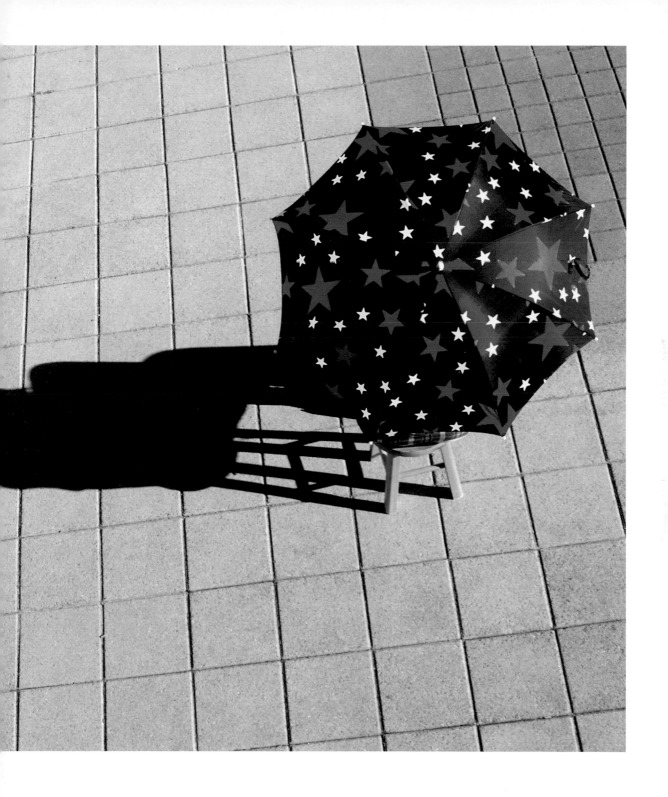

Backlight happens when the sun is in front of you and *in back of your subject*. With backlight, translucent subjects, such as leaves, flowers, or a boat's sails gleam magically. For portraits, your subjects can take on a halo from rim lighting (when the outline of a subject catches the rays of sunlight). Backlight also can create extended shadows that stretch toward the camera. And you can use the high bright-vs.-dark contrast to capture intriguing silhouette shots. (See more about silhouettes in chapter 2.)

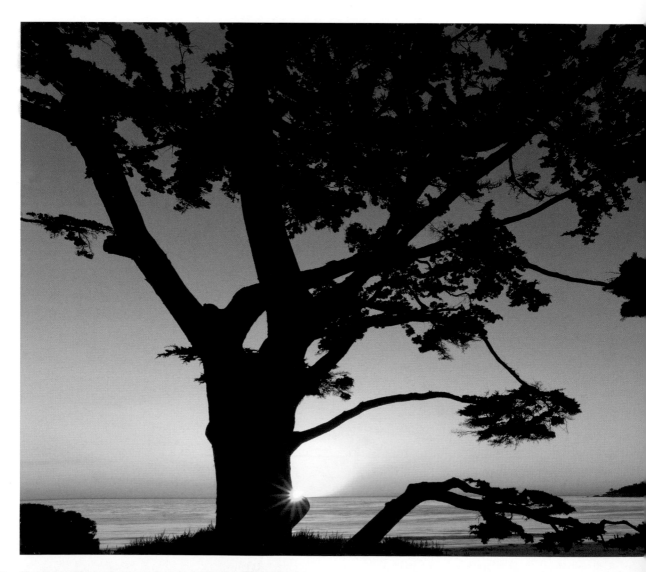

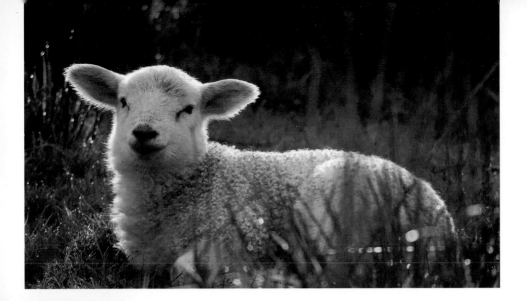

It was light that caught my attention—specifically, backlight. I liked how the sun rimmed the sheep with a bright halo. With my telephoto zoom set at its longest focal length (400mm), I shot through close-up grasses while setting the focus directly on this distant subject.
↑ Photo © Jim Miotke. 1/90 sec. at f/5.6, ISO 100, 100–400mm lens at 400mm

A number of great things were happening along the coast at Carmel, California, beginning with the evening light and a tree with an outstanding shape. I positioned my camera—on a tripod, of course—so that the on-the-horizon sun just barely peeked out from behind the tree. A small aperture (high f/number) helped to create the sun-star effect. I chose a low horizon to avoid including too much of the low, dark foreground while including a lot of the tree against the sky.
← Photo © Kerry Drager. 1/4 sec. at f/22, ISO 100, 12–24mm lens at 12mm

THE TWILIGHT ZONE

Here's a can't-miss tip if you love photographing city sky-lines: Shoot at twilight. Often overlooked, dusk just may be the most captivating time of day. And if you've never shot at twilight before, you're in for a light-and-color adventure.

Far too many people pack up and take off right after sunset. If this sounds familiar, we urge you to stay put and wait. Dedicated twilight shooters consider the sun dropping below the horizon as the beginning—not the end—of the evening's color performance. At twilight, the twinkling city lights transform buildings and streets into dynamic mixtures of color. The sky turns an amazing blue, if not purple, and makes a wonderful background to the illuminated buildings. Add rain-slicked streets or an adjacent body of water and the neon lights create wonderful reflections. Simply put, cityscapes come alive and look absolutely dazzling in the evening.

Other scenes look great at twilight, too—from villages to monuments to colorful car taillights to dazzling carnival rides. Landscapes also take on a dreamlike look. At the ocean, the end of the day can mean soft and sensuous surf during the long exposures in low light.

This beautiful transition between day and night usually lasts only minutes. As with sunset or sunrise photography, twilight photography requires scouting, planning, and working quickly to catch the magic. Also keep in mind that, due to the ability of a camera shutter to let in more light over time, the resulting photo may look even more special—brighter—than how it appeared at the time.

When twilight is at its peak, by the way, the exposure values between sky and land are frequently similar, often making for successful overall metering. Otherwise, if the sky is a rich color, just point the camera upward, fill the viewfinder with the sky, and take a meter reading. Shoot in manual, or if your camera is set for an autoexposure mode, then use exposure lock. However you do it, you'll need to recompose and shoot with those sky settings. Also, you can check the highlight warning or histogram in your LCD monitor and, if necessary, adjust the exposure compensation (for example, setting +1 if your result is too dark or -1 if it's too light).

Besides using a tripod or other solid support to keep the camera steady, it's also important to make sure your hand doesn't touch the camera, since any vibration can have an impact on sharpness during slow shutter speeds. Use a cable shutter release. A self-timer works, too, as does mirror lock-up (assuming your DSLR has this shooting feature).

This scene of the Space Needle and Seattle skyline shows the benefits of a high view-point—from Queen Anne Hill, specifically Kerry Park (no relation!). The "before" image was captured during early twilight right after sundown. The "after" image was shot during late twilight, with the city lights glowing and the sky a wonderfully rich color. The lesson to be learned? Stick around long after sunset and, along the way, keep on shooting.
↗ Photo © Kerry Drager. 1/20 sec. at *f*/6.7, ISO 200, 70–300mm lens at 195mm
→ Photo © Kerry Drager. 1/3 sec. at *f*/10, ISO 200, 70–300mm lens at 220mm

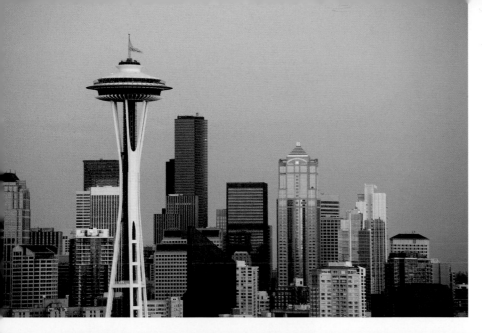

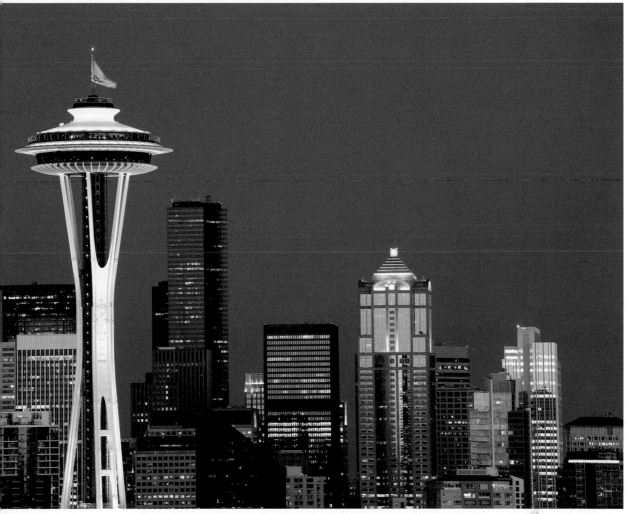

⬤ TWILIGHT TIP: WHITE BALANCE

We both tend to set our cameras to Daylight or Sunlight white balance (WB)—throughout the day, from dawn to dusk. At twilight, we find that this setting nicely captures the range of colors from the warm, golden lighting of buildings to the deep blue of the sky.

Of course, if you shoot in raw, as we both do, you have the ability to easily tweak the WB in the digital darkroom. But getting it right in the field has a double advantage: You can see what you're getting at the time (and, if necessary, switch to another setting), and it's one less thing to do in postproduction.

Auto white balance (AWB), by the way, isn't always reliable and can even be fooled by the range and color of late or early daylight. Particularly if you shoot in JPEG, which is less forgiving than raw, it's important to get the WB as close as possible. Our best advice is to experiment and see which setting works best for you. For instance, some photographers routinely shoot in Cloudy WB, since they like the warmer feel. Others try at least a few frames with Tungsten WB, which can enhance the blues of the scene.

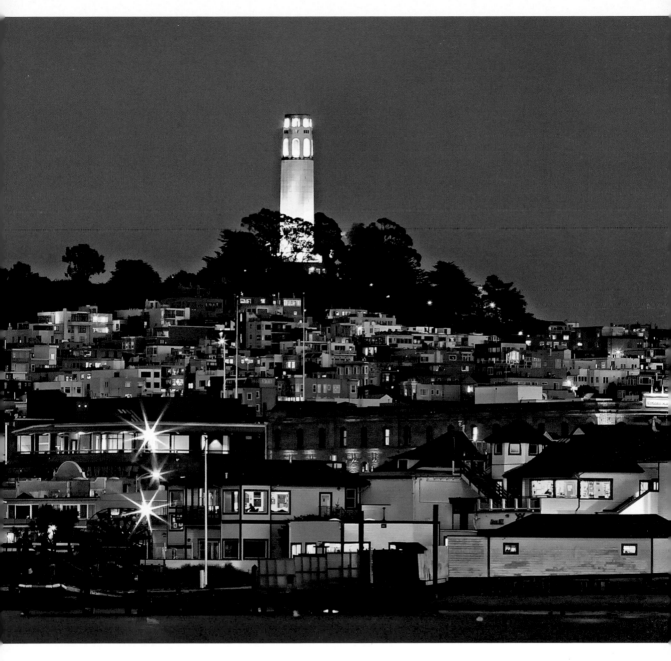

Photographer Lynn Sapadin shot this San Francisco scene at twilight from the Municipal Pier (near Fisherman's Wharf). Says the photographer, "This pier offers a panoramic view of the San Francisco skyline from the Bay Bridge to the Golden Gate Bridge. My original goal was to create a multiple-image panorama using a wide-angle lens, but after a few test images I realized that isolating Telegraph Hill and Coit Tower created a much more impactful photograph. I switched to a telephoto lens to fill the frame and waited for the sun to set."

↑ Photo © Lynn Sapadin. 20 seconds at f/16, ISO 200, 80–200mm lens at 115mm

GOOD PHOTOS IN "BAD" LIGHT

Many developing photographers freeze up when clouds gather. That shouldn't be a surprise. After all, nice and sunny weather just plain feels good. But there's also the fashionable notion that effective photography requires bright sunlight. Right? Not always! Although an uninspiring turnoff for casual photographers, overcast conditions should be a creative turn-on for serious shooters.

Nature's great white or gray canopy means pleasing light that pumps up colors, captures delicate details, and creates a narrow dark-vs.-light range that makes it easy to expose your photo properly. Often called diffused light, soft light not only comes from overcast but also occurs in moody fog, and it happens at dawn and dusk. On a sunny day, you can find diffused lighting in shade.

For pictorial success, soft light should be the determining factor in the subjects you choose and the compositions you design. For instance, a cloudy day can be very flattering light for photographing people, flowers, water in motion, intimate landscapes, architectural features, close-ups, pets, and so on. Overcast light is also great for shooting in forests and cities that otherwise would be splotched with a harsh mix of sun and shadow.

Outdoor portraiture can be ideal under a thick cloud cover, which mimics the softboxes and white umbrellas that studio photographers use to simulate a cloudy sky. In midday sunlight, however, you can make use of open shade by placing your subjects where they won't be hit with direct sunlight—say, under trees, a porch awning, or in the shadow of a tall building. Whether overcast or shade, the conditions are easy on the eyes and flattering on the face.

Colors and details really "popped" during this rainy day at Cades Cove in Smoky Mountains National Park. Says photographer Linda Lester, "I had my friend stand in front of the mill with an umbrella to add to the scene. It was fall, so the colors were nice, and with it being overcast, the even light made for a perfect exposure." Note how the colorful subject is placed at the far right while facing toward the left, which helps "point" the viewer into the rest of the scene.
↑ Photo © LindaDLester.com. 1/4 sec. at *f*/18, ISO 500, 24–105mm lens at 50mm

⬤ **TIP: WATCH OUT FOR BRIGHT WHITE SKIES**

A white or light-gray sky can overwhelm everything else in the photo and make other parts of the scene look dark in comparison. So when your subject or the landscape is in soft light, choose compositions with very little sky or, preferably, no sky at all.

A willing subject, a great location, and beautiful soft light came together in New York City's Central Park on a cloudy autumn day. Here, I chose an "environmental" portrait that showed a slice of the environment, as opposed to a tight close-up image that could have been captured anywhere. A normal 50mm focal length and a wide aperture (low *f*/number) helped create a shallow depth of field for a sharp subject against a background that's blurred but still shows details.
→ Photo © Kerry Drager. 1/90 sec. at *f*/4, ISO 400, 50mm lens

Managing in Midday Sunlight

With creativity and a little luck, you can find photos even in midday sunlight. In some locations—in steep valleys or canyons or below a city's skyscrapers—the sunlight may not hit until midmorning. Here are some tips and techniques if you must work in midday: Move in on colorful details and captivating small scenes. Work in the soft light of shade. Be on the lookout for translucent subjects that are backlit from the sun, such as leaves and flowers. Watch for objects that cast compelling shadows from the high sun.

I usually avoid bright midday sunlight, but at the Antique Powerland Museum in Oregon, color and clouds came together in a powerful way! This extremely cool, extremely yellow Caterpillar caught my eye. For the overall image (above), I used the wide-angle in a straightforward way, which included not only the subject itself but also surrounding and background elements. While the horizontal view documents the entire subject, it's not accomplished in an artful way. For the vertical, I chose a low-and-up-close camera angle and included a very cooperative cloud formation.
↑ Photo © Kerry Drager. 1/60 sec. at f/16, ISO 100, 12–24mm lens at 19mm
→ Photo © Kerry Drager. 1/160 sec. at f/13, ISO 100, 12–24mm lens at 12mm

ASSIGNMENT: EXPLORE THE TIMES OF DAY

Don't take our word for it when it comes to photographing at the right times of day. For this exercise, you get to try it yourself. Choose a nearby scene or subject. Then shoot it at different times of day. Yes, sunrise, too. You'll discover firsthand how light changes so drastically throughout the day. And you'll see how the quality of light varies, as well.

This assignment can be performed over a number of days. But if it's overcast, this test won't work to the same extent as when the sun is out. Find a scene that will get direct light as the sun goes down and when it comes up, too. For example, if tall buildings or trees block the view of a low-on-the-horizon sun, switch to a more open location.

This exercise will help train your eye to determine what a scene will look like in different light. That's important when scouting new locations. You'll learn that paying attention to the light will change your whole photographic life. There aren't many photography techniques that offer guaranteed success, but routinely shooting at dynamic times of day is one of them.

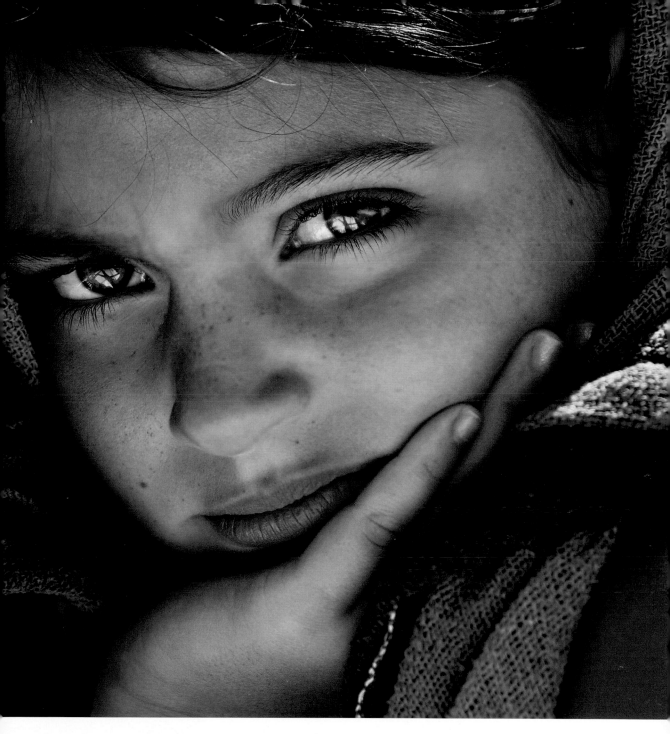

For this portrait of a young girl (the daughter of a friend), photographer Stefania Barbier was out in bright midday sunlight. Says the photographer, "We were at the beach, and I loved her tan and the colors of her clothing. So I asked her to put the cloth on her head, which also helped me to shield her from the harsh sun."

↑ Photo © Stefania Barbier. 1/320 sec. at *f*/5.6, ISO 100, 70–200mm lens at 200mm

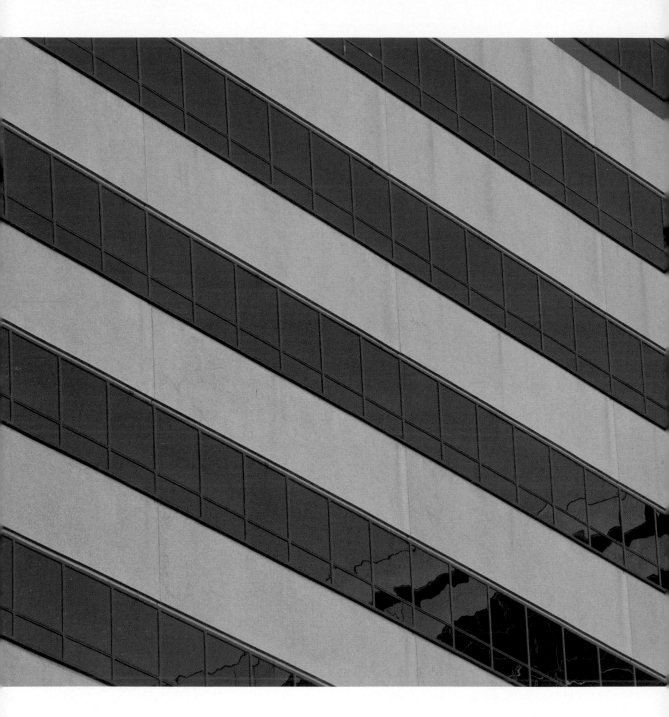

When photographing cityscapes filled with distinctive modern buildings, I'm always on the lookout for strong lines and bold reflections. Here, in downtown Sacramento, beautiful late-day sunlight pumped up the colors. I chose a telephoto zoom (80–200mm) to zero in tight on this sunset light-and-color scene. I selected an upper part of the glass-walled building with diagonal lines that were catching the evening light. I liked—and included—the reflection of a neighboring warmly lit building.
↑ Photo © Kerry Drager. 1/15 sec. at *f*/16, ISO 200, 80–200mm zoom lens at 200mm

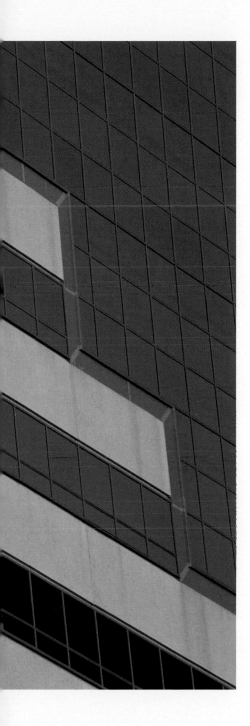

THE ELEMENTS OF DESIGN

Exploring the realm of graphic design can feel very intimidating at first. After all, the world around us is a visually hectic place, and our job, as photographers, is to turn these chaotic scenes into creative images. In this chapter, we'll break down many of the basic elements of design—color, line, shape, form, texture, and pattern— that can make your photos more visually compelling. Black and white, which is all about graphics, comes into play, too, as does repetition.

When composing an image, pay special attention to the design elements. Even if the lighting is wonderful and dramatic, if your photo isn't graphically pleasing, then the chances are the picture will fall short of your hopes. You may already use design elements subconsciously, at least in obvious situations, and most photos do include one or more these components. But many people really don't put much thought about these graphics into their photography. Yet, recognizing the building blocks of composition is the first step toward making more successful and more artistic photographs. Now, let's head forth and start on the vision quest for finding strong graphics and working them into your compositions.

THE POWER OF LINE

When it comes to the elements of design, lines are often the bottom line. But along with the graphic aspect, lines are about psychology. So let's start with a few questions:

• Do you like to be told what to do and where to go? Great! We have the perfect (leading) line for you.
• Or are you more of the direct and assertive type? Then go directly to the verticals and, especially, the diagonals.
• Or does the phrase "calm and content" fit your style? Then jump right into the horizontals and curves.

Those aspects help define the power of line. They are found everywhere—in nature and architecture, roadways and fences, close-up subjects and grand landscapes, the legs of a dancer and the legs of a tripod. Recognizing the strength of bold lines and the beauty of graceful lines—and learning how to use them effectively in your photography—will help boost your creativity in many innovative ways.

Lines can create visual excitement or form an intriguing pattern. They can lead the viewer directly to your main subject. But for a design element that appears in so many different variations, lines come down to two basic types: straight (vertical, horizontal, or diagonal) and curved (circular, arclike, or wavy). Let's look at how a few simple principles can start putting "wow" impact in your photography.

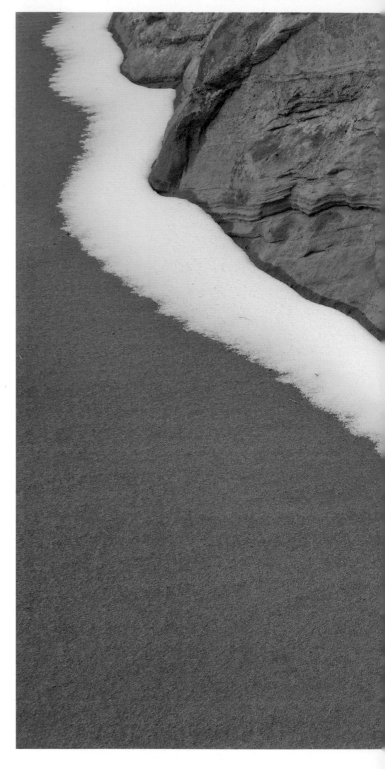

The U.S. Southwest's canyon country is simply magical. For this scene, it was the line of snow contrasting with the orange sand and rock that really made things special. I tried a number of bigger views, but for me, this tight shot best emphasized the line, color, and contrast. Also note that the line is a diagonal—often more visually dynamic than lines that are perfectly parallel to the picture borders.
→ Photo © Jim Miotke. 1/15 sec. at *f*/20, ISO 100, 16–35mm lens at 35mm

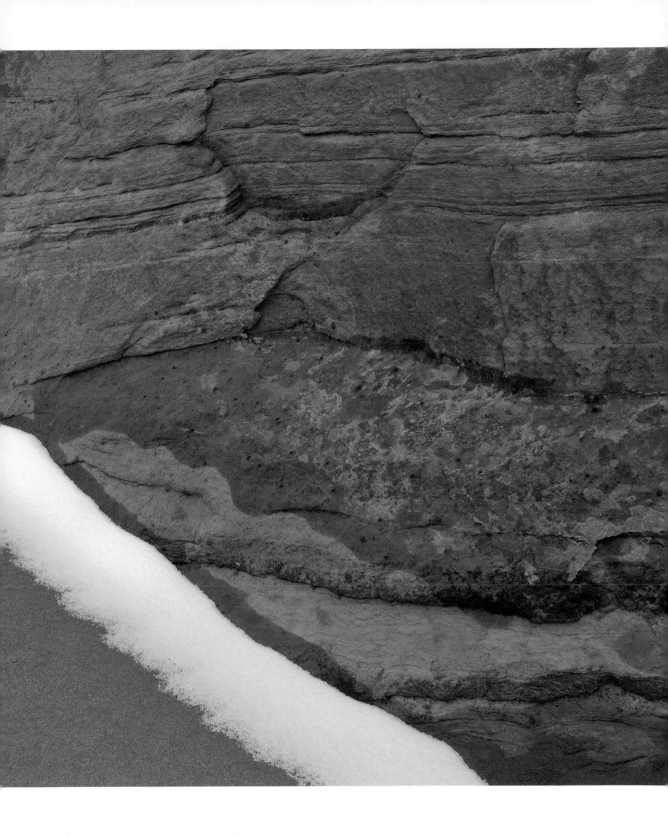

HORIZONTAL AND VERTICAL LINES

Our field of vision tends to scan things from side to side, which fits right in with the horizontal line's sedate personality. As a result, horizontals are considered less visually energetic than other types of graphic lines. Horizontals pop up routinely all over the place. For landscapes and seascapes, the horizontal serves as a fundamental line of reference. This also applies to the horizon line's close "cousin"—a lake's shoreline or waterline.

Like horizontals, vertical lines are parallel to two of the picture borders. However, verticals possess more visual strength, just as a person seems more lively standing up than lying prone. Combine tall lines with a vertical format, and the upward tension—or sense of height—is especially emphasized.

For vibrant expressions of height, think of skyscrapers, tall lighthouses, long waterfalls, columns, flagpoles. The list goes on. Many vertical subjects, such as towering redwoods or the stems of flowers, may not be perfectly straight, but that just adds to their visual power.

Not surprisingly, the colors of this wall first captured my attention. I moved in close to isolate the various components while leaving out any surrounding—and potentially distracting—elements. At the same time, I noticed a strong design of patterns, angles, and vertical and horizontal lines. In this composition, also note the balance going on: The vertical strip of color on the right is balanced by the section of color at the lower left.

← Photo © Jim Miotke. 1/200 sec. at *f*/7.1, ISO 400, 24–70mm lens at 50mm

A mix of vertical and horizontal lines can be very complementary. On a heavy overcast day along the California coast, I looked for intimate color scenes to take advantage of the soft and even light while avoiding the glaring white sky. I found this abandoned old shop in a coastal town and decided on a straight-on composition to capture the pattern of colors, angles, and lines. A polarizing filter removed much of the glare that was present to give the colors an extra boost.

↑ Photo © Kerry Drager. 1/8 sec. at *f*/11, ISO 100, 50mm lens

DIAGONAL LINES

Angled lines automatically create visual tension, since they form contrasting angles to the vertical and horizontal edges of the frame. They signify movement, bold design, and active composition, and they can lead to a more forceful image.

The ultimate diagonal divides the picture space into two equal triangles with a line that extends through the frame from the upper left corner to the lower right or the lower left to upper right. But all angled or oblique lines are generally known as *diagonals* and share the same design strength.

Viewpoint is a major factor in the formation of diagonals. In fact, photographers possess a surprising amount of control to turn straight lines into diagonal ones. While a straight-on viewpoint may reveal a line as a full-fledged vertical or horizontal, if you simply shift the camera angle in relation to the line, then, presto, you now have a diagonal.

At times, you can get a tremendous pattern of alternating diagonals—a situation in which some lines go in one diagonal direction and others go in another direction. Now, *that* is visual power!

The veins of this leaf captured my attention not only because of the color contrast of bright red against bright green but also because I could photograph them as diagonals for a more active composition. It didn't hurt, either, that rain had left some nice water drops and that soft sunlight peeked out momentarily. I used my macro lens to fill the frame with this pattern of line and color.
↑ Photo © Kerry Drager. 1/8 sec. at *f*/13, ISO 100, 105mm lens

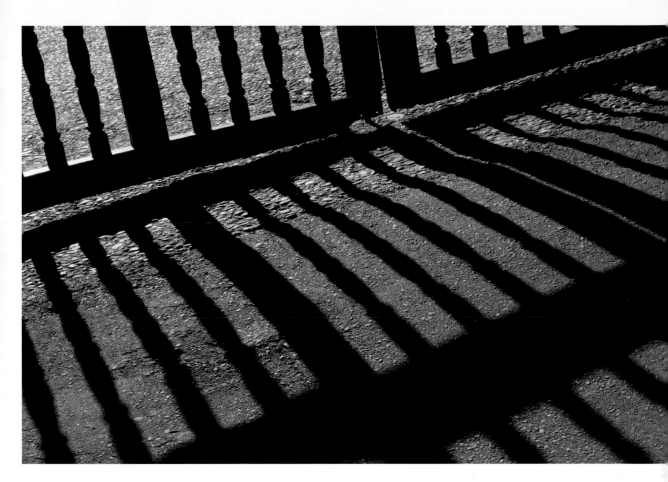

Low-angled sun and decorative iron fencing just seem to go together. For this scene, I created the repetition of diagonal lines by simply moving to the side, rather than facing the gate directly from the front for a straight-on viewpoint. Then, to leave out the background distractions and to really emphasize the shadowed lines, I pointed my camera downward.

↑ Photo © Kerry Drager. 1/30 sec. at f/16, ISO 100, 50mm lens

The Fine Art of Tilting the Camera

This shooting style—tilting the camera to turn a vertical or horizontal line into a powerful diagonal—has been around awhile. One term for it is the "Dutch angle," which is a longtime cinematography tactic employed for the same purpose as still photography: to create visual tension. Still, when we tell students that it's perfectly acceptable, if not totally desirable, to occasionally slant their cameras, they express surprise. After all, you're supposed to keep the camera level at all times, correct? Well, there are exceptions! Used at the right artistic time, a nice tip of the camera can pump up the visual tension by creating great angles and diagonals. Shooting with your camera askew (so as to change naturally appearing vertical or horizontal lines into diagonals) can be done for a variety of small scenes or big views and with just about any lens focal length. Like other creative techniques, you won't want to use this method all the time, but when the subject calls for it, angling the camera is one fine artistic weapon.

📷 ASSIGNMENT: A TWISTED POINT OF VIEW

Have you gone out and tilted your camera today? Go ahead and do it. It's okay—really!

Caution: Yes, when you're shooting in a public place, plan on curious glances—or even comments—from passersby who wonder why your camera is out of kilter. They may even ask if you know you're doing it. Such is the life of photographers who take their art to creatively lopsided levels!

Along a sidewalk in the St. Augustine area of Florida, I discovered this tile scene. I pointed my camera downward to isolate the graphic-design pattern of strong lines and angles. I chose a diagonal composition (via a quick slant of the camera) for a more visually energetic composition. Also, I felt the curved grating would make a good point of contrast.
← Photo © Kerry Drager, 1/15 sec. at *f*/13, ISO 200, 50mm lens

CURVING LINES

Curves make important compositional statements by conveying a flowing sense of move-ment with tranquil qualities. Like the diagonal, these elegant lines stand out against the vertical and horizontal picture borders.

Curves can be found seemingly everywhere—the sweeping curve of a shoreline, a rolling hillside, a meandering stream or trail, the edges of sand dunes, the curls of a flower's petals, the gentle bend of tree branches, an archway's beauty and strength, the flowing arc of an architectural feature, and the classic S-curve of a road, river, or an egret's head and neck.

Proper framing is critical. For instance, be sure to allow enough space for your curve to unfold in your composition, so that it moves freely through the picture space. Clipping off a curve with a border can disrupt the line's flow and spoil the design.

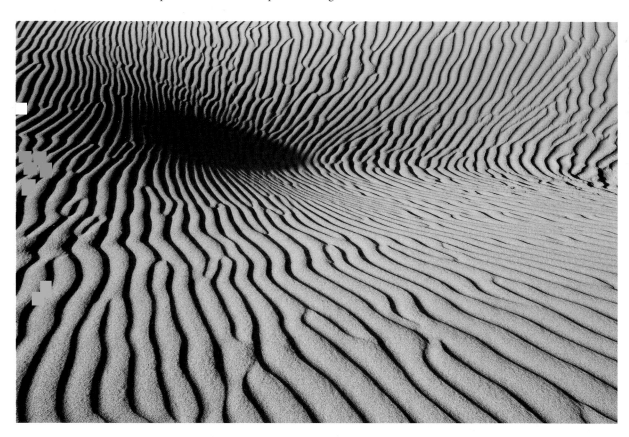

Sand dunes are all about the elements of graphic design, such as in this scene by photographer Doug Steakley, with the attention-grabbing repetition of curving and curling lines. The "trick" is to get out when a low-angled sun skims across the sand to bring out the textures and shadows.
↑ Photo © Doug Steakley. 1/90 sec. at f/19, ISO 200, 17–35mm lens at 35mm

Las Vegas has so much to offer the photographer, even beyond the neon lights and grand casinos. For example, photographer Christopher J. Budny shot this image after spotting a building with varied brick, stone, and metal treatments on the façade; swooping curves of green glass windows; great lines and shadows; and lots of square openings. Says the photographer, "I spent quite some time walking around this building, capturing many of the unique features, but mostly details of the whole."
→ Photo © Christopher J. Budny. 1/125 sec. at f/8, ISO 200, 17–85mm lens at 56mm

Leading Lines

Not all lines in a photo take the viewer places, but when they do, that image can venture into another dynamic dimension. Composing pictures with leading lines is a traditional technique that has long captured the attention of painters and photographers.

Like a tour guide, you'll be leading viewers where you want them to go—by giving direction to the eye. Whether the lines are straight, zigzagging, or softly curving through the composition, viewers will have a sense of satisfaction after having traveled along the line that you provided. Most often, a leading line starts in the near foreground and then draws your viewer into your heart of the scene. It's a very effective way to direct viewers to your subject or to simply lead them on a visual journey through your picture.

Once you start to recognize the potential for leading lines, you'll jump at opportunities to exploit them. They can be seen in landscaping, buildings, shorelines, streets, fences, and more. They can be colorful streaks of moving taillights at night, or they can be the long shadows of columns or trees that extend from camera to subject.

Multiple leading lines add to the graphic appeal. With railroad tracks, the railings of a long pier, fences that parallel both sides of a roadway, or any other parallel lines that venture into the distance, the two lines will appear to eventually converge, even though we know they are really parallel. The result is great visual drama.

This hotel's lines, repetition, and colors, along with the beautiful sunlight of early day, drew my attention. For this image, I saw the possibility of using both leading lines and repetitive patterns as the primary design elements. I moved close to the building and slanted the camera as I pointed upward to turn the lines into diagonals for extra visual energy.
→ Photo © Kerry Drager. 1/90 sec. at *f*/16, ISO 500, 50mm lens

Fall colors, the soft and even light of an overcast day, and a spectacular subject came together perfectly during a trip to New Hampshire. "Living in Australia," says photographer Renee Doyle, "I don't get to see covered bridges very often—especially not bright and beautiful red ones like this one!" Note how she composed the photo so that the road's curving lines lead the eye directly to the main part of the photo. At the same time, the lines of the railing at the left also "point" to the red bridge. *Note:* She also used a polarizing filter, which helped saturate the colors. A tripod kept things steady, since the combination of low light, deep-tinted polarizer, and a very small aperture (for a deep depth of field) resulted in a long exposure.

← **Photo © Renee Doyle. 3 seconds at *f*/22, ISO 200, 24–70mm lens at 43mm**

SHAPE

Shape is a surprisingly compelling design element. We first recognize many things based on their shape, whether it's the outline of a person or an animal, a cup or a rose, monument or vehicle. Fundamental shapes include squares, triangles, rectangles, and circles.

While sidelighting results in a gradation of light to shadow and expresses form, shapes are most often frontlit or backlit. In most cases, shapes can be made more evident by contrast—for instance, when one object is much darker or lighter than a neighboring one. The graphic study of dark against light particularly comes into view with silhouettes. These stark outlines eliminate any sense of depth or form in the subject, because they appear as simple, flat shapes.

A design of shapes and colors dominates this amazing small scene of bubbles. On a cold and wet winter day, photographer Katarina Mansson stayed indoors and, armed with macro lens, tripod, and window light, started shooting oil-in-water pictures. "To spice it up," she says, "I put a CD underneath the bowl with oil/water. Then I tried to capture a nice color spectrum together with a nice constellation of drops. It wasn't so easy. But after a couple of hours, lots of exposures, frustration, and fun, I had a few pictures I was happy with, including this one!"
↑ Photo © **Katarina Mansson. 1/6 sec. at *f*/6.3, ISO 200, 100mm macro lens**

Strong shapes make strong shadows in the right light. The beautiful low-angled sunlight of late day caught this colorful old truck. I was attracted to the mirror, so with a close composition of subject and shadow, I got two dynamic shapes for the price of one. Also, I felt the diagonal lines added a nice additional visual accent.
↑ Photo © Kerry Drager. 1/10 sec. at *f*/22, ISO 200, 105mm lens

Sometimes it simply pays to look down, and on a freezing day, ice can be a visual treat. For this scene, I walked around until I found the right scene. With an insulated pad to keep out the cold, I kneeled down and filled my viewfinder with this macro pattern of circular shapes.
← Photo © Jim Miotke. 1/100 sec. at f/2.8, ISO 100, 100mm macro lens

SHAPES AS SILHOUETTES

When it comes to natural light, high contrast can mean high drama. Backlight extremes can create a dynamic showstopper: the silhouette. This stark interplay of bright and dark produces a commanding impact. Silhouettes, in fact, help you start looking beyond the literal subject and see objects as shapes.

These eye-catching images rarely just happen, though. Usually you have to look for them, and advance scouting trips are highly recommended. A low-on-the-horizon sun—just after sunrise or just before sunset—always comes through with great silhouette potential. The key is to find subjects that have simple-yet-bold shapes, are readily identifiable, and that are surrounded by brightness.

In addition to sunrises and sunsets, any bright background (such as a bright beach or snow scene, a bright lake or a bright fountain) can be used to create beautiful silhouettes. Simply find a foreground element in the shade and position yourself so that this foreground is in front of the bright background.

For most of us, the first silhouettes we ever recorded were strictly unintentional, usually indoor family portraits in front of a bright picture window or friends standing outside in the shade of a tree with a big bright sky behind. With no compensation or fill flash to brighten the subjects, the result was invariably dark subjects against sunlight.

An intentional silhouette shows off your subject's contours but otherwise leaves the subject pretty much to your imagination. In other words, the best silhouettes are pure shapes—simple, startling, and dark with little or no detail.

You'll want a backlit or shaded subject that's sharply outlined, that's easily identifiable, *and* one that's set against a sunlit, uncluttered background. Good candidates include statues, people, towers, jagged peaks, bridges, trees, natural arches, railings, fences, architectural elements, horses, and the like.

Remember, however, that as with any photographic technique, you should plan to practice. Trial and error is part of the learning curve both in identifying scenes with silhouette potential and shooting them. But it won't take long to start capturing some striking shots, and a few silhouette images will add a dynamic element to your photography.

Exposing for Sunrise or Sunset Silhouettes

In most photos, the idea is make sure the main foreground subject is exposed correctly. With silhouettes, the goal is to ensure that the background is metered correctly.

Be careful that your shadowed form doesn't influence the meter reading, otherwise the picture may be overexposed as the camera tries to lighten your dark subject. Likewise, if your camera meters directly toward the sun, your exposure will likely be much too dark.

To counteract this, you must take an alternate meter reading off a middle tone—not too bright, not too dark. To do so, point the camera at the sky to the left or right of the setting or rising sun (or away from the bright sky if the sun is just below the horizon), but also leave out any big expanses of dark area. Just fill the viewfinder with the sky. Take the exposure reading. Set the exposure manually, or if in an autoexposure mode, use the exposure-lock button. Recompose your photo and shoot at those sky settings.

If you expose your silhouette correctly, the shadowed areas will go dark and the bright areas will show good color and detail. That would be a perfect silhouette exposure.

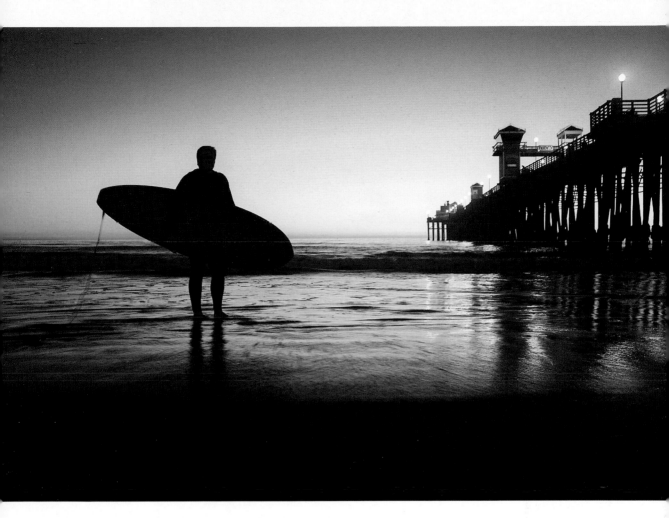

When it comes to a silhouetted surfer with his surfboard, it's all about arresting and identifiable shapes. Photographer Donna Pagakis explains how she captured this scene at one of her favorite locations (the pier in Oceanside, California) in her favorite time of evening (postsunset): "Twilight is when the pier lights light up and throw the most gorgeous reflections on the water. A surfer appeared on the shore and had just finished his evening session. I asked him if I could take a quick portrait by the pier. He was more than happy to pause for a moment. I exposed for the scene as I normally would, since I knew I wanted a silhouette."

↑ Photo © Donna Pagakis. 1/3 sec. at *f*/4, ISO 100, 18–55mm lens at 24mm

Palm trees make tremendous subjects, due to their very distinctive shapes. On a trip to Fiji, I wanted to show them as silhouettes. Early one morning, I turned to my wide-angle lens to catch a sweeping scene of palms against the sunrise sky. At sunset one day, I caught a tighter view—leaving out the ground entirely—while placing the silhouetted shapes against the colors and clouds.

↑ Photo © Jim Miotke. 1/100 sec. at *f*/7.1, ISO 100, 24mm lens
↓ Photo © Jim Miotke. 1/250 sec. at *f*/2.5, ISO 100, 50mm lens

🔆 TIP: BEWARE OF MERGES

When shooting silhouettes, aim to catch moments when the subject is clear and easy to differentiate from the surroundings. If your subject gets too close or touches other objects, it will appear to merge with the other fore-ground elements and create an unappealing large mass of darkness. Keep empty space around your silhouetted object (the most important parts of the subject) so that the eye can easily recognize the shape.

At our little ten-acre spread in California, we have a collection of birdhouses. On this day, it looked like a fine sunset was in the works, and I wasn't disappointed. I chose a silhouette scene—with the dark birdhouses against the bright sky—to highlight their great shapes. To get the exposure, I pointed the camera toward the sky and filled the frame with a medium-tone area (not the darkest, not the brightest). After pushing the exposure-lock button, I recomposed and shot the scene at those settings.
↑ Photo © Kerry Drager. 1/6 sec. at *f*/11, ISO 100, 80–200mm zoom lens at 80mm

Along the California coast, a sunset often means a wonderful sky and beautiful reflective colors on the sea, but sometimes you just need something else—a silhouette. Great plants and overhanging tree branches were just the thing for this scene. To get the right exposure of silhouetted subjects against colorful sky, I stepped away from the tree, pointed my camera to a middle-tone part of the sky, took a meter reading, and locked in the exposure settings. I then recomposed the picture (on a tripod, of course!) and fired off this shot.
↑ Photo © Jim Miotke. 1/13 sec. at f/8, ISO 200, 28–135mm lens at 135mm

How Lighting Contrast Works

Our eyes have an amazing dynamic range. We can detect good detail throughout a high-contrast scene of glaring highlights and deep shadows. Not so with the camera. A camera can't capture an extreme range of lighting in a single unaided image. For example, metering for the shadow area—to lighten it up—will mean the sunlit area in the image also will go lighter and, as a result, will become severely overexposed, or "blown out," with little detail or color. However, in this case, such contrast is a good thing. It's precisely what we want, since contrast is how creative silhouettes are made!

FORM

Light is the main ingredient that turns a two-dimensional shape into a three-dimensional form. But not just any kind of condition reveals the interplay of shadow and light to reveal a shape's form. It's light striking from an angle—often sidelight—that adds depth and volume to a shape.

Consider these examples: the rounded forms of sand dunes, rock formations, the gentle curves of a dancer's legs, rolled-up bales of hay, and rounded tree trunks. Small objects count, too, such as water bottles, apples and pears, a slice of cake, or little stones. Of course, bigger subjects show form, as well, including lighthouse towers, tall buildings, and even mountains. The forms in a sweeping landscape can look absolutely mesmerizing when hit by low-angled sunlight.

In most cases, you'll want to photograph under a sunny sky, since sharp sunlight often best defines the form of the subject. The degree of harshness can vary. But soft lighting can work, as well, assuming there's enough of a tonal range (a transition of light to shadow that outlines the form and gives dimension to the subject). Look for a gradual shift or progression of highlights to shadows. Too little contrast, though, and any form may disappear.

Sometimes it takes a lot of patience—while being ready to push the shutter at the best time—to capture unique interactions and behavior in animals. So says photographer Laurie Shupp, who used her technique to great success in capturing this tender moment between the two young elephants. Note the larger and older elephant standing behind the two. This provides additional depth and perspective of size. At the same time, the angled sunlight reveals the great forms and textures.
→ Photo © Laurie Rubin Shupp. 1/750 sec. at *f*/4, ISO 100, 70–200mm lens with 1.4x teleconverter for 280mm

The beautiful late-day sunlight transforms this rocky stretch of shoreline along California's Big Sur coast. The sidelighting reveals the strong forms of the rocks, boulders, and outcroppings. Getting this shot, however, wasn't easy, since it required a fifteen-minute climb—with backpack and tripod in hand—down a precarious cliff. But says photographer Debra Harder, "I was determined to get a lower point of view." Note, too, that she used a slow shutter speed to create soft and silky surf.

↑ Photo © Debra Harder, DRH Images. 1/2 sec. at *f*/22, ISO 200, 24–70mm lens at 32mm

For many photographers of close-up scenes, the kitchen serves as a very efficient "studio." During a food-shooting session one afternoon, says photographer Susan Gallagher, "I thought it would be interesting to line the tomatoes up with the green stem in the corner. My camera was on a tripod, and I focused very carefully on the stem. I chose an aperture of $f/10$ on my macro lens, and this limited the depth of field on the tomatoes behind. The light from the window gave some nice catchlights to the tomatoes."

↓ Photo © Susan Gallagher. 3/4 sec. at $f/10$, ISO 100, 105mm macro lens

TEXTURE

This is an element of design that you can just "feel." But while texture appeals to the sense of touch, it's the visual aspect that is most intriguing for photographers. Capturing these intriguing graphics will soon be another valuable tool in your artistic kit.

Consider fishing nets, rough hands, tree bark, frost on a window, a cobblestone pathway, the fur of a dog or cat, a wool sweater, a woven fabric. Even crumpled laundry. Subjects with strong texture can work in just about any light. For example, strong early or late-day sunlight makes texture come alive by raking across uneven surfaces. It can reveal the peeling paint of weathered wood, the roughness of a rock, the sand of a beach, the coarseness of snow. It can even enhance the sparkling coarseness of beach scenes. Each grain of sand and each granule of snow casts its own tiny shadow due to the sidelight.

Be ready to zero in on texture in a close-up shot, but not necessarily all the time. Bigger scenes can offer texture, too, with the low angle of light hitting the subject at an angle and accentuating a landscape's textures and contours. When the light's right, texture is revealed in great expanses of earth—such as a canyon or valley or a mountain cliff face.

However, diffused light also can work effectively. And it doesn't require a subject with a rough surface. Delicate subjects may require the soft approach, so don't let a white sky or deep shade ruin your texture dreams. If you plan to show the softness of a field of grasses or of animal's fur, for instance, you might even prefer diffused light.

Fresh snow lines the trees of this Oregon scene. The result is a picturesque land-
scape of great textures and contrasts. Photographer Debra Harder positioned the
main subject off-center in the composition, and although relatively small in the
scene, the red barn jumps out of the picture due to its color contrast.
↑ **Photo © Debra Harder, DRH Images. 1/250 sec. at *f*/8, ISO 200, 200–400mm
lens at 200mm**

Besides looking so tasty, these candies have texture written all over them. Says photographer Amalia Arriaga de Garcia, "I liked this these candies because of their geometric shapes, strong pattern, and vivid colors." With light entering from a window, she was also attracted to the textures of the candies.

↑ Photo © Amalia Arriaga de Garcia. 3/4 sec. at *f*/22, ISO 200, 60mm macro lens

Lions certainly have a look—and textures—all their own, and that's true in this close-up telephoto portrait captured at the zoo in Little Rock, Arkansas. Says photographer Stacey Bates, "I spent a lot of time at his exhibit watching him and waiting to get a shot with him looking at me with his piercing eyes. I used a monopod, while leaning against the railing or pole for extra support."

→ Photo © Stacey A. Bates. 1/250 sec. at *f*/5.6, ISO 400, 70–200mm lens at 390mm with 2x teleconverter

COLOR

Legend has it that *National Geographic* once issued this mandate to its photographers: If you can't make it good, then make it red! Another version had *Geographic* shooters packing a red jacket as an essential accessory, ready to pull out and brighten up a subject dressed in drab tones. These anecdotes were likely never more than fiction, but they do hammer home the point that color as a graphic-design element possesses an amazing amount of visual punch. It's impossible to overemphasize the power of color.

There's nothing quite like eye-popping colors. Such astounding impact! But color doesn't start and stop at wild and saturated colors. Pastel or desaturated hues can be so exquisite, with their own subtle beauty. In low clouds, fog, or even a light rain, the muted colors can possess a magically soft mood.

At times, it's the color that is the main subject, rather than the particular object. This might be a flower garden, stained-glass windows, bright clothing or costume, or the nighttime reflected colors in wet city streets after a rain. Also, instead of objects such as fall leaves or a fire hydrant, you might think more in terms of color—yellow or red in these two examples. You can artistically arrange the colors in your composition.

A white-sky day is often the signal for photographers to turn their attention to intimate scenes and fine colors. That's precisely what photographer Kathe Nealon did in New York City. She saw this tree, its form, and its colors and liked what she saw. After finding the right camera angle, she was able to catch this view—free of ground-level distractions.
→ Photo © Kathe Nealon. 1/80 sec. at *f*/5, ISO 400, 28–75mm lens at 44mm

A long telephoto let me zoom in tight on a parrot's feathers at the St. Augustine Alligator Farm in Florida. The layers of colors were just tremendous and certainly caught my eye. Still, just as important are the other graphic-design elements at work here: the line, texture, and pattern.

← Photo © Jim Miotke. 1/160 sec. at *f*/5.6, ISO 400, 70–300mm lens at 300mm

This scene, captured in the shade of evening, illustrates the visual power of color. Although the chairs are identical in terms of size and shape, the contrasting color makes the warm-colored subject jump right out amid the cool-toned chairs. That also meant placing the contrasting chair—as the scene's main subject—off-center in the frame.

↑ Photo © Kerry Drager. 3 seconds at *f*/16, ISO 200, 70–300mm lens at 250mm

When it comes to color impact, we naturally think of saturated hues, but light, bright, and airy images can generate attention, too, as this photo proves. Here's more from photographer Carla Saunders: "One morning, I woke up to fog so thick it pressed up against the glass windows. This was perfect for a high-key shot of this arrangement using natural lighting. The bright background light came from the sun behind the fog. The light on the tulips came from another side window."

↑ Photo © Carla Trefethen Saunders. 1/10 sec. at *f*/8, ISO 100, 28–135mm lens at 38mm

⬥ TIP: WORKING WITH COLOR CONTRAST

In a crowd of colors, it's contrast that can really make your subject stand out so that the viewer takes notice. The contrast can be bold saturated colors vs. more subdued ones. But things come together in a lively way when it's warm hues (reds, yellows, and oranges) vs. cool ones (greens and blues). For instance, it could be a warm accent in a cool-color scene or a cool accent amid warm colors. The eye is drawn directly to the contrasting color. Such a dramatic visual statement extends to other situations, too, such as a vibrant green against a muted or dull brown—or, in fact, just about any saturated color amid less-saturated hues.

BEWARE OF STRAY COLORS

Here's a topic that comes up a lot. So often, students and other budding photographers concentrate so much on their main subject that a stray splash of contrasting color slips by unnoticed. But that contrasting color can draw the viewer's eye away from your subject to the edge of the picture or to the background. So when composing your image, if a bright red or yellow object grabs attention—and it's not your subject—then the best advice is to recompose and leave it out of the picture.

In Kalapana, Hawaii, photographer Kathleen T. Carr caught this nighttime scene of the molten lava flow from the Kilauea volcano. Using a tripod for the long exposure, Carr captured several bystanders as dynamic silhouettes against the bright backdrop.
↓ Photo © Kathleen T. Carr. 1.3 seconds at *f*/5, ISO 800, 55–200mm lens at 67mm

 ASSIGNMENT: COLOR QUEST

This exercise is guaranteed to open your eyes to the wonderful world of color. But there's more: This assignment is also a great way to "force" creativity during those periods when you have the time to shoot but just can't find inspring subjects.

Before heading out for a shooting session, choose a color. Then shoot only scenes that include that color as a major focal point. While the color needn't fill up the picture frame, the idea is to compose the photo so that the target color is a key ingredient. This can be a multiple-step exercise, too; just pick a different color for the next time. The color could dominate the foreground, or it could be a bright color that's relatively small in the scene but jumps out amid the subdued surroundings.

Along the way, pay attention to how other colors in the scene impact your chosen color. Beware of a brighter color that draws attention away from your chosen hue. Also, look for colors that may complement it.

PATTERN

Once you set your mind to it, patterns are very easy to recognize. They're everywhere. Patterns are formed by repeating graphic elements, such as shapes, colors, and lines—and even repetitions of light-and-shadow designs, too. The more you have, the stronger the pattern. Look away from these pages right now and we'll bet you see some graphic designs nearby. Paying attention to pattern is a great way to keep your pictures looking like professional images rather than like mere snapshots, so be on the lookout for patterns. It's not hard to do.

The natural world provides unlimited pattern prospects. Look for them in tree trunks, flower blossoms, rock faces, a blue sky filled with puffy white clouds, the intricate design of a spiderweb, or ripples in sand or water. Or zoom in tight on the markings of an animal's fur (think giraffe). With a palm frond, note the pattern of lines and how they radiate outward. In autumn, zero in on fallen leaves, and look for shapes, lines, and colors that form a dynamic pattern.

But nature doesn't have a monopoly on pattern. Fields of crops offer potential for graphic combinations of the natural and the manufactured. Roads, buildings, and countless small objects offer excellent opportunities to photograph patterns. In the urban world, look for patterns comprising straight and curving lines, right angles, triangles, and rectangles, some of which are rarely found in nature. Architectural details can be a visual treat. Check for patterns on the side of a mirrored skyscraper, or look above for ornate ceilings. For intimate scenes, don't overlook chipped paint, leaf close-ups, and colorful fabrics as potential graphic images.

Want more ideas? Check out flea markets or wrecking yards. Produce stands, with their vibrant vegetables and fruits, almost always offer graphic displays of colors. If you're stuck at home, there are many opportunities to capture patterns. Be on the lookout for patterns of silverware and dishes, multicolored drinking straws, or colorful tumblers. No need to rely on the harsh light of flash that can overpower a subject. Since most scenes will be stationary, you can use a tripod. And window light works great.

Almost without exception, it's important to have complete depth of field when shooting patterns, since the entire scene is the subject. This may require a small lens aperture (high f/number) to get as much of the pattern as sharp as possible. If the subject is relatively far away, depth of field will likely not be an issue at all. For a flat subject, you may be able to make the camera parallel to the subject, which will help keep things in focus. (For more on depth of field, see chapter 4.)

Colorful window reflections are always a visual delight, and the pattern on this mirrored skyscraper caught photographer Rolan Narman's attention one day in New York City. "I noticed this beautiful reflection of a building on a Manhattan high-rise's windows," he says. "What interested me was that the afternoon sun was beautifully lighting some of the areas of the reflection, and the colors were complementing each other very nicely."
→ Photo © Rolan Narman. 1/160 sec. at f/6.3, ISO 200, 18–200mm lens at 48mm

If you're stuck at home—and even when you aren't—there are many opportunities to capture patterns. For most graphic-design shots, it's good to fill up the frame with the pattern while leaving out any surrounding distractions—including a background that may detract from your scene. For the main image below, I wanted to emphasize the overall design of colors and lines illuminated by backlight from a window and therefore moved in tight with my macro lens to leave out the busy upper background.
← Photo © Kerry Drager. 1/15 sec. at *f*/16, ISO 200, 105mm macro lens
↓ Photo © Kerry Drager. 1/10 sec. at *f*/10, ISO 200, 105mm macro lens

Looking down from a beach boardwalk, I noticed the wonderful patterns in the sand. I included the lines of the fence for added visual interest. *Note:* This is a soft-light overcast version of the sunlight-and-shadow images on page 31, proving that good scenes can also produce fine results in different light.
↑ Photo © Jim Miotke. 1/60 sec. at *f*/18, ISO 200, 24–70mm lens at 42mm

For one-of-a-kind images, you often don't need to look further than water reflections, especially when there are ripples present. In many cases, you might wish to use a long telephoto, as I did here, to fill the viewfinder with the abstract patterns.
↑ Photo © Jim Miotke. 1/1000 sec. at *f*/11, ISO 500, 300mm lens

🔆 TIP: MORE THAN MEETS THE EYE

Leave out anything that detracts from the pattern or that pulls the viewer's attention away from it. Actually, there's a double bonus when zooming in tight on a pattern: Not only can you delete any surrounding distractions, but by filling up the whole frame with the pattern, you will enhance and even expand the pattern. For example, if you're photographing a pattern of colorful ripples in a lake or of fallen autumn leaves, zoom in tight. As a result, it will appear that the ripple or leaf pattern continues indefinitely beyond the edges of the picture frame. That makes your pattern shot take on additional visual strength.

📷 ASSIGNMENT: PUT THE "GRAPHIC" BACK IN "PHOTOGRAPHIC"

This easy exercise can be performed anywhere and will give your artistic vision an enlightening workout. Go on a photographic scavenger hunt. But rather than looking for specific objects or subjects to shoot, you'll be working from this list: line, shape, form, texture, pattern. This doesn't mean that you must capture all of them—or even two of them—in one photo. But your goal is to bring back a series of images in which each photo features at least one of these design elements as the key feature. This may take several shooting sessions to cover all of them. Have fun!

In a quest to make a common scene look special, photographer Jacqueline Rogers focused on close-ups. "I was on a weekend getaway in a small town near the California coast," she recalls. "While waiting for some friends, I noticed the sunlight shining through this colorful nylon flag. I decided to see what kind of shots I could make with the flags. The end result was this shot with the light shining through the flag, giving a rainbow effect of color and line."

↑ Photo © Jacqueline Rogers. 1/400 sec. at *f*/5.6, ISO 400, 28–75mm lens at 57mm

BLACK AND WHITE

Think of old-time photography and black and white quickly comes to mind. And why not? The early grand masters of photography elevated black and white to high art and high style. Then along came color, and black and white slipped into the specialty or boutique realm. In recent years, however, black and white has seen a resurgence of interest. This shouldn't be a surprise, as it offers a certain mood, a timeless appeal, and a classic, elegant, quality.

Stripped of color, a black-and-white image can communicate its visual strengths very clearly. Its simplicity also helps put the focus on the photo's graphic elements without the viewer being distracted by color. With black and white, photographers can focus on shape, texture, pattern, and other graphic-design elements, as well as tonal nuances and the striking interplay of light and shadow. Depth and dimension also seem to jump out in monochromatic images.

Color remains king, of course, but digital technology has made black and white far more accessible. For instance, software makers are providing more tools for custom conversions. There are numerous software options for converting a color image to a monochromatic one, with each method acceptable in its own right. As we often say, "All roads lead to Rome."

But what if your camera has a special black-and-white shooting mode? We still highly urge you to shoot in color and convert the images to black and white in the digital darkroom. This way, you aren't locked into just the black-and-white version. You can have both color and black-and-white images of your favorite photos. Also, at the time of shooting, you may not even know which will be the best treatment for a scene—black and white or color—so that's all the more reason to shoot color.

When considering a scene or photo for black-and-white treatment, look for graphic-design elements such as shape, form, line, or texture. Sometimes it works best to use an image that looks great in color, but not necessarily. In certain cases, color can be distracting and take away from a photo's potential impact. Especially when the color is a bit gaudy or distracting, you may find a great black-and-white image hiding behind a failing color photo.

Remember: In black and white, it's all about contrast (transitions between shadows and highlights). In fact, you'll need to forget about color. Black and white is a translation of colors into tonal differences—shades of gray—along with pure whites and blacks. That's why black and white can be such a visual treat for viewers.

◉ TIP: GIVE BLACK & WHITE THE QUICK TEST

Can't decide if your color shot is a good candidate for black-and-white treatment? Then give it a quick test. Go to Color Saturation in Photoshop or your other imaging-editing software, and remove all color. The image may not be perfect, but you should have a rough idea of how the scene will look from a monochromatic point of view. If you can see the makings of a fine black-and-white image, then proceed and finesse it with contrast, filters, or special software. If it just doesn't look quite right, or the black-and-white treatment doesn't really add anything, drop it and move on to the next contender.

This tulip bouquet sat on photographer Greg McCroskery's dining-room table, adjacent to a large picture window. On an overcast day, he noticed the soft quality of light falling on the bouquet. "I couldn't let this light go to waste," he recalls. "The original image was shot in color, but after processing, I realized that the tonal range and shadow transitions would really look good in a black-and-white rendering." For this scene, he placed a black reflector behind the bouquet to isolate it from any distracting background. A very small aperture (f/20) provided enough depth of field to keep most of the leaves in sharp focus.
→ Photo © Greg McCroskery/Imagism. 8 seconds at f/20, ISO 100, 105mm lens

Photographer Stacey Bates was photographing a ten-and-under baseball team, making individual portraits of the players, and was seeking other-than-standard posed shots. Her subject, Connor, had a great face with expressive eyes, and she had been wanting to get a close-up of a catcher. She felt that a black-and-white treatment fit the scene perfectly.

← Photo © Stacey A. Bates. 1/250 sec. at f/2.8, ISO 250, 70–200mm lens at 200mm

REPETITION

Identifying a single subject is the compositional goal in most situations. Two identical subjects? Things are starting to get interesting. Three or more similar elements? The scene now moves into the artistic realm of graphic design: repetition or rhythm.

With repeating design elements or objects, pattern is the primary point of interest. Things to look for include straight or curving lines, simple graphic elements, and strong shapes or forms. Repeating objects can be seen within any subjects, from small scenes to big landscapes and cityscapes. For example, be on the lookout for rows of trees, taxicabs, or school buses; repeating surf lines; repetition of decorative designs, rooftops, repeating archways, or other architectural elements; and lineups of objects, such as deck chairs, rental kayaks, or boats. The list goes on and on.

Arranging objects in rows can lead the eye through the composition in a visually satisfying way. Be sure to compose carefully, since you'll want to arrange the elements in an organized manner. As always, watch for a potentially distracting background, and reposition yourself or use a lower *f*-stop number (larger aperture opening) if it's necessary to make the background softly focused and less distracting.

Some additional thoughts on recording repetition:

• If you move or zoom in tight and fill up the picture frame with your subjects, then the repetition will seem to continue far beyond the borders indefinitely.
• Any focal length can be used, depending on the scene. A telephoto lets you "stack" subjects, although in some cases, you'll want a wide-angle to more fully develop the repetition or rhythm.

In California's Gold Rush country, many nineteenth-century buildings offer all sorts of design features. In the case of these decorative stairway railings in Old Sacramento, I was attracted by the repetition pattern of diagonals and curves, as well as the strong design concept that relates to groupings of three objects. My telephoto zoom lens served a double purpose: (1) to fill the frame with the graphic design and (2) to take advantage of the telephoto's unique visual perspective that "compresses" objects and makes them appear closer together than they really are.
↑ **Photo © Kerry Drager. 1/8 sec. at *f*/9, ISO 200, 80–200mm lens at 125mm**

On this cloudy day, a quick detour to a fairground (no events, but open to the public) revealed an outdoor storage area with great repetition—these rows of colorful portable fencing. I chose an off-to-the-side camera position, so the close-up fence posts extended across the frame as a nice diagonal. With a tripod, I was able to vary the *f*-stops while using my DSLR camera's depth-of-field preview to get my desired sharp-to-blurry transition. (See more on depth of field in chapter 4.)
↓ Photo © Kerry Drager. 1/15 sec. at *f*/9.5, ISO 100, 50mm lens

These outstanding colors and patterns all but screamed for photographic attention. The hat's subdued color and graceful curve contrasted with the serape's bold colors and strong diagonal lines. I filled the picture space with this scene to leave out some surrounding distractions. This close-up scene was photographed in the low-angled sunlight of late afternoon, ideal for bringing out the textures of serape and hat.

↑ **Photo © Kerry Drager. 1/180 sec. at *f*/16, ISO 200, 105mm lens**

COMPOSING YOUR PHOTOGRAPH

Now that we've covered the basics of design, it's time to talk about composition—the artful arrangement of objects, graphics, and space within the picture frame. The goal is a photo that produces a thoughtful look rather than a fleeting glance. As a photographer, you decide what to include in the photo, where to place it, and how much of the picture the subject occupies. Just as important, you also decide what to leave out of your image.

In this chapter, we focus our attention on specific, practical tips for carefully composing strong photographs. We begin with some basic concepts but then move right into the more advanced ideas that can start raising your photography to the next artistic level. Bending the rules—and out-and-out breaking them—will be covered, too. Yes, art is in the eye of the beholder, but there are generally accepted rules to help give any photographer an express route to picture-taking success. At the same time, the compositional guidelines are not set in stone, and there are many exceptions in which you can come up with acceptable or even better results. So consider rules really just as suggestions.

Much of this has to do with experimentation—an idea that you not just accept the world as you first see it. Here's what we tell students: A pro will take many photos—dozens or even hundreds—to make sure no artistic option has been overlooked.

Understanding composition will help you get better photographs. It is that simple. Now let's jump in and start considering all the artful ways that we can organize the world around us.

SUBJECT PLACEMENT

There's an old back-and-forth exchange that goes something like this:

Question: Do you know how to sculpt a horse out of a block of wood?

Answer: You carve away anything that doesn't look like a horse.

That may seem to be stretching things a bit in terms of photography, but it's not, really. The idea is roughly the same: From a big scene, you identify the photographic "star" of your show and any supporting "characters," and then you strip away anything that doesn't belong or that detracts from your key subjects.

This is just the start of the process. Next comes the artistic positioning of your key subject. There are rules and guidelines to help you decide, but there are creative exceptions, too. (*Note:* Not every photo needs a single subject—such as abstracts—but most do.)

Many amateur shooters generally aim for the middle of the frame, creating a bull's-eye composition that's too often static and uninteresting. But photography isn't archery or darts. Just because the main subject is the picture's center of interest doesn't mean it must occupy center stage. Most often, the more you move your subject from the middle of the frame, the stronger and more visually energetic the composition.

Ideally, subject placement should be a matter of trying assorted variations. Start making a conscious decision about what might be the best spot for your picture's main focal point. This can be a big landscape with a distant tree or mountain as the primary subject, or it can be a close-up portrait with a small part of the face—such as the eyes—commanding top billing. Looking through the viewfinder, move back and forth, up and down, and then make your decision. More often than not, the option you pick is somewhere away from the middle of the image.

One late afternoon, I set out on a no-goal-in-mind tour of a city park. As the sun sank lower in the sky, a footbridge caught my attention with its interplay of light, shadow, shapes, and lines. As shown above, the overall view was very "busy"—lots of elements competing for attention. I zoomed in tight on this slice of decorative railing set against the white part of the bridge. Check out how the main subjects (the silhouetted lines and shapes) are placed away from the often-static middle of the image.
↑ Photo © Kerry Drager. 1/15 sec. at *f*/16, ISO 200, 70–300mm lens at 70mm
↗ Photo © Kerry Drager. 1/45 sec. at *f*/22, ISO 200, 70–300mm lens at 170mm

The World of Macro

Good composition and visual creativity apply to everything from grand scenes to extreme close-ups. Many compact digitals have a macro mode. But if you're a DSLR owner, you'll need a specialty lens or accessory to jump into the exciting world of macro, where little things can have a great visual impact.

A macro lens—or optional macro accessory—lets you focus far closer than a regular lens. Otherwise, for DSLRs, macro lenses attach like any lens and allow focusing to 1:1 magnification (close enough to produce a life-size image of a subject on the image sensor). A macro lens also functions as a "standard" lens for general photography, with full infinity (far-distance) focus. That's a nice advantage when you're shooting landscapes, portraits, and close-ups at one location.

Macro lenses generally come in a fixed (prime) lens—i.e., normal (a fixed focal length in the 50mm to 60mm range), short telephoto (in the 90mm to 105mm range), and telephoto (say, 200mm). Tele-macros cost more, but a 105mm or 200mm macro produces its 1:1 ratio from farther away than, say, a 60mm macro—handy when you need a little working space when photographing a skittish insect.

There are also macro accessories available that can help you focus a regular (nonmacro) DSLR lens much closer. One option is a close-up filter (also called a close-up lens or diopter). But our favorite macro accessory is the extension tube (often sold in sets of three), which works with any lens. Tubes are hollow metal rings that mount between the camera body and the lens, thus moving the lens out away from the camera body. Since there's no glass element in an extension tube, there's no reduction in image quality. However, extension tubes do reduce the amount of light transmitted to the image sensor—a possible problem when shutter speed is an issue—and there can be limits to some of the camera's auto features.

An off-center placement of the main subject is just one of the aspects that made this macro shot a success. Also, two types of contrast make the butterfly stand out in the photo: color contrast (yellow and black against mostly green) and the sharp-against-blur contrast (thanks to careful close-up focusing and the use of a wide aperture). In addition, says photographer Laurie Shupp, "I used a ring flash to create a soft yet natural light on my subject. This helped to brighten the butterfly." *Note:* Ring flash fits around the lens and is used in macro photography to provide diffused light.
→ **Photo © Laurie Rubin Shupp. 1/125 sec. at *f*/4, ISO 100, 105mm macro lens**

THE RULE OF THIRDS

For centuries, the Rule of Thirds has guided artists and photographers. This design principle offers a quick and easy way to add even more vitality to your picture. It's not only a valuable off-center reminder, but it's a guideline on the best spot to position your subject within the picture frame—specifically, one of four visually pleasing power points: upper left, upper right, lower right, or lower left. To use this design concept, imagine dividing your frame into thirds both horizontally and vertically—like a tic-tac-toe grid. Then place your subject on or near one of the four power points where the lines would intersect. The result is a subject that's placed away from the static middle of the frame to create a more visually energetic design. Until this concept becomes second nature, keep this tic-tac-toe framework in mind by imagining the grid in your camera's viewfinder as you size up your picture.

But how do you decide which precise power point to use? It really depends on what else is going on in the scene. For instance, a distracting element in the background could narrow your options as you try to leave out the offending object. Or a key secondary subject in the scene could help balance the composition if the primary subject is placed in the opposite side of the picture. Or a subject may simply look best in one particular spot. If you aren't sure, shoot different versions and compare the results later.

The splendid green-vs.-red color contrast is stunning, but that's not all. "What inspired me to take this shot," says photographer Margaret Barry, "was the beautiful light coming in through the greenhouse windows. The composition captures the light, shadows, and water droplets on the plant." Also note how the green subject is placed in one of the Rule-of-Thirds positions.
↓ Photo © Margaret Barry. 1/2 sec. at *f*/32, ISO 200, 180mm macro lens

Photographer Carla Saunders titles this photo, appropriately, "Your Tax Dollars at Work." As she says, "Hearing noises coming from the street below, I went out on our small balcony to see what was going on. Looking straight down, I saw a man in an orange uniform filling in the cracks on the blue/black asphalt. The workman's T-shirt was the complementary color blue. Perfect! I ran to get my camera. Steadying the camera on the railing, I pointed the camera down and clicked away." Note the subject's placement at the upper right power position of the Rule-of-Thirds grid. The photo's success also hinges on the strong diagonal and curving lines.

↓ **Photo © Carla Trefethen Saunders. 1/250 sec. at *f*/4, ISO 400, 70–200mm lens at 200mm**

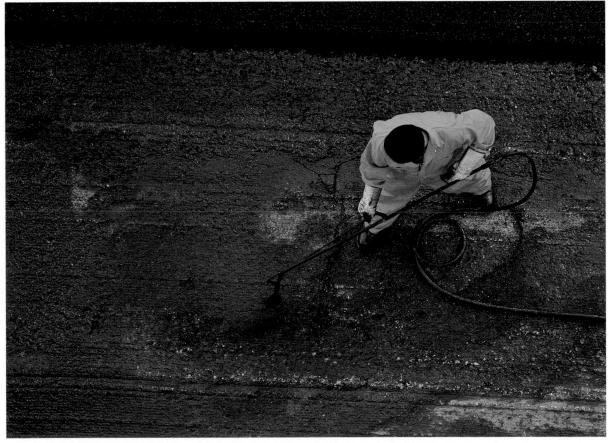

EXCEPTIONS CAN SOMETIMES BE THE RULE

You'll rarely go wrong in choosing a photographic composition that follows the rules. However, for stepping up the creativity at times, don't get locked into the Rule of Thirds as a hard-and-fast policy. At times, it can be restrictive for those scenes that just don't fit into a Thirds setting. While the best spot for the subject may be somewhere off-center, for example, it might not necessarily be in one of the power points.

In fact, there are times when a dead-center composition is dead-on. This can be a subject with strong symmetry, such as a wheel, in which the hub is in the middle while the spokes spread out in all directions. Certain flowers, when photographed close up, work, too, as does symmetry in architecture. Likewise, some pictures don't even have a specific subject; rather, the entire photo is the subject, such as pattern or repetition scenes.

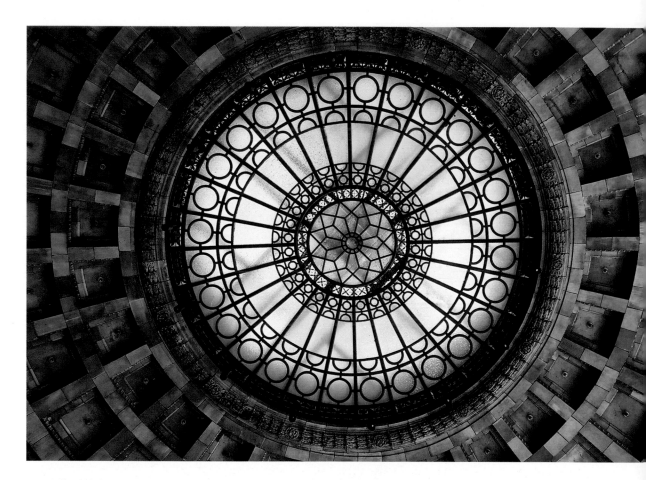

Scenes like this almost demand that compositional rules be broken. The centered placement of this magnificent skylight in the rotunda of the Pennsylvania Station in Pittsburgh helps underscore the building's symmetry. Here's more from photographer Mary Beth Aiello: "I positioned a tripod on the floor of the central atrium and aimed straight up to capture the soft light and maximize the fine details. The shadows added depth and a third dimension to this spectacular rotunda. I composed to balance the lights and darks of the photo."
↑ Photo © Mary Beth Aiello. 1/25 sec. at f/5, ISO 100, 17–55mm lens at 17mm

Not every scene is conducive for a Rule-of-Thirds treatment. In fact, with close-up vertical portraits, such as this one, the idea is to place the subject—the face—in the upper third of the frame. Then it's centered, more or less, from left to right. Photographer Donna Rae Moratelli describes the making of this memorable shot: "I asked Holly [the model] to wear her blue sunglasses and pull up her hood. I wanted to see her beautiful eyes, so I asked her to lower the sunglasses a bit. I loved the bold color, graphic shapes, and the way the hood framed her face."
← Photo © Donna Rae Moratelli. 1/50 sec. at f/8, ISO 100, 50mm lens, fill flash added

ASSIGNMENT: FOLLOW—AND THEN BREAK—THE RULES

This exercise can be performed anywhere—inside or outside the house, down the street, or wherever you happen to be with your camera. Find a scene and choose a main subject that fits well within the picture frame so that you can place it in your composition. Then simply shoot a series of photos, each image with the subject in a different spot: in each of the four power positions and then in the middle. Next, choose another scene, and repeat the exercise. Keep repeating until you run out of scenes, run out of time, or run out of patience.

THE SKY: HOW MUCH OR HOW LITTLE

We often see students split landscape or seascape images into equal halves, with the horizon line or maybe a distant shoreline extending right across the middle of the frame. The viewer, then, is left to decide which half of the scene is most important. But that's for you—the photographer—to decide when composing your image! Keep this in mind as you compose, instead of cutting the composition in half. This will force you to decide: Which is more important, the land or water? Or the sky?

A photo's visual weight (the most interesting things in the scene) should determine where you place the horizon. With the Rule of Thirds, you can place the horizon line on the lower third dividing line or the upper third. And you can adapt the Thirds principle as necessary. If things are exceptionally dull overhead or down low, even a third of the frame devoted to that space could be too much. So you can be more extreme and place the line extremely low or high—say, a thin strip of sky or landscape.

The strong graphic shapes of U.S. Midwest farms are always distinctive, as this scene shows. The early morning light and fresh snow heighten the look. The low horizon helps emphasize the outstanding sunrise sky. Because the morning sun was directly behind the farm scene (resulting in high contrast), says photographer Leland Saunders, it was a great candidate for HDR (high dynamic range). He used the process of taking three autobracketed photos with different exposure times—*f*/22 for 1/4 sec., *f*/22 for 1/15 sec., and *f*/22 for 1 second—that were blended together in the digital darkroom.
↓ **Photo © Leland N. Saunders. ISO 100, 50mm lens**

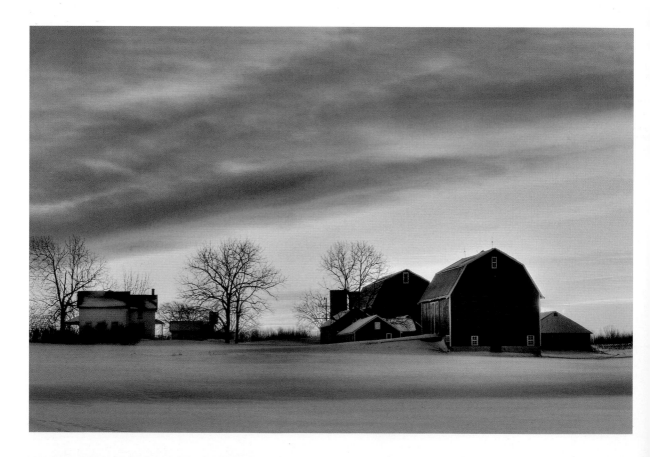

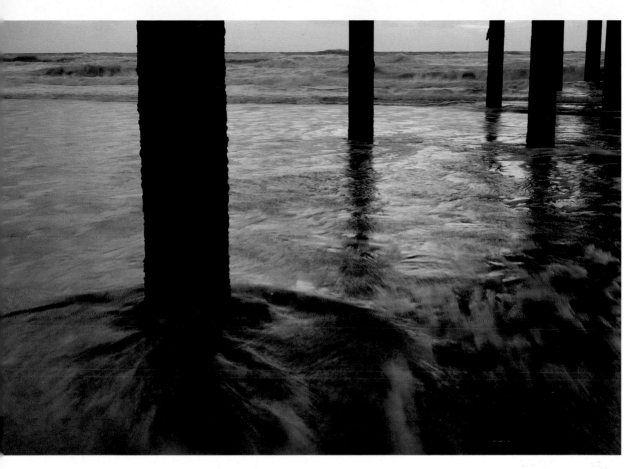

Underneath a pier at sunrise, I loved how the silhouetted columns interacted with the reflections and incoming surf, which was soft due to the slow shutter speed. Safety comes first when shooting at the coast (i.e., never turn your back on the ocean), but in this case, only my shoes and tripod legs were threatened—and yes, they did get a soaking! To put the emphasis on the foreground, with the water in motion and the colorful reflections, I chose a high horizon placement.

↑ Photo © Kerry Drager. 1/4 sec. at *f*/16, ISO 200, 50mm lens

🔘 TIP: NOT SURE? PLAY IT SAFE!

At times, you may simply not know for sure which is the best place to position your horizon. In a landscape scene, maybe both the top and the bottom are equally eye-catching, so you aren't sure of the best horizon or shoreline placement. To be safe, when presented with these choices, cover all the compositional bases by shooting multiple versions—the sky shown low, high, and middle—and then back home, study the images to decide which one works best.

SKY RULE BUSTERS

Occasionally, splitting the composition roughly in half is best. This mostly involves water reflections, when the scene above is just as compelling as the reflection below. Giving equal weight to both elements helps capitalize on the eye-catching blend of symmetry and serenity.

Other times, you may want to leave out the sky entirely. Often, this is when a bright white canopy envelops the sky on an overcast day, since the stark brightness can overwhelm everything else in the scene. In other situations, you may simply want the visual competition of the blue sky, concentrating on a non-sky landscape or cityscape scene or a more intimate view.

And at times, you may not need a sky at all. As pointed out in chapter 1, a bright/white sky can detract from the rest of the scene. Or, on a sunny day, the contrasting blue could draw the eye away from the other colors in the scene. In those situations, no sky at all may be the best strategy.

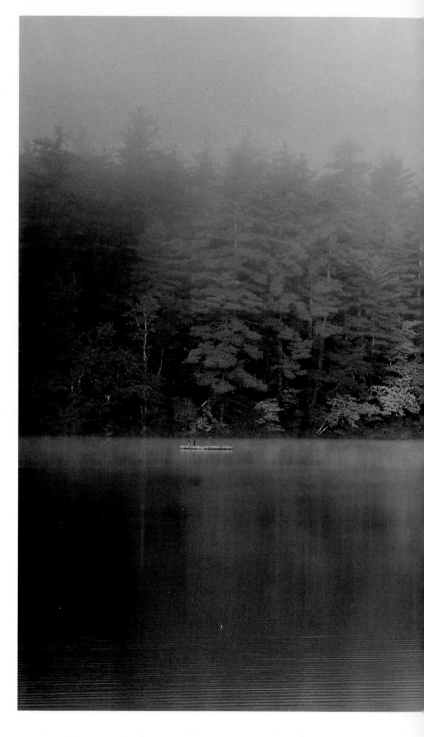

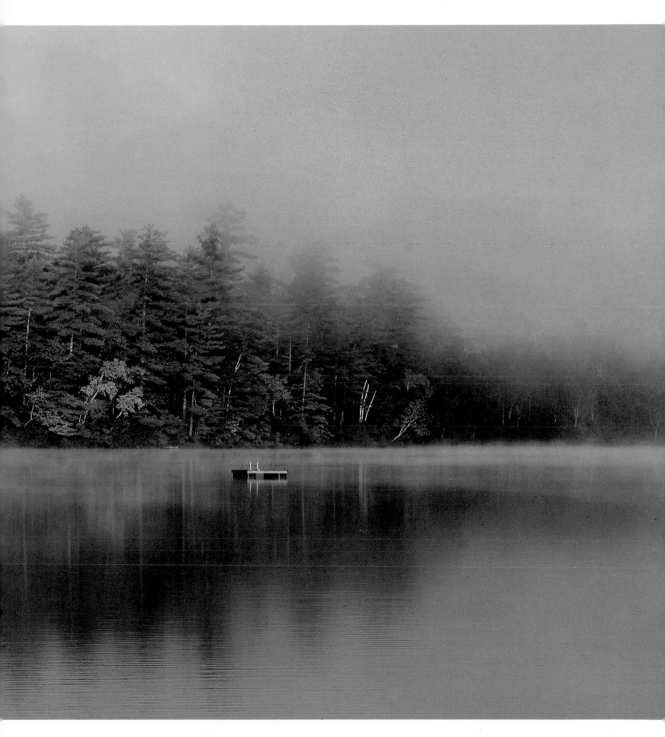

In this Chocorua Lake scene in New Hampshire, the photographer chose a near-center placement of the shoreline, to add mist and a hint of blue sky at the top while including a good amount of the beautifully soft lake reflections. "A hint of daylight was beginning to color the sky when I arrived," photographer Nancy de Flon says. "Not only that, but an extra added attraction—a heavy mist—promised to enhance the scene still further." Of course, the beautiful fall colors and reflections added great visual interest, too, as did the swimming platform that, she says, "someone had thoughtfully left behind from the summer."
↑ Photo © Nancy de Flon. 1/15 sec. at *f*/14, ISO 200, 18–135mm lens at 70mm

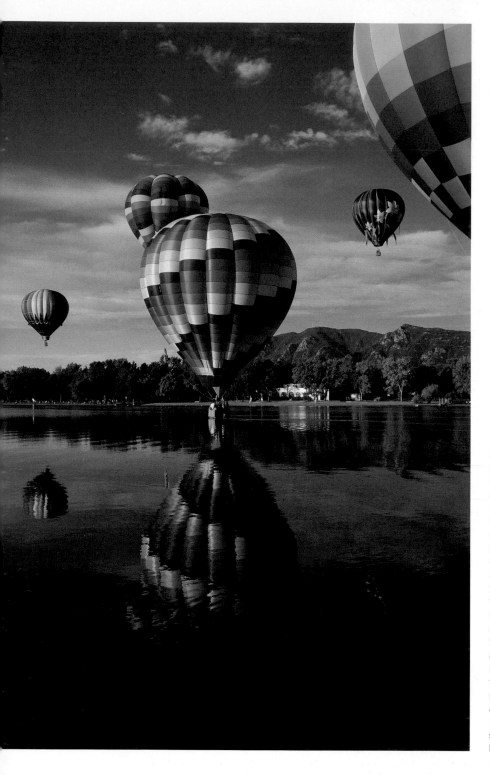

In ballooning, points out photographer Debbie Payne, the "pièce de résistance" is touching down on water. At the Colorado Balloon Classic, the trick to getting the shot is always to "get to the park as early as possible and stake out your claim at the water's edge," she advises. "If you get too far back, someone will invariably stand in front of you. Even though you are tempted to handhold your camera, get the shot with your tripod and a shutter release! Even if your tripod feet get muddy, and your shoes are soggy, you will be handsomely rewarded for your efforts." With the near-mirrored reflection, a middle horizon placement seemed a natural.

← **Photo © Debbie Payne. 1/400 sec. at *f*/8, ISO 200, 17–85mm lens at 24mm**

Regardless of whether the sky is bright white (something to avoid) or bold blue, sometimes leaving out the sky entirely is the best approach, since the contrasting tone could detract from the rest of the scene. For this tulip field, I was attracted to the layers. So with a long telephoto, I zoomed right in on the colors. I selected one layer to serve as the "star" of my show by focusing the lens on it. As a result, the sharp layer stands out amid the blurred close layer and the blurred distant scene.

↑ Photo © Jim Miotke. 1/350 sec. at f/6.7, ISO 100, 100–300mm lens at 300mm

The orderly placement of the posts—and their reflections in the frozen water—attracted Rolan Narman to this scene in Port Jefferson, New York. He chose this camera angle to include as much of the posts as possible, without including the sky. His goal was to emphasize the posts' isolated state on a cold winter afternoon.

↑ Photo © Rolan Narman. 1/200 sec. at f/7.1, ISO 200, 18–200mm lens at 62mm

BEWARE: BACKGROUNDS AND BORDERS

It's easy to get so wrapped up in composing your shot that you miss the extra things that can slip into an image. Assuming that fast-changing light or a moving subject doesn't demand quick action, perform this last-minute viewfinder inspection: Scan things from foreground to background, border to border, corner to corner, keeping an eye out for the following things.

• Distractions: Look for anything that takes the viewer away from your subject, and then eliminate it. This includes "hot spots" (sunlit glare or reflections), stray branches or pieces of litter, out-of-focus close-foreground objects in an otherwise all-sharp picture, out-of-place bright colors in subdued scenes, or background colors that contrast with your subject. Remember: The brightest, lightest, or most colorful part of an image will attract the viewer's eye first; this is almost always a problem if that area is *not* your picture's main subject.

• Merges: The oft-cited example of a merge is a tree or pole sprouting out of someone's head. But a merge also can be any separate subject or same-color object that overlaps another one in a visually distracting way. With silhouette scenes, it's all too easy for a dark foreground subject to merge with a distant shadowed subject.

Assuming you're shooting a static scene, this process of scanning your viewfinder from front to back and side to side works most efficiently with a tripod. Often, fixing things means changing your shooting angle, using a wider aperture to blur the background, using a smaller aperture to sharpen that stray blurred item, or zooming in a little tighter to clean up the edges.

In addition, you can make use of one of digital photography's great advantages: instant feedback. We regularly use the digital camera's LCD screen to check out exposure (via the histogram and highlight warnings). But the monitor is also valuable for double-checking your compositions for any distractions. This is a terrific technique for analyzing your photography right in the field and, if possible, reshooting to get it right.

Never underestimate the background's power to make or break a photo. In this scene, the subject stands out beautifully against a blur of colors. A long telephoto and wide aperture ensured a soft-focused backdrop. Note, too, how the subject is placed to the left of the composition, since her eyes are gazing rightward. As for the light, photographer Sarah Christian chose soft shade to avoid hot spots from the direct sunlight.
← Photo © Sarah A. Christian. 1/180 sec. at *f*/4, ISO 200, 70–300mm lens at 178mm

Photographer Fran Saunders and her husband—both avid birders—have a series of feeder-gyms set up in their backyard. A long telephoto, coupled with a wide aperture, isolated the light-toned mourning dove against the blur of green. "For this shot, I set up the tripod and lens in my kitchen. I was able to position myself so that I could prefocus, and I just waited, and waited, and waited for the right shot. The overcast day and my position parallel to the windows eliminated glare. My kitchen remains one of my most favorite 'blinds' for bird photography!"
↑ Photo © Fran Saunders. 1/200 sec. at *f*/4, ISO 500, 500mm lens

ORIENTATION: HORIZONTAL VS. VERTICAL

Looking both ways is certainly a good practice when navigating city streets, and it's a good practice when it comes to navigating the camera viewfinder. Some subjects work successfully in both the horizontal (landscape) and vertical (portrait) formats, while other compositions perform better in one or the other. Yet, for many developing photographers, far more pictures are taken as horizontals. It just seems to be the automatic choice, because cameras seem more comfortable to handle when held horizontally.

However, switching formats is a strikingly successful way to beef up and vary your compositions. Since it isn't an intuitive thing, imagining things vertically and turning the camera on its side must be a conscious effort. It may even mean a little sticky note applied to the back of your camera or on your bag that reads "Think vertical!"

So how do you decide? The choice depends on visual concerns (which way appears best to you in the viewfinder) and informational aspects (what elements you wish to include in your photo). In general, landscape framing stresses a subject or scene's width, while portrait framing emphasizes its height. Does one tell a different story or provide a unique impression?

On other occasions, the vertical approach can add extra energy. For instance, it can help emphasize the near-to-far relationship of your scene's foreground and background by exaggerating the feeling of distance and depth.

Sometimes a simple shift of the camera from a horizontal to vertical position, or vice versa, can solve a design dilemma. For example, if a horizontal format shows too many distracting elements on the sides or in the background, then a flip of the camera might quickly and definitively "clean up" the composition.

Be on the lookout for creative exceptions. For instance, a tall subject in an eye-grabbing scene might work in a horizontal format, or a "wide" subject might look great if tightly composed in a vertical format.

Still not sure? Experiment. For instance, even if your first thought is to shoot a vertical or portrait format, take a look at a horizontal or landscape orientation. Sometimes your subject may fit equally well into both vertical and horizontal orientations. Regularly rotating your camera not only adds variety to your work, but it also serves this purpose: When shooting for a print or online publication, or for stock agencies, editors will appreciate the extra choices.

The slot canyons of Arizona deserve all the photo compositions they can get. For these two images, the results were more than simply a horizontal and vertical version—both of which I like, by the way! Both images show intimate compositions with the bright golden area as the main focal point. Otherwise, the horizontal version includes the strong diagonal lines from upper left to lower right, while the vertical shot puts more emphasis on the diagonal line that extends from the lower right to the upper left.

← Photo © Jim Miotke. 6 seconds at *f*/10, ISO 100, 28–135mm lens at 70mm
↑ Photo © Jim Miotke. 6 seconds at *f*/10, ISO 100, 28–135mm lens at 65mm

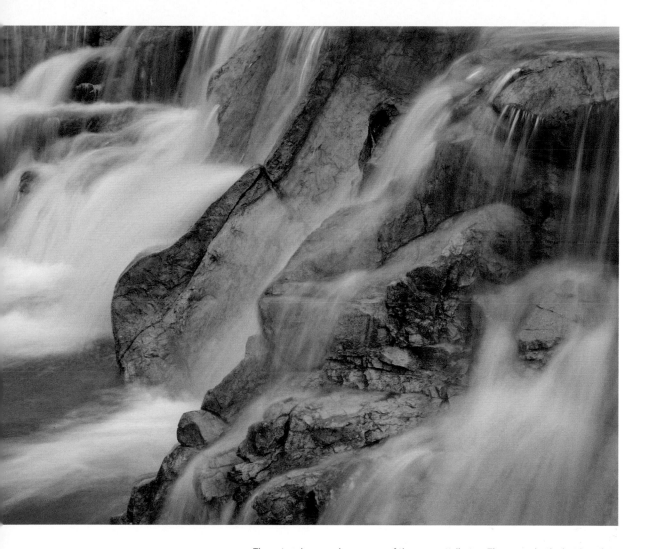

These two images share many of the same attributes. They were both shot in soft overcast light, an ideal condition for shooting water in motion, and each benefited from a long exposure that created the water's soft, flowing look. But otherwise, what a difference orientation makes! The vertical version conveys a top-to-bottom sense of the fountain's height, as the water smoothly moves downward from ledge to ledge. For the horizontal, there's a side-to-side sense of the scene starting at the close-up right and moving leftward into the distance.

← Photo © Kerry Drager. 1 second at *f*/22, ISO 100, 50mm lens
↑ Photo © Kerry Drager. 1/2 sec. at *f*/22, ISO 100, 50mm lens

FACING THE RIGHT (OR LEFT) WAY

Here's another way to expand your portfolio of successful photos: When a person, animal, or vehicle is pictured fairly small in the frame, make sure the subject moves into—not out of—the composition. This keeps the viewer's attention directed to the main center area, rather than having the eye wander distractedly to the edge of the frame and out of the picture.

Of course, as with any rule, there can be artfully stylish exceptions, and when a subject occupies a big part of the frame, this guideline may not even apply. But, in general, when a subject moves or faces in one direction, leave room to breathe in front of that subject. Viewers will find this visually pleasing, as opposed to a more unsettling placement of a subject near a picture border and facing toward that close edge of the image.

Your subject doesn't even need to be moving. Plus, this concept applies not only to human subjects but also to animals, cars, boats, and even statues. Other objects may have a front that "points" in a particular direction, such as when photographing a house or vehicle from the side. Likewise, a tree that leans, for instance, should tilt toward the middle of the frame.

Yes, this strategy is yet another thing to worry about when composing a photo. But trust us. You'll soon get the hang of this concept of directing the movement toward the center of your image. When raising the camera to your eye, you'll find it the automatic choice . . . whether you're shooting fast-breaking action or photographing stationary subjects.

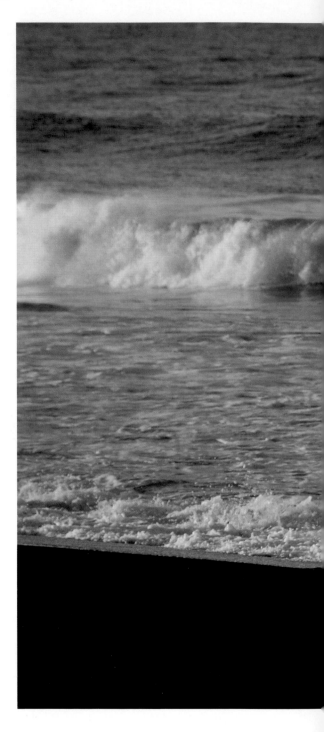

Just after sunrise, the warm and low sunlight caught the surf at this Marin County beach just north of San Francisco and the Golden Gate Bridge. I saw this surfer walking along the beach, just before heading out into the waves. Note how I positioned the surfer at the right so she's heading toward the rest of the scene. If the subject had been moving rightward? Then I would have gone with a left-side placement. Although the surfer is very small in the image, she stands out due to the color contrast of black wet suit against bright background.
→ **Photo © Kerry Drager. 1/250 sec. at f/8, ISO 200, 70–300mm lens at 300mm**

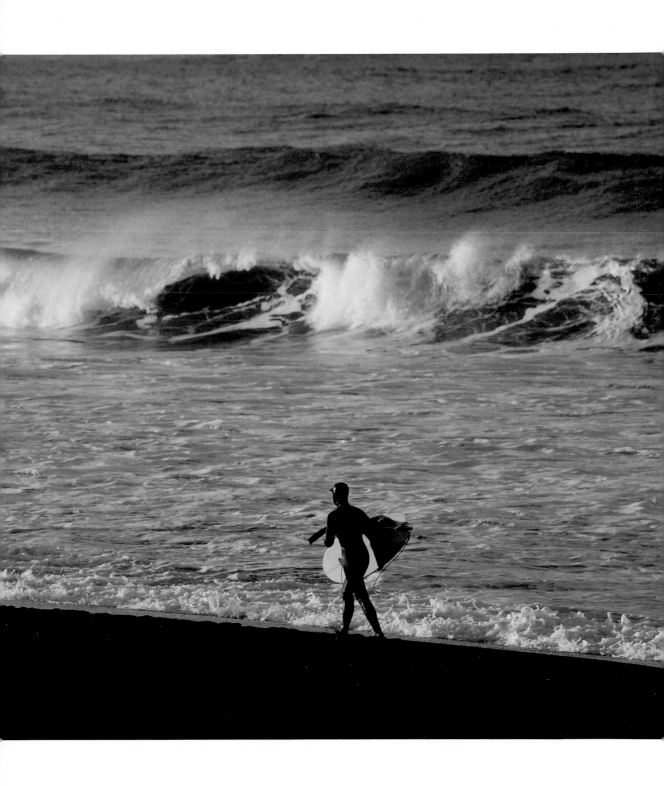

THE TRIPOD: THE NO. 1 PHOTO ACCESSORY

We've seen many budding photographers break out of the snapshot stage and many experienced shooters take their work to the next level. They've done it by regularly using the so-called accessory that photographers love to hate: the tripod.

Okay, we can already hear you saying, "A tripod is such a hassle. It just gets in the way." We can relate. In the beginning, we also found tripods to be cumbersome, rigid, and downright annoying. Plus, we feared the tripod drew attention to ourselves. However, when we began using a tripod whenever—and wherever—it was possible, our photography improved immediately. Yes, immediately! That will work for you, too.

Of course, for many moving subjects, the tripod might hinder your necessary movement. In popular tourist areas or busy marketplaces, or at festivals, concerts, and special events, a tripod might be impractical. And in some museums and other venues, it may be downright forbidden. But whenever you can, using a tripod is guaranteed to boost your photography up a notch—in terms of not only image quality (due to the tripod's stabilizing benefit) but composition and creativity, too. You'll wonder why it took you so long to get into the tripod habit.

A tripod encourages photo-making discipline. Using a three-legged support forces you to slow down, analyze the scene, and consider how you want to photograph it. The tripod then allows you to carefully compose your picture. Locking your camera into place also lets you tweak the composition just a little bit more.

In addition, it opens up the dramatic, nonflash world of low light—for instance, in deep shade, at daybreak and sundown, and during twilight time. It permits cool special effects, such as turning a waterfall into a silky flow of motion with a superslow shutter speed. It makes possible the longer exposures necessary when using small apertures (high f/numbers) to attain a deep depth of field. And if you pursue HDR photography (high dynamic range, in which you shoot multiple exposures of a high-lighting-contrast scene and then combine them in the digital darkroom), the tripod is a must.

Check out the coauthors at work—each of us using a tripod! In one photo, Kerry captured Jim just after sunrise while photographing the pier in St. Augustine, Florida. In the other image, Jim caught Kerry in the soft light of shade at the colorful Experience Music Project building in Seattle. Note the subject position for both pictures: not only off-center but placed at the left, since both subjects are facing rightward.

← Photo © Kerry Drager. 1/350 sec. at *f*/5.6, ISO 200, 50mm lens
↑ Photo © Jim Miotke. 1/60 sec. at *f*/5, ISO 100, 28–135mm lens at 30mm

TRIPOD BUYER'S GUIDE

If you find using a tripod really frustrating, it might just be that you've been saddled with a clunker. Don't go the cheap route. We still find it hard to believe that we see photographers with expensive cameras and lenses using flimsy tripods. A good tripod is sturdy, with quick and easy controls, and is a joy to use. It will be one of the best investments you make in your photographic hobby.

Picking the right tripod is such a personal decision. Ask a dozen serious photographers what model of tripod they use, and you'll likely get twenty answers, or more! No, our math isn't off. Many people own two tripods—one a hefty carry-in-the-car model, the other a lightweight, go-anywhere one.

Nonetheless, there are certain traits to consider when buying. But first, be aware that while many tripods are available as a complete set, in other cases, you can purchase the legs and head separately in a mix-and-match situation.

• Tripod legs: Carbon fiber models may cost more than steel ones, but carbon fiber is lighter and easier to tote while still retaining the necessary sturdiness.

• Tripod head: We like the ball head, and many pros and serious shooters do, too. The ball head allows you to change your view quickly, since it involves only one knob to loosen or tighten the head. Ball heads come in various sizes, with the larger ones more easily locking down and holding your camera in position. There are many photographers who passionately prefer the pan/tilt style of head. This model is usually slower to use than a ball head, since it has multiple handles. But some people prefer the pan/tilt's system for leveling the camera. Also, since you loosen one knob at a time, it reduces the possibility of a heavy camera dropping unexpectedly against the tripod—which can happen with the single-lever ball head. But any model of head can slip—and that goes for the tripod's legs, too. When setting up, always make sure all knobs and levers are securely fastened, and be sure to double-check things periodically when shooting.

• Sturdiness: Make sure the tripod you buy can handle the gear you have. If shopping in person, take your heaviest camera/lens rig and see how the tripod performs. If shopping online, confirm the maximum recommended weight that both legs and head can carry.

• Quick-release system: This is an absolute must. The mechanism makes it a snap to take the camera on and off the tripod head.

Not even rain stopped this photographer, who's armed with a tripod and umbrella. For that matter, rain and heavy fog also didn't stop photographer Linda Lester, who took this photo. "It was funny—we were just shooting each other," she says. "And I had the better background. I had a van behind me and the hood up, so I was dry. These were great conditions for lighting and color, making for a great mood. One of my favorites!" Note how the trees and fence fade into the distance.
← Photo © LindaDLester.com.
1/5 sec. at *f*/20, ISO 250,
24–105mm lens at 50mm

◑ TIP: THE TRIPOD'S ESSENTIAL ACCESSORY

A cable shutter release keeps your hands off the camera, thus letting you record the image without jarring your camera. Also, some DSLRs have a lock-up mode that reduces the possibility of vibration when the mirror flips up during slower exposures. If your camera lacks this feature, you can use the self-timer. Like a cable release, a timer also prevents your finger from jiggling the camera. Use of the timer, of course, assumes your scene doesn't require a decisive moment at which to take the picture.

◑ TIP: STEADY AS IT GOES

More and more DSLR lenses have image stabilization. But a tripod is still frequently the sturdiest alternative. It also has the added ability to help you critically compose your photos. In any case, be sure to read your lens's instruction sheet. Many lens models require that stabilization be turned off when using a tripod, otherwise possible blurring in the image could occur. When in doubt, turn off the feature.

Mountain sunsets (sunrises, too!) can be so eye-catching, especially when you can include a lake reflection. For this scene in the North Cascades of Washington State, I arrived in late afternoon in anticipation of great light and color. The lake showed a near-mirrored reflection of Mount Shuksan. I chose a perfectly balanced composition—with the image split in half by the distant shoreline—and emphasized the scene's symmetry and tranquility.
↑ Photo © Jim Miotke. 1 second at *f*/11, ISO 100, 16–35mm lens at 30mm

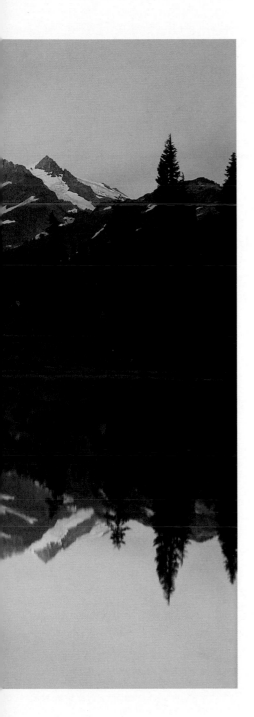

CHAPTER 4

DEPTH & BALANCE

In this chapter, we explore two more aspects of visual design: depth and balance. Even though the photographic image is two-dimensional, it's possible to convey eye-catching illusions of depth. To do this, compose your photo with a very near foreground and a more distant background. Such a front-to-back perspective can achieve a three-dimensional quality that's very visually powerful. We'll also discuss the very closely related "cousin" of depth: depth of field. This relates to the range of sharpness in a photo—what's sharp and what's not.

We'll also cover balance, considering visual weight while exploring this sometimes abstract yet always intriguing concept. Balance refers to how the various elements in a scene work with one another; in short, it means evaluating your composition as a whole, rather than concentrating solely on your main subject. When a photo's balance works to perfection, the whole composition just seems to fall into place, even if you can't put your finger on the reason why.

Interestingly, for often-critical compositional components, there sure are a lot of exceptions. And we'll explore those aspects, too. Nonetheless, depth and balance are always something to keep in mind.

DEPTH AND FOREGROUND FRAMING

Scenes with depth—when objects are at different distances from the camera—can be very compelling. Depth can range from a sweeping wide-angle scene, with an object placed near the camera while other elements stretch into the distance (as discussed in chapter 1), to a close-up scene with a foreground and background. Whether a big or small view, a scene with front-to-back elements gives your picture a feeling of depth.

A classic way to express depth is to use a foreground frame to put the spotlight on a distant subject. In fact, framing is pretty much a slam-dunk compositional technique that can add punch and pizzazz to your photography.

Unlike a picture window that frames an outdoor scene beyond, photographic frames aren't necessarily square or rectangular, or even circular. A foreground object within the composition can frame a more distant subject. This helps direct the viewer's attention to a specific part of the composition that you feel is important. At the same time, you give the photo a greater sense of depth.

Mention an outdoor frame, and trees or overhanging branches usually come to mind. A traditional example shows overhead tree branches setting the stage for a distant building or a landscape feature. But potential framing devices are almost limitless. Consider public art exhibits, fence rails, columns, doors, and so on. A natural or architectural arch makes a graceful close-up frame. In the southwestern United States, landscape photographers have long framed the desert with a rock "window." The possibilities are endless!

In Seattle, photographer Jon Lamrouex used a very eye-catching foreground subject—the *Grass Blades* sculpture (comprising 30-foot steel reeds)—as a frame for another eye-catcher, the Space Needle. He felt that "the selection of the extreme upward angle and wide-angle lens gave an interesting viewpoint and scale to the Seattle Space Needle."
→ **Photo © Jon M. Lamrouex. 1/15 sec. at f/22, ISO 200, 17–40mm lens at 29mm**

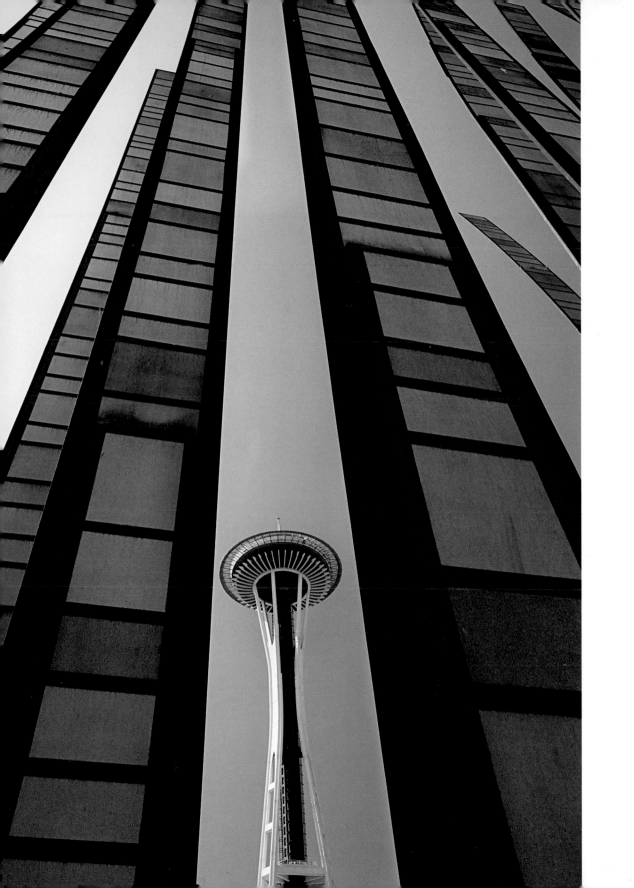

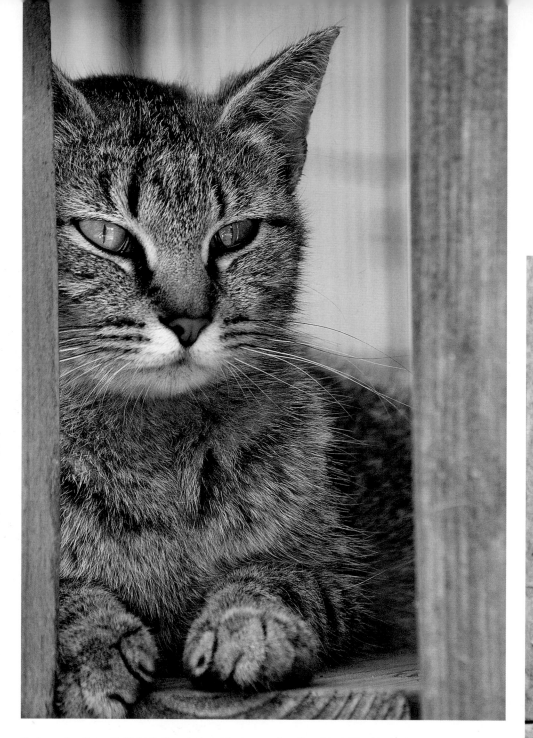

Photographer Sonya Hatfield-Hall's outside cat is always a favorite subject. "On this day," she says, "I was photographing her kittens when I noticed her framed between the slats on the porch. Since our porch is high, I was able to comfortably capture her at eye level."
↑ Photo © Sonya Hatfield-Hall. 1/80 sec. at *f*/9, ISO 200, 70–300mm lens at 112mm

These old boots caught the photographer's eye through the framing on her front porch. With the identical knobs on both sides, the scene had nice symmetry, complete with soft light. With a telephoto zoom, Sonya Hatfield-Hall composed the scene straight on from a low camera angle.
↓ Photo © Sonya Hatfield-Hall. 1/30 sec. at *f*/25, ISO 100, 70–300mm lens at 80mm

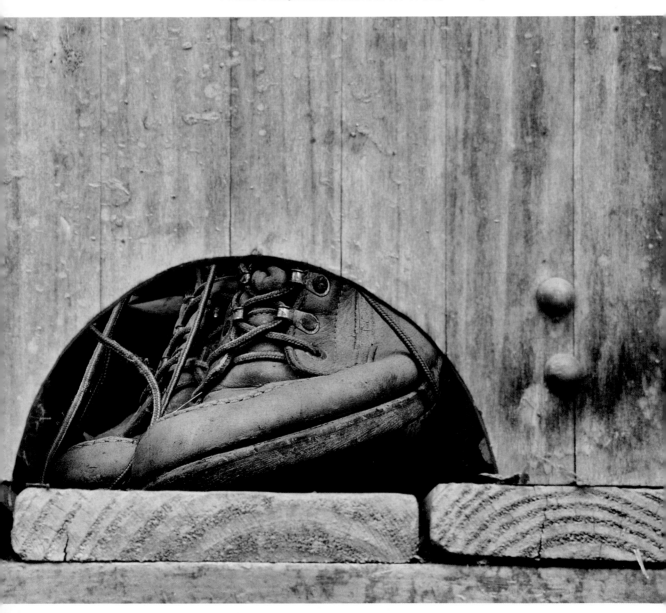

DEPTH OF FIELD

For many people, how to obtain the right range of sharpness in a scene remains a mystery. They simply zero in on their subject and never consider whether objects in front of that point, and ones behind it, will also be in focus. No matter how wonderful the light or how wonderful your scene or how many eye-grabbing design elements you have, if the depth of field is wrong, your picture will be off, too. But with a little understanding and attention to detail, you can take full control of the sharpness zone in scenes with front-to-back depth.

Depth of field (DOF) refers to the area of sharp focus between the closest and the farthest objects in your picture frame. In general, with landscape scenes, you'll want everything sharp from near to far—deep depth of field. On the other hand, you'll likely prefer that sharply focused people, pets, flowers, and other subjects stand out in contrast against a softly focused background—shallow depth of field.

SHALLOW DEPTH OF FIELD

Narrow depth of field helps isolate a sharp foreground subject. To create it, do the following:

• Use a larger aperture, such as *f*/4 or *f*/5.6.
• Bring out the telephoto. The longer the lens, the easier it is to blur out the distance, since greater focal lengths shrink depth of field.
• Be sure there's a good distance between subject and background. The greater this distance, the more out of focus the background will be.
• Also, the closer the subject is to the camera, the narrower the depth of field.

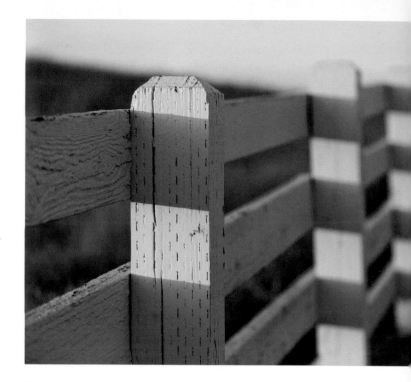

For this fence series, I was attracted by the low sun and the pattern of shadows. The only thing that has changed is the depth of field—via a different *f*-stop for each image. In Aperture Priority mode and with the focusing set on the far left post, I changed the aperture for each picture. The camera automatically adjusted the shutter speed to give the right exposure. See what a dramatic difference there is due to the simple change in *f*-stop. With your own stationary scenes, you may wish to shoot different variations of depth of field to compare and select your favorite rendition.
↑ Photo © Kerry Drager. 1/180 sec. at *f*/4, ISO 200, 105mm lens
↗ Photo © Kerry Drager. 1/30 sec. at *f*/10, ISO 200, 105mm lens
→ Photo © Kerry Drager. 1/6 sec. at *f*/22, ISO 200, 105mm lens

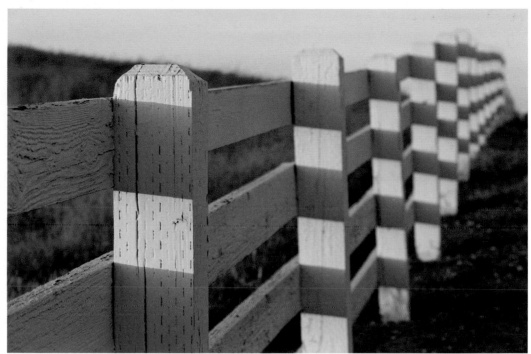

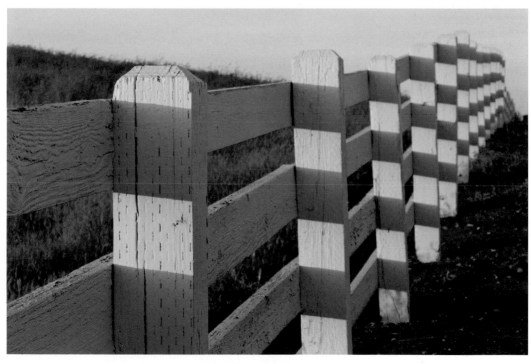

Macro and Depth of Field

In macro scenes with depth, it's usually impossible to get everything sharp from front to back. The macro lens's inherently shallow depth of field is due to the radically close-up camera position. This applies even if you use a small aperture, such as f/22 or f/32. The key is precise focusing—setting the lens's focus on the part of the scene that will be your sharp main focal point. Nevertheless, the choice of f-stop is still important, so whenever possible, it pays to experiment by shooting multiple versions with different apertures.

The soft light of early morning sent me on a search for color at Balboa Park in San Diego. The colors fulfilled my photo goal, with the diagonal design being an eye-catching bonus. With my macro lens, I carefully chose the specific spot to set the lens's focus and then selected a wide aperture (low f/number) to narrow the depth of field as much as possible, so that the background and much of the flower turned into a soft blur of color and form.
→ **Photo © Kerry Drager. 1/20 sec. at f/4.8, ISO 200, 105mm lens**

For this photo, shot in the warm light of early evening, I carefully considered the background before taking an outdoor portrait of my niece, Hannah. I looked for—and found—a background without any glaring brights or contrasting colors. With the close-up composition, a telephoto lens (105mm), and a midrange aperture (*f*/11), I was able to make the background blurred enough so that my subject stands out but still show identifiable (yet fuzzy) distant details. To further achieve the "storytelling" perspective and create an environmental portrait, I used a horizontal format, which shows more of the background than a tight vertical orientation. With the storytelling technique (whether people shots, landscape images, or whatever), the photographer looks beyond the single subject and incorporates some of the surrounding environment to provide additional context for the viewer.

↑ Photo © Kerry Drager. 1/250 sec. at *f*/11, ISO 400, 105mm lens

Selective focus was my goal here for these grasses. I selected one blade of grass to set the focus, and with a fairly wide aperture, the range of sharpness (depth of field) was very shallow. As a result, the only grasses in sharp focus are the ones that are on the same plane (the same distance from the camera) as the spot on which I set the focus. This shallow depth of field was my creative intent—to show much of the scene as a blur of warm, soft color with just a few sharp accent points.
↑ Photo © Jim Miotke. 1/500 sec. at *f*/6.7, ISO 100, 100–300mm lens at 300mm

When shooting close-ups with a telephoto lens or a macro lens, it's usually impossible to get both a close foreground and a distant background sharp at the same time, regardless of aperture. But, often, your choice of f-stop really matters! In these images, I used a long telephoto lens and focused directly on the close-up fence post. I angled the camera slightly to turn lines into strong diagonals. I wanted to keep the fence post and some of the wire sharp, so I avoided a superwide aperture. For one image, I used a small aperture and for the other, a middle-range aperture.

← Photo © Kerry Drager. 1/4 sec. at *f*/22, ISO 100, 300mm lens

↙ Photo © Kerry Drager. 1/15 sec. at *f*/11, ISO 100, 300mm lens

Using selective focus—narrow depth of field—is a great way to put the spotlight on a single subject. Here in this fall scene, I wanted the leaf to serve as the main focal point. With the telephoto focal length and the wide aperture, the leaf stands out against the blurred foreground and soft background. I really liked how the blur of warm colors balanced out the scene, while also contrasting with the cool bluish tones.

← Photo © Jim Miotke. 1/45 sec. at *f*/4.5, ISO 100, 100–300mm lens at 115mm

DEEP DEPTH OF FIELD

With total depth of field, everything in the photo is in sharp focus from front to back. To get there, do the following:

- Use a wide-angle focal length (particularly under 28mm but whatever you have).
- Use a very small aperture, such as *f*/16 or *f*/22.
- Precise focusing matters. For information on where to focus, see page 155.

Using my collection of timeworn vehicles and ranch equipment, I framed this scene with an old red grille and a bright yellow wheel. I chose a vertical format to emphasize the lines leading to the wheel. With a wide-angle lens and small aperture (f/22), things are sharp from front to back.

← Photo © Kerry Drager. 1/4 sec. at f/22, ISO 100, 12-24mm lens at 22mm

Colorful horse blankets draped over our ranch fencing caught my attention one day. I moved physically close to the blankets with my wide-angle lens—just 1½ feet away from the closest point—to spotlight the colors while leaving a slice of background as a storytelling element. As I was fine-tuning the composition, our horse started to move into the frame as the perfect background focal point! My depth of field goal was to ensure that the all-important blankets were crisp and clear, so I set the focus directly on the blankets. Due to the superclose focusing, the distant scene isn't razor sharp, but it doesn't really need to be, since the distant details are readily recognizable and the foreground is crisp and clear.

↑ Photo © Kerry Drager. 1/125 sec. at f/22, ISO 400, 20mm lens

DETERMINING DEPTH OF FIELD

By default, DSLR cameras are set for a wide aperture to let in the maximum amount of light for ease of viewing. At the moment of exposure, the aperture is decreased to whatever *f*-stop is selected. So how do you know what your front-to-back scene will look like?

Many DSLR cameras have a built-in solution for this called *depth-of-field preview*. Pressing down the depth-of-field preview button while viewing your scene will show the approximate effect your *f*-stop will have on the final depth of field. For small apertures, it will also reduce the amount of light coming into the camera, so the image will get darker, making it difficult to get a good view. However, if you can see the scene even dimly, you'll notice that the foreground and background elements are sharper. We both routinely use DOF preview for most shots, and with practice, you'll learn to quickly "read" the darkened screen in all but the lowest lighting conditions.

Another tool for checking sharpness is your camera's LCD screen. If possible, zoom in and review both the closest and farthest points. Do they appear as sharp as the details in the middle of the image? Or, if you're going for more of a selective-focus effect (shallow depth of field), are the out-of-focus parts sufficiently blurred? And is the main subject good and sharp? If the depth of field isn't to your liking, you can try one or more of these quick fixes: Change the aperture, move closer to the foreground (or back away), or alter the composition.

Photographer Ibarionex Perello used a shallow depth of field to separate this flower from the background, as well as a shaft of sunlight illuminating the flower. His choice of a middle-of-the-frame placement for this round subject is a successful exception to the more traditional off-center guideline.
↑ Photo © Ibarionex Perello. 1/500 sec. at f/4, ISO 400, 12–60mm lens at 60mm

WHERE TO FOCUS FOR DEEP DEPTH OF FIELD

When using a telephoto or macro lens to isolate your subject, it's easy to pick the best focusing point (i.e., the precise spot on which your lens sets its focus): Just pick the main focal point that you want crisply sharp, and make sure your lens focuses on that spot. But with a sweeping landscape shot that involves a very close subject, a middle ground, and a very distant background, maximum depth of field demands extra attention to the focusing point.

There are depth-of-field charts (sometimes called *hyperfocal charts*) available in stores and online; these outline the focusing strategy for achieving maximum depth of field for a given *f*-stop and focal length. Do you remember the instruction sheet that came with your lens? The one that you promptly lost or tossed out? Well, it likely included a table on depth of field. With a 20mm lens, for example, to get everything sharp from about 1½ feet to infinity (the farthest distance), lock in the focus at 3 feet and set the aperture at *f*/22. But with a 70–300mm tele-zoom set at its lowest end (70mm), getting an object sharp at 9½ feet—along with infinity—means setting the focus at 20 feet and using the supersmall aperture of *f*/32. Focusing any closer and/or going with a lower *f*/number would decrease the depth of field.

Lacking any chart, for maximum depth of field in a wide-angle scene, use your camera's smallest aperture and choose a focusing point just beyond the closest point in your photo. With wide-angle, this focusing distance might be anywhere from 3 feet to 6 feet from your camera, but it depends on the scene. Again, this is where depth-of-field preview, or LCD reviews, will round out your depth-of-field "workflow."

ASSIGNMENT: DOF STILL NOT CLEAR? TRY THIS!

If the subject of depth of field still isn't quite clear, that's okay! For many, it really takes a hands-on approach to get a handle on this concept. Try this exercise: Choose a stationary scene with a nearby subject and a distant subject. It can be a small scene on your patio or on your kitchen table, or it can be a sweeping scenic. Then set the lens's focus on the closest subject. With everything the same (a tripod is highly recommended here), shoot three photos: one with your lens's largest aperture (lowest *f*/number), another with your lens's smallest aperture (highest *f*/number), and a third with an *f*-stop roughly in between. Be sure to keep precisely the same lens focal length for each shot.

Assuming you photographed a scene with depth (i.e., with objects both very close to and very far away from the camera), you'll really see the difference in the background. The smallest aperture will yield far more front-to-back sharpness than the widest aperture. That doesn't mean the small-aperture shot will have both foreground and background totally sharp (especially if you aren't using a wide-angle), but this exercise will be really enlightening!

BALANCE

Simply put, balance relates to how well a photo works overall—from side to side, bottom to top, corner to corner. Elements on one side balance things on the other, and elements low in the frame offset those high in the picture.

Balance can be an elusive concept. Sometimes the reason a photo doesn't work has to do with balance. The image just doesn't look right, and we aren't sure why. At other times, the picture does feel right. With experience and awareness, balance becomes more intuitive.

Perfect balance is struck with symmetry. This often involves architecture, when one side is a mirror image of the other side. But it can occur in nature, too—such as a mirrored lake reflection with a centered shoreline cutting the scene into equal halves.

Little in the world is symmetrical, though, and that's a good thing, since an asymmetrical image is often more visually energetic than a symmetrical one. Asymmetrical balance can create a visual tension. In fact, it's also important to think of balance in terms of visual "weight." This concept of weight refers to the size, color, shape, proportion, and placement of elements within the picture frame.

With asymmetrical balance, the elements counterbalance one another. Study the composition to see how the main parts interact with one another. Basically ask yourself, does one side of the composition appear "heavier"? That's not a problem as long as there are elements elsewhere in the photograph to attract attention as secondary subjects. But if there's a relatively big object, a bold and bright color, or a contrasting element on one side, and there's nothing of consequence on the other, then the picture will look unbalanced.

But that doesn't mean both sides must carry the exact same visual weight. For instance, you might have a large object on one side as the primary subject, with a smaller object on the other. Although the smaller one might not carry as much visual weight as the primary subject, it offsets things as a secondary subject that commands enough attention to balance out the composition. That's the idea behind the photo of the old kayak on page 159. Or a contrasting dark object may command primary attention while being offset by a lighter-toned one. Or a saturated color may pop right out of the picture as the main subject, while a more subdued color performs a valuable role elsewhere in the image—as a subordinate balancing element and as a point of interest in a part of the scene that would seem "lost" or empty without it.

The magnificent pipe organ at the First Church of Christ, Scientist, in Boston has a style that seemed perfect for a symmetrical composition. I placed myself in the precise center to get peak symmetry. That's important with a symmetrical scene. Otherwise, shooting even slightly to the right or left can make things look askew.
← Photo © Jim Miotke. 1/30 sec. at f/10, ISO 3200, 28–135mm lens at 28mm

One evening along the Las Vegas Strip, I turned my attention downward to this railing along the sidewalk. For the first image, I was drawn to the repetition of these decorative posts. I shot from an angle, so that the posts run from close-up at the left to far away at the right. For the second shot, I was intrigued by the symmetry. I chose a grouping of five posts and then carefully set up my tripod directly in front of the middle one.

← Photo © Kerry Drager. 6 seconds at *f*/13, ISO 200, 50mm lens
↓ Photo © Kerry Drager. 1/2 sec. at *f*/6.7, ISO 200, 50mm lens

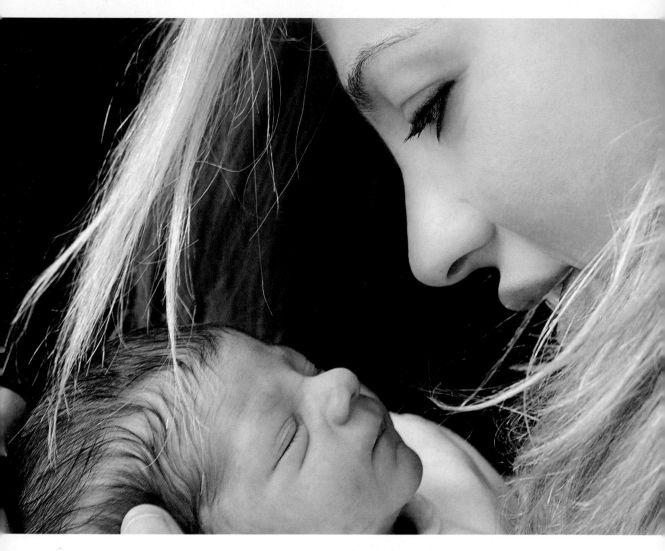

A close-up composition emphasizes a wonderful moment between mother and child. Note the balance of a joyful mom at top right and the baby at bottom left. Photographer Stefania Barbier tells how she captured this striking photo: "My friend just gave birth to a baby boy. I rushed to the hospital with my camera and a black backdrop. She loved the idea of newborn shots and even prepared herself with makeup. But it took us a while before the baby seemed ready for the moment. Her husband held the backdrop. I had beautiful window light—and voilà!"
↑ **Photo © Stefania Barbier. 1/50 sec. at *f*/5, ISO 400, 60mm lens**

A low camera angle, a colorful old kayak, and thick fog came together for this scene. Although I used a wide-angle lens, my intent was not front-to-back sharpness. Instead, I wanted the front to be crisply sharp, while the depth of field faded into the foggy distance. For me, the tree in the right background was of critical importance. It balances the composition while also serving as a point of interest in the upper right area of the composition.
→ **Photo © Kerry Drager. 1/30 sec. at *f*/13, ISO 200, 20mm lens**

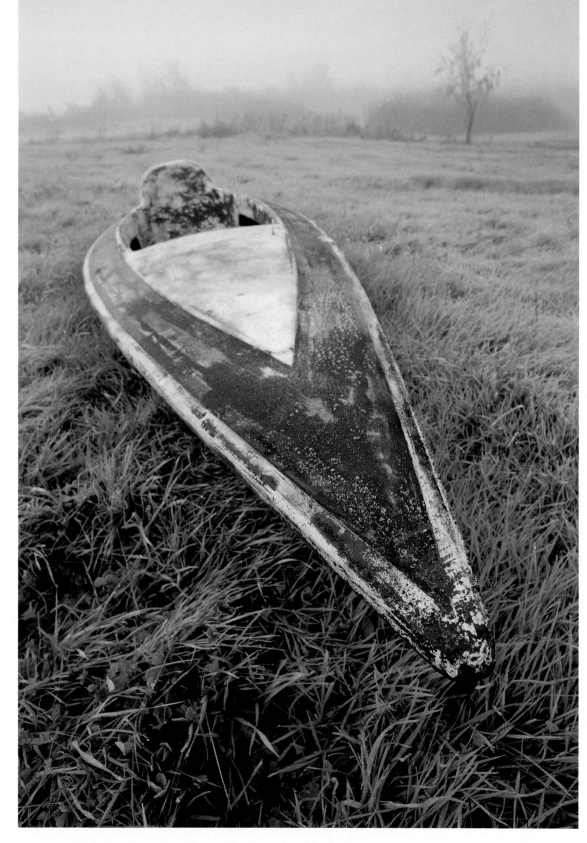

NEGATIVE SPACE

Despite its name, negative space can be a very positive thing. This design ingredient is an area of a photograph without substantial detail. It can be an empty blue sky, an expanse of blank wall, the sweeping surface of a body of water, a strategically placed shadow, or an out-of-focus background that's a soft blend of colors.

The right amount of negative space can bring a composition into balance, and it can help force the viewer's attention to your subject. The key is to consider negative space as one of the major elements of your composition. It has a certain visual weight that, combined with the main subject or subjects, brings the composition into balance. This graphic design element also helps direct attention to your subject.

The compositional balance involves the proportion of negative space to the other elements or subjects in the frame. There's no hard-and-fast rule. A picture with an off-center subject can be balanced by the visual weight of negative space on the other side of the frame. There doesn't have to be an object on the other side; negative space can function as that "object."

As with other aspects of compositional balance, the what-feels-right or what-looks-right factor is important; if things just look or feel right, your composition probably works. But if a this-just-isn't-working thought comes into play, you probably need to think again about your composition. In any case, the idea is to become aware of negative space—another key design element that's at your creative disposal.

Detail shots can help round out any photo essay or storytelling series, but so often, they simply make interesting photos. For this New Zealand train shot, I was attracted to the bright red logo, of course, but also to the range of grays in the scene—all highlighted by the soft light. I then chose a composition with the red subject in a Rule-of-Thirds position at the lower right while balanced by the pipe at the lower left. But there's more. Along with the subjects at the bottom, negative space—the fine textures and grays—helped balance the composition at the top.
↓ Photo © Jim Miotke. 1/25 sec. at *f*/5.6, ISO 200, 28–135mm lens at 135mm

Twilight is always special, and with a city skyline, you can achieve a wonderful contrast between the bright, warm lights and the cool blue sky. For me, the blue of the sky was outstanding, and a low horizon and vertical format also helped to capture the expanse of this San Diego scene. As a result, the negative space of the big sky balances out the relatively smaller area of cityscape.
↑ Photo © Kerry Drager. 4 seconds at *f*/4.8, ISO 200, 105mm lens

SCALE

The whole notion of scale in photography might bring to mind the story of David and Goliath. That's because, in photographic composition, a dynamic and relatively small subject can be a surprisingly big statement in a giant scene.

Due to contrast, a subject shown at a distance can call attention to a large scene. This sense of scale can convey a tall building's height and a mountainscape's vastness.

Just about any subject known for its size can be used to designate the scale of the surroundings: a distant animal, a lone tree, a house, and people, too, of course. Certainly, the human form is instantly recognizable—even if shown small—and will readily convey scale when shown in a big nature landscape, an urban landscape, or an architectural scene. Pictured small and often not even recognizable,

people can not only show scale but can also boost energy, add visual impact, and create mood and depth. These tiny figures set amid a towering backdrop make a nice twist on classic landscape photography.

Figures in a grand landscape can capture the imagination—and certainly the eye—by virtue of the difference in size. But there must be other contrast present, too, to prevent the subject from getting lost in a big scenic. Here are some examples: a well-lit figure in shadowed surroundings, a silhouetted form in front of a bright backdrop, a colorfully dressed person among dull tones, a subject outfitted in white against darker colors or vice versa, and a person dressed in a bold color in a foggy setting.

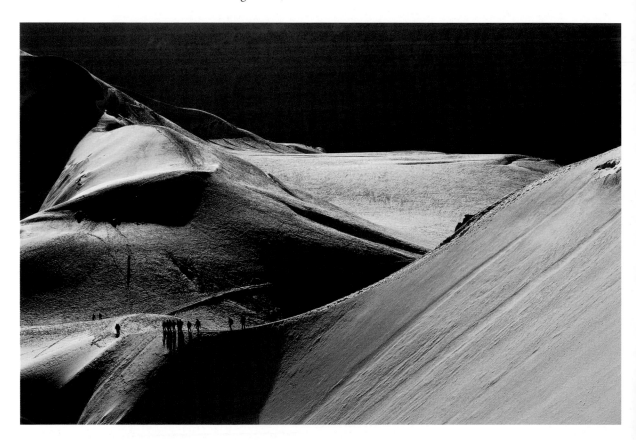

Light, shadow, and form combine for a dramatic scene in the Mont Blanc area of the French Alps. Pictured extremely small in the photo, the silhouetted hikers make a big statement, while showing the grand scale of this mountainscape.
↑ Photo © Stefania Barbier. 1/500 sec. at *f*/7.1, ISO 100, 24–70mm lens at 70mm

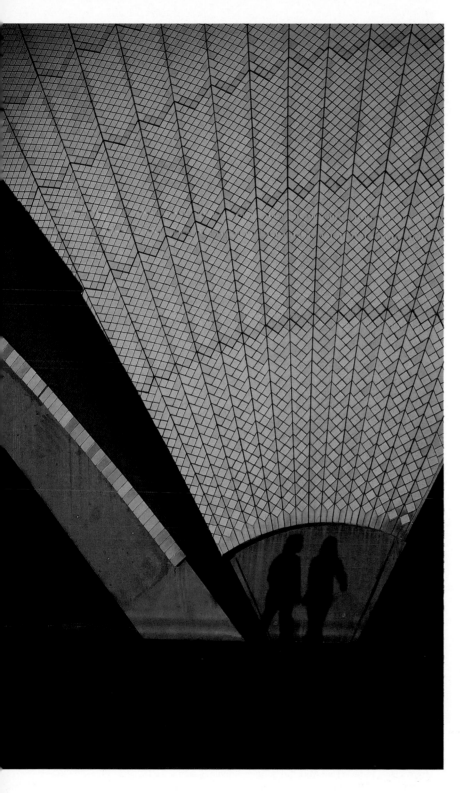

Photographer Renee Doyle has aptly named this image "The Phantoms of the Opera." The striking shadows give a real sense of the scene's scale. Says the photographer, "This image was taken by pure chance at sunset at the Sydney Opera House. We all were facing toward the Sydney Harbour Bridge waiting for a spectacular sunset to take place, and a thought that had been drummed into my head by a wonderful photographer reminded me to always look at what was behind me, as well. I then turned around and saw the two elongated shadows of people strolling past—playing on the walls of the opera house, which was glowing golden in the evening sun."

← **Photo © Renee Doyle. 1/320 sec. at _f_/8, ISO 200, 24–70mm lens at 70mm**

There are a number of great ways to imply motion in a still photograph. One approach is by showing the streaks of colors and night lights in a busy street scene. Here, in New York City's Times Square, I used a very slow shutter speed to catch the cars moving through the scene. This photo reminds me of the traffic, lights, colors, motion, and excitement of one of the world's most exciting cities!
↑ **Photo © Jim Miotke. 1/6 sec. at *f*/5.6, ISO 100, 16–35mm lens at 35mm**

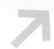

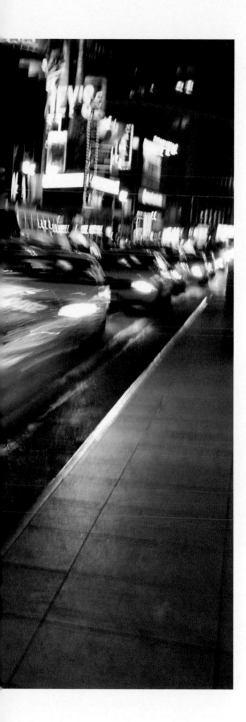

PHOTOGRAPHING MOTION

Moving subjects and still photography complement each other. Really! Photographing anyone—or anything—on the move can trigger a lot of visual energy. And, as a creative photographer, you have a surprising number of techniques in your artistic arsenal to convey motion.

In this chapter, we start out with freezing the action with a fast shutter speed. Subjects frozen at peak moments pack a photographic punch. While always effective, stopping movement isn't the only creative choice for capturing motion. Expressing an illusion of movement also can be accomplished through the artistic use of slow shutter speeds.

We'll encourage you to play with new ideas. In fact, if coloring outside the lines attracted you as a kid, then you'll love some of the thrilling shooting-outside-the-box techniques that we'll be sharing with you—techniques to make your still images "move."

You can't always predict what you'll get when you explore the world of blurred motion, but that's the intriguing and captivating challenge. This is where the digital advantage can work wonders: In between shots, you can review on your camera's LCD monitor what's working and what's not. Consider these thoughts and techniques as a springboard for your own artistic pursuits and creative explorations.

FREEZING THE ACTION

"Almost but not quite" are words you don't want to say when reviewing your photos. But even for top pros, the failure rate for photos with moving subjects is far higher than for shots with stationary scenes.

Catching the peak of the action is the goal when trying to freeze the motion—a child playing, a pet running, an athlete in action, a car speeding by, an ocean wave crashing.

For unpredictable subjects in particular—such as candids and active kids—creating eye-catching action photos is frequently less about precision and more about flexibility. The key? Set your camera for a fast shutter speed, and then start shooting like crazy. Forget about getting a high ratio of good to bad. It won't happen. The goal is to capture a few great images.

So what do we mean by a fast shutter speed? It's always relative and depends. For instance, when the action is heading toward you, the shutter speed can be slower than when the action is moving across your field of vision (for example, left to right) at the same speed. The longer the lens or the closer you are to your subject, the faster the shutter speed will need to be to stop movement. Of course, some subjects (speeding cars) move faster than others (people strolling).

We recommend using shutter speeds of around 1/250 sec. or 1/500 sec. to try to freeze the action of a child or animal on the go. For other subjects—whether a bicyclist, runner, or car moving side to side across the picture plane—you may need to go to 1/1000 sec. For still other action, including sports, you may need to resort to 1/2000 sec. As a very rough rule, 1/500 sec. or 1/1000 sec. will stop most activities in crisp sharpness. You probably can't go too wrong shooting at a higher speed than you think you need; it's a good safety net.

Of course, you can see firsthand whether you caught the action. Review your photos on your LCD panel. If there's still time, make any changes in the shutter speed. If you require a faster shutter speed, then you have to shoot at a wider aperture or raise the ISO.

In most cases, you'll need anywhere from 1/500 sec. to 1/2000 sec. to stop the action. But not always! It really depends on how fast the subjects are moving and their direction. Here, the galloping cowboy was stopped at 1/250 sec., since he is heading toward the camera; if he were caught while moving across the frame (say, from left to right), at least 1/500 sec. or 1/1000 sec. would have been needed. For the storm scene, the ranchers are moving slowly—due to the heavy snow—and 1/180 sec. was sufficient.

↑ Photo © Jim Miotke. 1/250 sec. at f/4.5, ISO 100, 100–400mm lens at 250mm

↗ Photo © Jim Miotke. 1/180 sec. at f/6.7, ISO 400, 28–135mm lens at 85mm

⬡ TIP: WHAT'S THE BEST EXPOSURE MODE?

First off, whatever exposure mode has been working for you—in terms of getting the shutter speed or *f*-stop you want—stick with it. Personal preference is why camera manufacturers provide such a variety of modes. For ourselves, though, we almost always shoot in Aperture Priority, a semiautomatic mode in which you set the *f*-stop and the camera sets the shutter speed. We use Aperture Priority for its value with depth of field, of course, and we also use it for situations in which shutter speed is the priority. Here's why:

If the main concern is freezing movement with a fast shutter speed, then choose a large aperture. In fact, the lens's widest aperture (lowest *f*/number) will result in the fastest shutter speed for the given light and ISO. If you have to go even faster, then increase the ISO. It's that simple. At the opposite end of the speed dial, your lens's smallest aperture (highest *f*/number), combined with your camera's lowest ISO number, will give you the slowest possible shutter speed for the given light.

Again, to emphasize: Shoot in whatever mode works best in your quest to get inspiring images and to learn the art of creative exposure.

Ocean waves are great sources of movement. One nice thing is that there really isn't a "correct" speed to use for stopping motion. Another is that each crash of the surf is different from the previous one—and different from the next. That's good news for photographers who love shooting these one-of-a-kind occurrences. For this image, I found 1/500 sec. gave me the look I wanted.
↑ Photo © Jim Miotke. 1/500 sec. at *f*/5.6, ISO 100, 70–300mm lens at 300mm

⬡ TIP: FOCUSING STRATEGY

DSLRs have multiple ways of focusing, often including ones designed for shooting action. Consult your manual for the specifics of your camera. Otherwise, here are approaches that have worked for us:

For subjects that are moving through the scene at a predictable pace and in a predictable route (running horse, car, bicyclist, runner, etc.), we like the prefocusing technique. That means setting the focus on a spot in front of the subject. When the action reaches that point, fire away.

If the action is unpredictable, just wait for a slight lull in the action, press the autofocus button, and as soon as the lens focuses on your subject, start shooting in continuous mode. Odds are one of those frames will be a winner, and you can simply delete the rest. (Have we mentioned that we love digital?) This is a great strategy for photographing many situations.

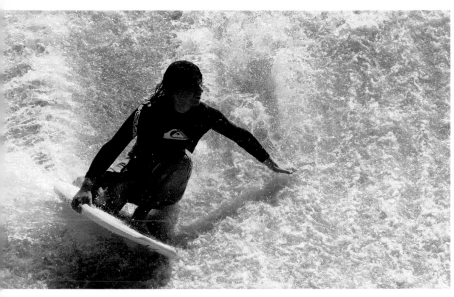

Photographer Donna Pagakis loves the fast action and walls of waves in the growing sport of flowboarding, which involves continuous artificial waves that mimic ocean waves. Photography sessions at two Southern California water parks produced these images, one of her son Andy and the other of her daughter Rebecca. Fast shutter speeds and a continuous shooting mode helped capture the decisive moments.

← Photo © Donna Pagakis. 1/2000 sec. at *f*/8, ISO 400, 28–135mm lens at 50mm

↓ Photo © Donna Pagakis. 1/1000 sec. at *f*/11, ISO 400, 28–135mm lens at 44mm

A fast shutter speed is needed to capture birds in flight, but photographer Deborah Lewinson had another shooting strategy, too, at this New York beach: "Attempting to be at eye level or lower, I was sitting on the beach, using elbows on knees to stabilize the camera. From a distance, I had been shooting a family of oystercatchers, scooting in closer and closer so as not to disturb them. Tail movement alerted me to the possibility of imminent flight, and I was able to isolate this one bird." Focusing on the eye kept the bird sharp, and panning with the movement of the bird blurred the background. With bird photography, Lewinson advises, "Look up, down, and all around. Always be open to and prepared for new opportunities!"

↑ Photo © Deborah Lewinson. 1/4000 sec. at *f*/8, ISO 800, 300mm lens with 1.7x teleconverter for 500mm

⬤ TIP: SHOOTING STRATEGY

Here's a tactic we like: Set your camera for continuous mode, in which you can take a rapid-fire series of images for as long as you press the shutter button. Firing off several shots right around the time you see an expression about to occur—or just before the critical point or the peak of action—increases your chance of getting the shot.

Peter Burian used a fast shutter speed of 1/1250 sec. to freeze this freestyle
motocross rider in midair. The camera position—low and pointing upward—
enhanced the drama by placing the high-flying stunt rider right against the sky.
↑ Photo © Peter K. Burian. 1/1250 sec. at *f*/5.6, ISO 400, 200mm lens

STEADY CAMERA + SLOW SHUTTER = BLURRED MOTION

Some beautiful things start to happen when a moving subject, a steady camera, and a slow shutter all come together. That's certainly true when it involves water in motion—waterfalls, ocean surf, rivers, streams, and even fountains. With a long exposure, you can get the so-called "cotton-candy" effect—the soft and silky smoothness of flowing motion.

But just about any moving subject can be turned into an expressive scene with a slow shutter speed—such as runners, bicyclists, a wind-blown field of grasses or wildflowers, an amusement ride at twilight, falling rain or snow, a ceiling fan, trains, and cars. While a slow shutter implies motion with your moving subject, stationary objects in the scene will record in sharp detail. That makes the moving parts all the more eye-catching due to the sharp-vs.-blur contrast.

But long exposures don't just happen. You'll need to do the following:

• Get out during the low light of early morning or late evening, find a scene in deep shade, or wait for a solid overcast day. Your lens's smallest aperture gives you the slowest possible shutter speed for the given light and ISO setting. Many scenes with depth also benefit from small apertures and result in great depth of field.

• Set your camera for its lowest ISO number: 100 or 200. Save the high ISOs for when fast shutter speeds are necessary.

• Use a tripod or other sturdy support. A cable shutter release also reduces the likelihood of any vibration caused by your hand touching the camera during the slow exposure.

The best shutter speeds for recording blurred movement vary widely and depend on the speed at which your subject is moving as well as the distance between subject and camera. But here are some starting points: A shutter speed of 1/2 sec. usually will start showing the ethereal qualities and cotton-candy effect of flowing motion of waterfalls, streams, and fountains. One rule of thumb might be between 1/4 sec. or 1/8 sec. and down to 2 seconds for cascading water. Slower speeds work great, as well; in fact, a mystical or surreal mood can be the wonderful result of a multiple-second exposure.

Again, these are rough estimates, and things can vary when shooting subjects that don't involve water. This may sound pretty much like trial and error, and to a certain extent it is! It also depends on the effect you're after. But here's a very general rule for moving water: Oftentimes (though not always), the slower the better. Actually, when the light gets really low, an exposure lasting many seconds may be the norm. This is a great technique for taking advantage of your camera's LCD panel to view—instantly—the results of your shooting. Check your pictures, and vary the shutter speed—the composition, too, perhaps—until what you see is what you want.

Low light, plenty of traffic, and the colors of dusk were just the ingredients for capturing head- and taillights from a freeway overpass in the Seattle area. Slow shutter speeds turned the cars into long streaks of light and color. Here, I used an 8-second exposure. I also included a good slice of the twilight sky, since the beautiful blue contrasted so well with the colors below.
→ Photo © Jim Miotke. 8 seconds at *f*/13, ISO 100, 28–135mm lens at 44mm

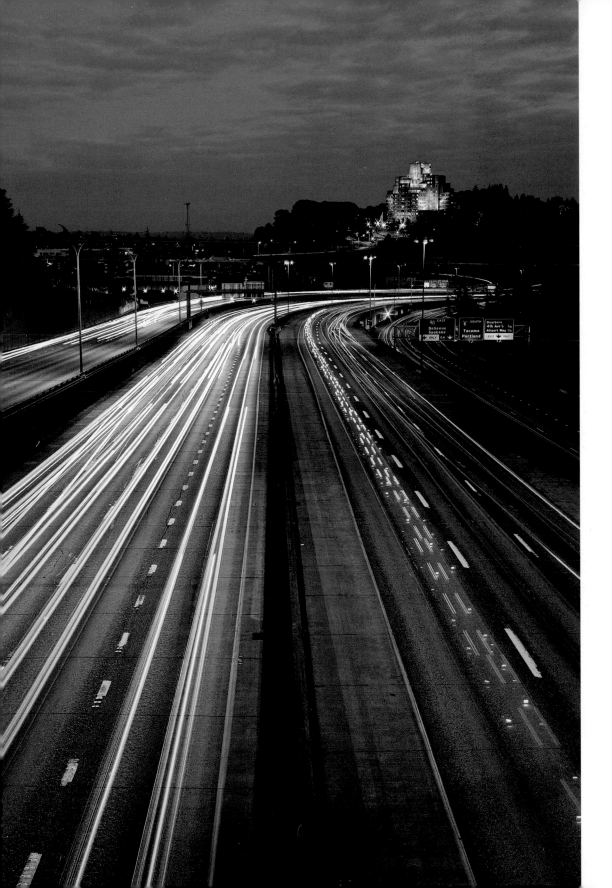

Diffused light is almost always required for satisfying shots of moving water to pre-vent an unappealingly harsh mix of glaring highlights and inky-black shadows. At the same time, a long exposure turns the water into a silky, smooth flowing motion. The use of a low ISO number and a small aperture contributed to the slow shutter speed (6 seconds), with the small aperture also creating deep depth of field.
↑ **Photo © Jim Miotke. 6 seconds at *f*/19, ISO 100, 16–35mm lens at 18mm**

A 4-second exposure, with camera on tripod, created quite a study in motion on a pool table. But this isn't a take-one-shot-and-nail-it type of subject. Rather, I shot this scene multiple times (many breaks) to get the picture's elements and ghost effects in all the right places. Of course, I wanted the eight ball front and center.

↑ **Photo © Jim Miotke. 4 seconds at *f*/14, ISO 100, 24–70mm lens at 70mm**

NOT SLOW ENOUGH? USE A FILTER!

Sometimes you just can't get a shutter speed that's slow enough to meet your artistic needs. One solution is to return when the light level is lower. But if you'd like to push through *now*, this is where a deep-tinted filter comes into play. In most cases, these filters screw right onto the front of your lens. Here are a couple of options:

• Polarizer: The polarizing filter reduces the light entering the lens by the equivalent of about 2 stops. Otherwise, the polarizer's main purposes are to cut the glare on reflective surfaces, to boost colors, or to deepen a pale blue sky. *Note:* You must turn the outer ring on the filter to see the effect and to get the right orientation.

• Neutral-density (ND): This filter has no other function than to decrease the light entering the camera. ND filters come in various strengths, with popular ones slowing the shutter by 3 stops or 4 stops. A variable ND filter, by the way, lets you dial in the density from 2 stops to 8 stops.

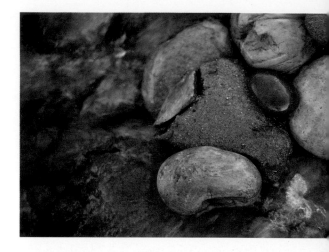

For the faster shutter speed (1/30 sec.), shown in the photo at top, a wide aperture and high ISO number were needed. To obtain the slow shutter speed (3 seconds), shown at right, I used a low ISO and a small aperture, which had the added benefit of an increased depth of field. By the way, a polarizer reduced the reflections while increasing the color and also slowed the shutter speed, too, since the filter is deeply tinted (letting in less light).
↗ Photo © Kerry Drager. 1/30 sec. at *f*/4.8, ISO 800, 70–300mm lens at 112mm
→ Photo © Kerry Drager. 3 seconds at *f*/19, ISO 200, 70–300mm lens at 125mm

📷 ASSIGNMENT: GETTING UP TO SPEED

Start getting a feel for working with motion and shutter speed. For this exercise, find a safe spot beside a street or road, attend a sporting event, or select a fountain or stream, a carnival amusement ride, or any other place where there's a steady stream of moving subjects. Then start shooting with different shutter speeds. Vary the focal length, too. If possible, change camera positions so that the movement runs across your field of vision for some shots and moves toward (or away from) you for other images. Compare your results later. See what shutter speeds—and directions of movement—are freezing the subject in crisp sharpness and which are just a bit soft. Redo the exercise on another day with other subjects.

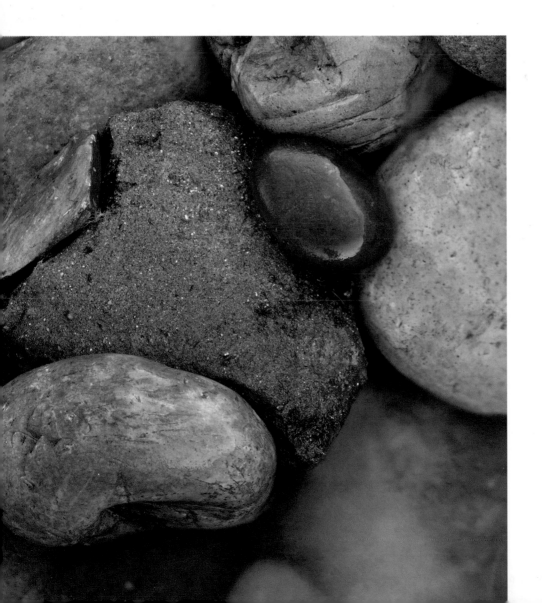

PANNING A MOVING SUBJECT

There are many unwritten rules in photography. Keeping your camera steady is one of them. Well, for this artistic technique, you'll need to forget all you've learned about the importance of shooting with a rock-solid camera. The creative result will be many cool motion-blur images. Best yet, just about any subject in motion qualifies.

This technique involves deliberately moving or panning your camera along with your subject. The result is a fairly sharp subject set against a blurred and streaked backdrop for a real feeling of motion and action.

Here's how this technique works: Position yourself so that you're mostly parallel to the path of your subject. In other words, you want the action to run across your field of vision. Then start panning with the camera at the same speed as the moving subject. Along the way, press the shutter smoothly. For the best result, be sure to start panning the subject before you press the shutter button and continue the follow-through after you release the shutter. Try to use as smooth a motion as possible—avoid any jerky motions and sudden stopping.

The best shutter speed for panning depends on not only how fast the subject is moving and your distance to the subject but also on the effect you want. For instance, a slower speed equals more blurriness and thus more of a sense of motion. But go too slow and things might be so blurry that you can't tell what the subject is. Too fast and you might come closer to freezing the action than blurring the motion.

Common shutter speeds for panning are 1/15 sec. or 1/30 sec., but going slower (1/8 sec. or less) or even a little faster (1/60 sec. maximum) often works, too. Whether to use a tripod is a personal choice. We sometimes do, and we sometimes don't. Some confirmed panning shooters always use one (to get as smooth a panned background as possible), while others never do (to have more flexibility while shooting). If you handhold the camera, always keep your elbows right at your side, and turn your upper body while you track the object.

It's a challenge to get the panning just right, but this is where digital cameras are so handy. Between shots, check your LCD panel to see your motion-blur results and consider the best settings for next time. Also check for potential distractions in the background. For instance, if a contrasting bright color or a stark white sky comes into the composition at any point, then choose another camera position with a less busy background.

Panning does take practice. Be prepared to "waste" many shots to achieve success. But panning is an enjoyable and creative pursuit that you'll love. and it will give you some great artistic looks at conveying motion.

✦ TIP: FOCUSING

It may be helpful to prefocus on an object located exactly where the subject will be. That means setting the focus before and then locking in the focus for the entire panning process by using a focus-lock button or holding the shutter halfway down. Or consider switching to manual focus mode. In any case, you'll likely have the assistance of greater depth of field—the result of a higher f/number to obtain the necessary long exposure.

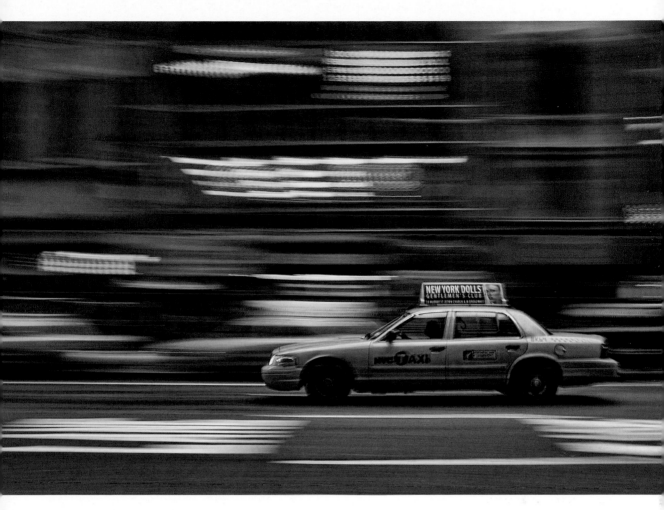

Planning and persistence can really pay off. An overcast day, neon lights and colorful taxicabs were the perfect conditions for panning this New York City scene. Photographer Deborah Lewinson explains: "I took a couple of test shots and determined that 1/8 sec. was the best shutter speed for the traffic. I set the focus manually by using a car entering my chosen lane of traffic. The lighting was excellent for panning. It was overcast, creating a soft light and enabling a slow shutter speed with a low ISO. I handheld the camera, while keeping my elbows tucked in tight. The panning started as a car entered the viewfinder and did not finish until after it left the viewfinder. I took twenty-two shots of different vehicles; some were reasonable, others were outright misses, and this was my favorite."
↑ Photo © Deborah Lewinson. 1/8 sec. at *f*/9.5, ISO 200, 18–200mm lens at 18mm

When photographing wildlife in captivity, Jim and I try to avoid compositions that include any signs of humanity—unless our intent is to document the captive environment. My pair here shows two approaches to wildlife photography. One is a portrait of a wolf in a natural-looking environment. But I really was after something more unique. For the other image, I chose panning to convey a sense of motion by catching these two wolves with a 1/30-sec. shutter speed.

← Photo © Kerry Drager. 1/350 sec. at *f*/5.6, ISO 200, 80–200mm lens at 155mm

↓ Photo © Kerry Drager. 1/30 sec. at *f*/11, ISO 100, 80–200mm lens at 80mm

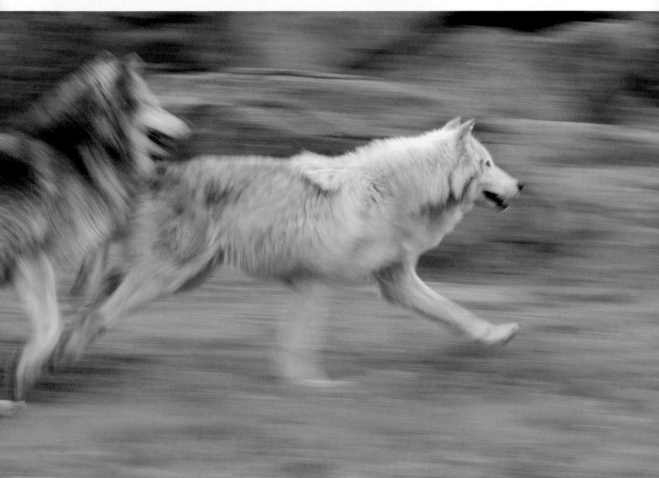

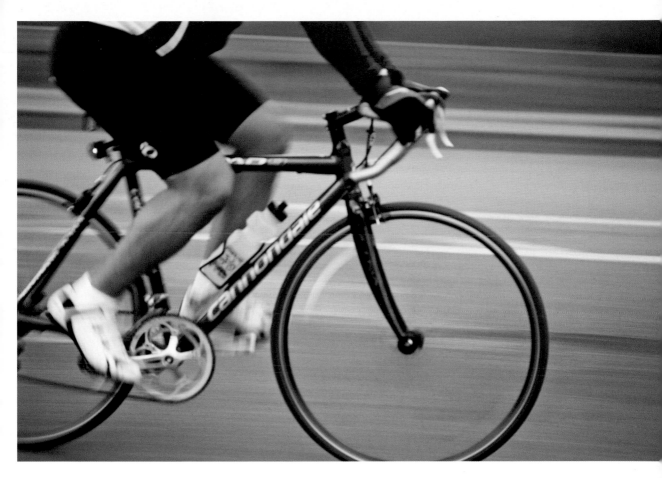

Bicyclists make great subjects for panning, especially when they're wearing colorful clothes. On this cloudy day, the colors really popped. Plus, the low light let me shoot with slower exposures. With 1/25 sec. and with a rider fairly close (with my short tele-photo lens), I decided to put the emphasis on wheels, feet, and arms with a tight composition. I made sure to leave breathing room in front of the subject.
↑ Photo © Jim Miotke. 1/25 sec. at f/2.8, ISO 400, 100mm lens

🔆 ASSIGNMENT: GIVE PANNING A TRY

You'll get the hang of panning relatively quickly. Pick a place with consistent subjects in motion. That way, you'll have a choice and you'll be able to regularly inspect your results, and when necessary, adjust settings, knowing that other subjects will be available. For example, look for popular areas for runners or bicyclists, busy streets for cars, etc. Then position yourself to catch them crossing your field of vision. Also, vary your shutter speed so that you can see the differences.

🔆 TIP: BREATHING SPACE

Position your panned subject so there is suf-ficient "breathing room" between the front of your subject and the picture border. Otherwise, things can appear cramped or crowded—even off-balance. It's unnerving for the viewer to see a subject just about to leave the frame.

PAINTING WITH LONG EXPOSURES

Okay, now's the time to channel your inner rebel. You are going to be ripping pages right out of the photographic rule book, and you'll be having fun doing it. We guarantee it!

First, you must reevaluate all those negative thoughts about totally blurred photos. No, we're not talking about photos that are partly, or even mostly, blurred but with some sharpness. We actually mean 100 percent blurriness—impressionistic images, really. Nothing sharp, nothing steady.

You'll be dealing with a scene that stays put and a camera that's on the move. Expect artistic abstracts of blurred color, light, and design—one-of-a-kind painterly images. With the use of a slow shutter speed and the camera's shutter open, you're panning or twirling the camera in a motion that's side to side, up and down, or round and round. This lets you blur all the details together and create a blurred blend of colors.

Gardens and flower fields are often the top picks for painting with slow exposures. But other stationary subjects work effectively, too: trees, meadows, fruit stands, produce markets, graffiti walls, crowds of people, and even boats in a harbor.

As for shutter speed, there are no absolutes, except that you'll want a speed that's not too fast, otherwise you may not have time to complete enough movement for the creative-blur effect. A shutter speed in the neighborhood of 1/15 sec. to 1 second is a good place to start. But painting with exposure also can be done in superlow light, where shutter speeds can hit multiple seconds. It does depend on the speed of your camera movement, too. As a matter of fact, your own panning movement works hand in hand with the shutter speed.

Start panning before pressing the shutter button and continue moving after the picture is taken to ensure that the camera is in motion the entire frame. Like the follow-through of a golf swing, you'll want one smooth, nonjerky motion.

Review your LCD screen periodically to see if you need to try a different movement or to change your viewpoint or to change subjects. You may even wish to alter the focal length—for instance, to narrow the view (to leave out distractions) or to widen your view (to include more of the scene).

A last word of caution: This is yet another situation in which you can expect to receive curious glances or comments from passersby who see a photographer spinning, jiggling, and twirling the camera. They just won't understand now much creative joy you're having. It will be your secret!

The brain is attracted to multiples of three and also to the color red, and this photo has both. Along with those aspects, photographer Chellie Stull also wanted a painterly, abstract effect: "This was one of many images I made of these three flowers, trying various shutter speeds and camera movements," she says. "This one, using a 1/5-sec. shutter speed—and using a circular camera motion—was the most compelling."
→ Photo © Chellie L. Stull. 1/5 sec. at *f*/22, ISO 100, 70–200mm lens at 70mm

Photographer Kathe Nealon loved how these Easter eggs turned out and describes how she captured this study of color and motion: "While the eggs were drying, I grabbed a camera to capture their vibrant hues. After trying a few 'regular' shots, I realized that the best way I could convey what I saw was to 'pan' the eggs. Using existing light, it took about fifteen minutes—and more than a few tries!—to achieve the right blend of shutter speed and camera movement."

↑ Photo © Kathe Nealon. 1/2 sec. at *f*/16, ISO 800, 18–135mm lens at 100mm

Photographer Kristi Howson was attracted by an "exotic and beautiful small grove of trees with the right mix of light, color, and line," she says. "Using camera movement over time, I enjoyed blending the elements in an abstract fashion for their collective beauty."

→ Photo © Kristi A. Howson. 1.5 seconds at *f*/19, ISO 100, 40mm lens

↑ Photo © Jim Miotke. 1/2 sec. at *f*/36, ISO 100, 28–135mm lens at 135mm

↑ Photo © Jim Miotke. 1/8 sec. at *f*/9, ISO 100, 70–300mm lens at 100mm

↑ Photo © Jim Miotke. 1/8 sec. at *f*/13, ISO 100, 70–300mm lens at 70mm

↑ Photo © Jim Miotke. 1/13 sec. at *f*/13, ISO 100, 70–300mm lens at 195mm

Riding in a speedboat, it's hard to think of anything but water and motion! For this image, I noticed rope extending from the back of the boat. A slow shutter speed created the sense of motion that I had envisioned. I also photographed the rope as a diagonal.
↑ Photo © Jim Miotke. 1/15 sec. at *f*/40, ISO 200, 70–300mm lens at 300mm

A still camera can capture motion in so many ways, as described and shown throughout this chapter. Photographer Beverly Burke created this colorful study in motion with a close-up camera position and a Lensbaby—a specialty lens that creates a unique selective-focus effect. "I set up this shot indoors with the Slinky near a window, providing natural light," the photographer says. "While my daughter was playing with the Slinky, I moved in close to create an abstract feel to the image."
↑ Photo © Beverly A. Burke. 1/250 sec., ISO 400, Aperture Priority mode, Lensbaby

📷 ASSIGNMENT: EXPERIMENT LIKE CRAZY

Painting with a long exposure can be a hit-or-miss affair. The point is to try one thing and then another. Practice getting your rhythm down. Vary the shutter speeds, the speed of your movement, and the focal length. This is an exercise that can be performed anywhere. Any subject or scene will do. After all, this is rehearsal for your next big shoot. But don't be surprised if you end up transforming that ordinary or boring-looking subject into a creative image with this technique. You just never know for certain what you'll discover!

BLURRING MOTION BY ZOOMING

Here's another enjoyable and artistic way to breathe life into inanimate scenes: Try a special-effect zoom technique with your lens. Specifically, zoom the lens while the shutter is open during a long exposure. It's a great way to add energy to an image and to imply motion, with the best results being very cool impressionistic interpretations.

What are the best subjects for this "zoom-blurring"? You're only limited by your imagination and your willingness to experiment. Here are some zoom-blur tips and techniques:

• The shutter speed must be slow enough so that you have time to zoom—say, 1/4 sec. to a full second. Stop down the lens to a small aperture (such as *f*/16 or *f*/22). Use a low ISO number. Avoid shooting in bright midday sunlight, but if you must, then you'll likely need a deep-tinted polarizer or neutral-density filter to get a shutter speed that's slow enough.

• You can do this with or without a tripod, but we suggest using a tripod to avoid extra camera movement during the slow shutter speed.

• It's advisable to first compose the scene at the zoom's shortest focal length (lowest mm number). Then zoom in closer—toward the zoom's longer end.

• To get smooth streaking, begin zooming *before* pressing the shutter button. Then keep on zooming *after* the shutter closes. In addition, be sure to zoom the lens at as consistent a speed as possible and in a nonstop motion. You can zoom through the full focal-length range of your lens or just partway. It's your choice, depending on the camera's shutter speed, the speed at which you zoom the lens, and how you wish to interpret the scene.

Don't worry if your early attempts fall short. It could be that the shutter speed is not long enough. But it also could relate to your zooming speed: too slow or too fast? By analyzing your results on the LCD monitor and then experimenting with a variety of shutter speeds and zooming speeds, you'll discover the combination of settings that works for you. Practice getting your zooming and timing just right.

As with other shooting techniques involving motion, this zooming tactic provides a ton of creative fun—along with a high failure rate in the beginning. After all, the results just aren't predictable, and it takes a while to get the process down. But once again, this is where digital's great advantage comes in: You can review the results instantly and see where you need to tweak things.

Not surprisingly, colorful flowers are favorite subjects for the zooming technique. But don't stop there, since just about any subject can work—even railroad tracks and old buildings.

← Photo © Jim Miotke. 1/2 sec. at *f*/36, ISO 50, 28–135mm lens at 117mm
↑ Photo © Karol Grace. 1/13 sec. at *f*/22, ISO 200, 28–135mm lens at 53mm

The only hard-and-fast zooming guideline is this: When you see a potential subject, give it a go and see what you get. It's always a gratifying adventure!
← Photo © Jim Miotke. 1/3 sec. at *f*/36, ISO 50, 70–300mm lens at 130mm
→ Photo © Jim Miotke. 1/10 sec. at *f*/11, ISO 100, 28–135mm lens at 65mm
↓ Photo © Jim Miotke. 1/8 sec. at *f*/13, ISO 100, 70–300mm lens at 130mm
↘ Photo © Jim Miotke. 1/6 sec. at *f*/22, ISO 200, 28–135mm lens at 60mm

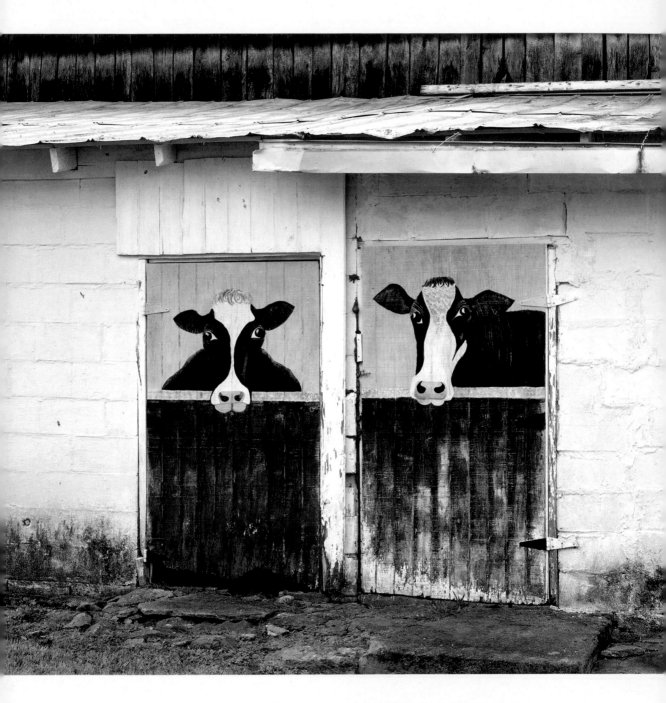

Bold colors, soft overcast light, and a fun subject always make an intriguing combination. This photo resulted from a quick trip to Tennessee and from following our own advice of always having a camera handy, just in case. Along with the right light and fine color, composition was an important ingredient, too, especially the balancing of key elements in the scene. The main focal points are clearly the cow paintings. But I felt the dark window at the right, which stands out on the white wall, was important, too, in terms of overall balance.

↑ Photo © Kerry Drager. 1/90 sec. at *f*/11, ISO 200, 50mm lens

CHAPTER 6

PULLING IT ALL TOGETHER

Thank you so much for taking part in this photographic quest for visual creativity. We hope you've enjoyed reading our thoughts and techniques, reviewing the many photographs, and trying some (hopefully all!) of the exercises designed to take things out into the field.

There's no doubt that one needs to have a deep commitment and passion to take your photography to the next level. We know you do, since you would not have set aside your valuable time to read this book if you didn't. You have the driving desire to be creative. Now you have almost all the tools you need to get the results you want—consistently.

We say "almost all the tools" because we aren't done yet. Pulling it all together means continuing your own visual quest. So in this chapter, we cover three important techniques: Two of them include editing your work and planning personal projects. The third strategy is a deceptively simple one—a goal we often strive for but all too often forget: to take the camera everywhere you go.

Now let's set out to pull it all together!

For photographer Susana Heide, challenging themes have proven to be one of the best ways to get her creativity going. In fact, she says, this eye-catching image was the direct result of a theme—in this case, forks. She adds, "The natural inclination would have been to pair the fork with food, but I guess when it comes to photography, I like to take the road less traveled. I like to stretch my imagination and go for the less obvious. Sometimes the result is favorable and sometimes it's not. Live and learn—but never blend in!"
↑ **Photo © Susana Heide. 1/85 sec. at f/2.5, ISO 100, 50mm lens**

PERSONAL PROJECTS

Shooting with a clear-cut purpose can be the answer to escaping the inspirational or motivational doldrums that periodically strike photographers. Exploring a subject, location, or theme over a long period of time can help you expand your skills, rediscover your photographic passion, and flex your artistic muscles.

An ongoing assignment often involves a subject or location close to home, so you can pursue the same scene at various times of day, in unusual weather conditions, and throughout the year. These projects also give you the opportunity to study your results and return for more images.

Possibilities might be a local zoo, a nearby park, or your own backyard. Perhaps you'd like to make people aware of an environmental issue; your pictures could serve as a valuable way to highlight a natural area worth saving. Or you could take on a historic preservation goal, using your images to help gain protection status for a significant site.

Or you might choose themes or concepts that can be captured anywhere—at home or away—whenever you have a desire to dip into a theme or whenever a lack of inspiration hits. The list of possible subjects is endless, but here are a few to get you started thinking:

Humor (funny signs or billboards), color (a scene dominated by, say, red or blue), design element (line, shape, texture, and so on), blurred motion, ornate doors, patterns in nature, window reflections, unusual hats, striking silhouettes or shadows, back alleys, graffiti walls, street photography and portraits of interesting people, window-light scenes, still lifes, or unique points of view.

There's a major benefit to having personal projects that involve do-it-anywhere concepts. Can't find something to photograph? Then pull a predetermined theme out of your photo-idea bag!

JIM'S PROJECT: FAMILY ALBUM

As a parent, I photograph my children because I find endless joy in this creative activity. I try to have a camera available whenever possible. My finger is poised on the shutter button, always ready to capture a meaningful moment or a funny scene. I have three adorable children—Julian, Alex, and Alina—who prove to be cooperative subjects time and again. My wife, Denise, often gets into the action, too. As with any subject, you'll want to vary the composition, the light, and the viewpoint. Also, with active kids—and even with portraits, when expressions can change suddenly—I'll switch the camera to Continuous mode to shoot a rapid-fire series to help ensure that I get what I want. Keeping your camera ready for action, having willing subjects, and looking for variety are keys to satisfying children's photography!

↑ Photo © Jim Miotke. 1/80 sec. at *f*/14, ISO 400, 28–135mm lens at 85mm

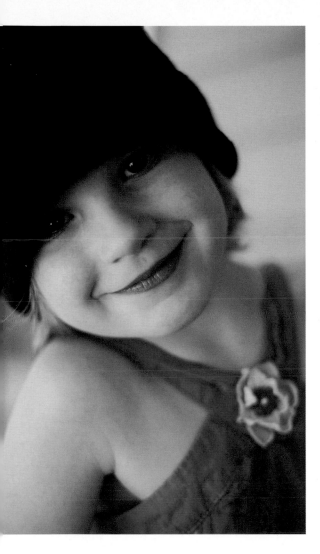

↑ Photo © Jim Miotke. 1/160 sec. at *f*/2, ISO 100, 50mm lens
↗ Photo © Jim Miotke. 1/320 sec. at *f*/4, ISO 200, 30mm
equivalent (digital compact camera)
→ Photo © Jim Miotke. 1/320 sec. at *f*/6.5, ISO 400, 50mm

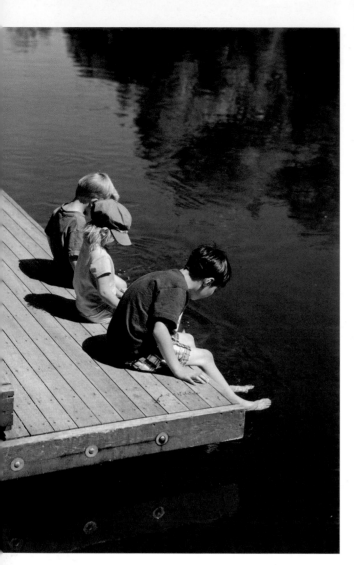

↑ Photo © Jim Miotke. 1/400 sec. at f/5.6, ISO 100, 24–70mm lens at 70mm

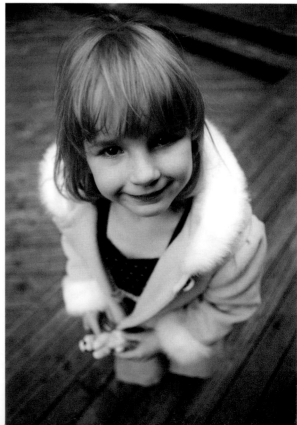

↖ Photo © Jim Miotke. 1/1000 sec. at *f*/5, ISO 200, 28–135mm lens at 75mm
← Photo © Jim Miotke. 1/2500 sec. at *f*/2.8, ISO 400, 24–70mm lens at 24mm
↑ Photo © Jim Miotke. 1/60 sec. at *f*/4.5, ISO 100, 85mm lens
↘ Photo © Jim Miotke. 1/80 sec. at *f*/4.5, ISO 400, 30mm equivalent (digital compact camera)

KERRY'S PROJECT: COOL CARS

I love photographing at outdoor car shows—the gleaming array of custom vehicles and restored classics. But I mostly avoid the straightforward or documentary shots—for example, no this-is-what-a-19XX-Model-XYZ-looks-like pictures. Instead, I'm working on a smaller canvas—tight compositions that zero in on all the vibrant colors, sensuous curves, bold lines, gleaming chrome, mirrored reflections, and artsy abstracts. Mostly, I shoot early in the morning (just after the doors open) and in late afternoon—times when there are fewer showgoers and when the light is at its best. In between shots, I'll review my results and reshoot when necessary. Often, I chat with the always-friendly car owners who invariably love the attention of photographers!

↑ Photo © Kerry Drager. 1/8 sec. at *f*/29, ISO 100, 105mm lens
↓ Photo © Kerry Drager. 1/25 sec. at *f*/32, ISO 100, 105mm lens

↑ Photo © Kerry Drager. 1/180 sec. at *f*/13, ISO 200, 105mm lens
↓ Photo © Kerry Drager. 1/40 sec. at *f*/25, ISO 100, 105mm lens

↑ Photo © Kerry Drager. 1/8 sec. at *f*/25, ISO 100, 105mm lens

📷 ASSIGNMENT: DRAWING UP A LIST

This is a thinking exercise. On your computer or on paper, start listing all the nearby subjects, places, events, or activities that you're interested in and that you can photograph over a long period of time. Also come up with possible themes and concepts that seem intriguing—ones that can be found and shot anywhere. At first, jot down everything—don't filter. Once you are done, go through and rate your favorites. Then get out, start looking, and begin shooting!

← Photo © Kerry Drager. 1/8 sec. at *f*/19, ISO 100, 105mm lens
↓ Photo © Kerry Drager. 1/10 sec. at *f*/22, ISO 100, 105mm lens

SELF-EVALUATION

It's true that to get inspiring photos you have to take a lot of pictures. But if you leave it at that—a ton of images—you'll be looking at too many rejects that can overwhelm your winners. That's why the second stage—selecting the best of your work—is so important. As the old saying goes, the difference between novice photographers and advanced photographers is that novices show all of their photos, while experts show only their best images.

There's great value in going over your best photos from the past six months or the past year. See how you have progressed. Look for trends in your work. Also check to see that you haven't hit a visual rut, in which you are repeatedly photographing the same types of subjects in the same ways.

Granted, it's not easy to assess your work, yet self-evaluation is a critical step in a photographer's growth. Try to analyze your work as dispassionately as possible, casting aside the emotions that can cloud objectivity. Time is often a part of the best approach here—if possible, wait a day or two, or longer, after a photo shoot for any serious editing so that the immediate postshoot excitement has worn off. This will help you let go of those photos that missed the mark.

However, the editing process should involve more than just admiring your good pictures and tossing the rest. It also should involve trying to determine *why* certain photographs succeed and others don't. After you've finished a shoot, go through those shots and identify the bad ones—you know, the images that are totally blurry, too dark, too light, or just plain boring. Don't be too quick to delete them, however. It's important to figure out what went wrong. It has been said that we can often learn more from our errors than we can from our successes. Of course, you may know precisely why some images missed the mark—for example, you accidentally clicked the shutter and shot your foot.

After weeding out the clunkers, you'll be surprised how much better your images appear from that day of shooting. After all, with a portfolio almost—but not totally—filled with fine images, the viewer's eye always seems to be drawn to the weakest images. Get rid of them!

Next, set aside pictures that are okay but not great (or that you can't decide on one way or the other) in a folder labeled "Mediocre" or "Outtakes" (or whatever). Also, identify those images that only have personal meaning to you—i.e., those snapshots that appeal only to you, your family, or your friends. Place them into a folder named "Personal."

Finally, after deleting the bad ones and setting aside the mediocre and personal ones, you should be left with only the winners. This process isn't easy, but when you show only your best images, your viewers will think you're a real pro, if not a genius!

Also remember that if your photos from your recent trip or family outing didn't meet your highest expectations, those photo shoots still did complete another, equally exciting objective: getting you out and exploring the visual possibilities and striving to further develop your vision. Now, isn't that a worthy goal?

In the "old days," film photographers would line up their color slides—or negatives—on a big light box. Then the editing began: evaluating the images as a whole, zeroing in for a close look, tossing out the mistakes, and comparing two or more similar images. Well, you can still do that! This photo shows the light table of Adobe Bridge. This is just one example, since many other image-editing programs also feature great ways to review your digital images. This view shows the photos as small thumbnails that let you easily and quickly edit the best from the bad. For a closer look, you can enlarge specific ones.

In this photo, the early-morning winter light strikes the stained-glass windows of the Washington National Cathedral at a nice low angle, flooding the southern aisle with intense color. But this photo is actually the result of analyzing and reshooting. Explains the photographer, Christopher J. Budny, "The first time I shot this aisle was with my point-and-shoot camera, handheld. By the following winter, I'd learned so much more about photography that I wanted to try the shot again. This image then came about after I'd moved up to a DSLR and a tripod that could sit quite low, just inches off the floor. I wanted a low shot, to make sure the receding arches were clearly visible, as well as to capture more wall space (and color!) of each receding bay."

↑ Photo © Christopher J. Budny. 1.6 seconds at *f*/16, ISO 100, 17–85mm lens at 47mm

YOUR CAMERA: DON'T LEAVE HOME WITHOUT IT

Do you grab your camera each time you leave the house? You should, since this uncomplicated act separates casual picture-takers from serious image-makers. Routinely carrying a camera has an awesome double bonus: (1) You'll come up with some good pictures that you wouldn't have captured otherwise, and (2) you'll give your shooting eye regular workouts.

Take your camera to work, to a party, to the game, onto the airplane, out for a drive. Even to get your car's oil changed. Everywhere. Take this minimalist approach to heart: Go light, go simple.

Sure, not every outing will produce superb pictures. But having a camera close at hand helps keep your creative vision sharp as you look for possible subjects and discover how light affects certain scenes. A camera also has this street photography benefit: It gives you a reason to stop and talk with people—even strangers.

If you don't already pack along a camera, why not? Maybe your usual rig consists of a heavy backpack or a bulky shoulder bag overflowing with lenses and accessories. Here are a few tips:

Some serious DSLR shooters own a compact digital camera just for traveling light. Other photographers pare down their DSLR rig to only a single lens—say, a favorite zoom. And some who own a heavy pro DSLR opt for a lightweight backup DSLR for quick outings. Regardless of the particular model, after consistently packing a camera, you'll start feeling "naked" when heading out the door *without* it.

The story behind this photo is just as entertaining as the image itself. It was in New York City, just after the first big snowstorm of the season, and a snowball fight was in the works. Titling this image "The Big Payback," photographer Oscar Suárez captured the boy's expression, the gleam in his eye, the vibrant colors, and the falling snow. Here's more: "He had just been hit with a flurry of snowballs by his older cousins, and he was looking to retaliate. Prior to capturing this photo, I had taken some test shots to get a feel for how much light I was working with and set the camera settings accordingly. Now, it was all about being alert and keeping my eyes open to capture the moment. I was lucky enough to capture this precise moment where you can feel the tension in his emotions while he packs the snow for the big payback. I wanted a tight composition to pull you right in and make you feel what he is thinking—that although he was the smallest, he would not go down without a fight!"

↑ Photo © Oscar Suárez. 1/400 sec. at *f*/5.7, ISO 400, 50mm lens

Taking your camera everywhere means carrying it with you when going, among other places, to the market. In this case, the "market" is renowned Pike Place Market, which is one of Seattle's most popular tourist stops. Seeing this humorous sign, I couldn't resist taking a picture. At the same time, I couldn't resist composing the shot carefully, too, with the sign off-center and a tight composition that just includes the rows of fruit without any adjacent or background distractions.
↑ Photo © Jim Miotke. 1/60 sec. at f/5.6, ISO 100, 28–135mm lens at 109mm

This photo combines a great subject and great color. Says photographer Donna Rae Moratelli, "This image was captured in the morning light on an overcast day. The red background is an exterior wall of a restaurant that caught my attention." Note the horizontal composition with an artistic balance—main subject on the right and negative space on the left.
→ Photo © Donna Rae Moratelli. 1/45 sec. at f/8, ISO 100, 15–30mm lens at 22mm

Busy city streets can produce eye-catching results, assuming you have your camera close at hand. Photographer Anna Krukowska found this cart—with the colorful wheel and the pattern of melons—along a street in Cairo, Egypt. The soft light enhanced the colors and details, and a vertical format nicely captured the colors and details.
← Photo © Anna Krukowska. 1/60 sec. at f/6.3, ISO 400, 18–70mm lens at 50mm

It's hard to beat an extreme close-up with a wide-angle lens when photographing ranch life. Here, the sidelight from a low-in-the-sky sun enhanced the colors and created a warm-vs.-cool color contrast with the blue sky.
→ Photo ©Jim Miotke. 1/125 sec. at f/4.5, ISO 100, 16–35mm lens at 16mm

GLOSSARY OF PHOTOGRAPHIC TERMS

AF (autofocus) lock. A function that allows you to hold the focusing point while you move the camera to recompose your photo. It also allows you to prefocus on a fast-moving subject to help you catch the right moment when shooting action shots.

Aperture. The size of the opening in the lens, which controls how much light enters the camera.

Aperture Priority (A) mode. This mode automatically calculates the shutter speed after you choose your preferred aperture setting (*f*-stop).

Autoexposure (AE). When the camera automatically sets the aperture and/or shutter speed to what it considers best for your particular lighting situation.

Autofocus (AF). When the camera focuses for you, as opposed to manual focus, when you have to set the focus yourself.

Backlight. When the sun is in front of you, lighting your subject from behind.

Blinkies. You may be able to set up your camera so that you see overexposed highlights flash in the LCD monitor. This warning flashing is often referred to as the blinkies.

Blown out. When the highlights are completely white and washed-out, with no detail.

Camera shake. When the camera moves a little as you press down the shutter button, causing the picture to come out blurry. A faster shutter speed or a tripod are generally the cures.

A great advantage of macro photography is providing a unique look at things most people never see. For this scene, I chose to fill up the picture frame with my subject, while placing the flower's main focal point low in the frame, so the petals extend upward through the rest of the picture. I used my macro lens, but there are also various macro accessories—such as extension tubes or close-up filters—that attach to any DSLR camera lens, thus letting you focus closer for a macro look.
← Photo © Jim Miotke. 1/6 sec. at *f*/22, ISO 100, 100mm macro lens

Close-focusing distance. The minimum distance you can get to a subject before the lens can no longer focus properly.

Composition. Arrangement of everything in the photo.

Contrast. This can refer to color (i.e., bold vs. subdued or warm vs. cool) or lighting (i.e., the difference between the bright areas of a photo and the shadowed areas).

Cropping. Cutting off the edges of your composition, either by moving in closer to your subject when you're taking the picture or by trimming off the edges of your finished photograph.

Depth of field (DOF). The range of sharpness in a scene from front to back.

DSLR. An acronym for *digital single lens reflex*. A DSLR camera allows you to use interchangeable lenses. Digital SLRs feature sophisticated focus, exposure, and flash systems. Also, users of DSLRs look through the lens itself to see the scene, rather than through a separate window.

Exposure. The amount of light that is allowed to hit the sensor. Balance is key here. Too much light results in overexposed (too-light) images; too little light results in underexposed (too-dark) images.

Exposure compensation. A function found on more expensive cameras that lets you adjust exposure levels to compensate for circumstances (very light or very dark) that might trick the camera meter.

***f*-stop or *f*/number.** The *f*-stop numbers represent the size of the lens aperture. This, combined with shutter speed, serves to expose each photo with the correct amount of light.

Fast. A fast lens can be set to a very low *f*-stop number to allow more light to pass through. Fast lenses can come in handy when shooting sports, weddings, or other subjects where you need a fast shutter speed in low-light situations.

Filter. A piece of glass placed in front of your lens to enhance light and/or colors, or to protect the more valuable lens glass. Also, in the world of digital imaging, filters are software functions that can be used for creative effects, for fixing lighting issues, and so on.

Fixed lens. Also called a fixed-focal-length or prime lens. This lens is permanently a wide-angle, telephoto, or something in between; it does not allow you to zoom in or out.

Focal plane. The point in your photo that is in focus (this includes everything that's at the same distance from your camera).

Focal length. A way to measure the magnifying power of a lens. A 50mm lens has a focal length of 50mm and sees things at roughly the same size as the unaided human eye sees them. A 400 mm telephoto focal length is like looking through a pair of binoculars; things far away are greatly magnified. A 20mm wide-angle lens allows you to squeeze in an expansive vista.

Form. A shape with three-dimensional depth.

Format. Refers to digital file format. JPEG is the most commonly used, but capturing raw files (photos before they're processed into a file format) gives a digital photographer more flexibility and latitude when it comes to processing the photo later.

Frame. The view you see through your camera's viewfinder. Also, framing can refer to a compositional trick where you look use an element within the composition, such as tree branches or a window, to frame another element in the shot.

Frontlight. When the sun is behind you and therefore lighting your subject from the front.

Glare. When light reflects off of a reflective surface, such as glass, water surface, wet rocks, and so on.

Glass. Another term for lenses.

Highlights. The extremely bright points in a scene.

In camera. Refers to doing a technique while shooting, to save yourself the time and hassle of having to later fix the image in a program like Photoshop.

ISO. With initials deriving from the International Organization of Standardization, ISO refers to how sensitive a camera sensor is to light. A fast ISO, such as 1600, will capture images more quickly and generally will provide sharper results when handholding the camera in dim conditions. An ISO of 50 to 200, on the other hand, is much slower, less sensitive, and works best in bright light or when combined with the use of a tripod. In most cases, when shutter speed isn't a factor, a low ISO is recommended to reduce the possibility of noise.

Landscape. Besides a grand outdoor scene, this term also refers to images shot in a horizontal orientation (as opposed to vertical—"portrait"—images).

LCD. An acronym for *liquid crystal display*. The LCD is the monitor on a digital camera that allows you to review images immediately after shooting them and, in more and more cameras, is also used as "live view" for composing photos.

Light meter (or exposure meter). A device that measures the brightness in a scene to help the camera get the proper exposure. There are in-camera light meters, and some photographers use special, handheld light meters, as well.

Long lens. See *Telephoto lens.*

Macro. Extreme close-up photography. A specialized macro lens or macro accessory (such as an extension tube) lets you focus far closer to a subject than a regular lens.

Manual focus. When you dictate what to focus on in your scene, as opposed to letting the camera automatically do the focusing.

mm. Millimeter. A unit of measure used when referring to either a lens (for example, a 100–400mm zoom lens) or to film formats (for example, 35mm film). Confusingly, though, millimeter also specifies the filter sizes on some lenses; for instance, you may have a 50mm normal lens that accepts 52mm-size filters.

Noise. An effect of grainlike texture in a photo. The colors often appear duller and the grainlike texture can seem to reduce clarity. One major cause is the use of a really high ISO.

Normal. A normal lens—in the neighborhood of 40mm to 50mm—sees things at about the same magnification level as the unaided human eye. Telephoto and wide-angle lenses, on the other hand, make things bigger or smaller than the human eye usually sees them.

Overexposure. When the sensor receives too much light and the picture looks bright.

Perspective. The way lines converge as they travel farther away from the eye. Also, the way objects in your photo relate to one another in size.

Point-and-shoot. A basic, automatic camera. The term point-and-shoot also refers to the "snapshooting" style of quick shooting.

Point of view. The place and position from which you shoot.

Polarizer. A filter you can attach to your lens to reduce glare and saturate colors or to make skies a deep blue.

Portrait. Along with a picture depicting a person or group of people, this term also represents images taken in a vertical orientation, when you turn your camera on end before shooting the picture.

Prefocusing. See *AF lock*.

Program mode (P). On some cameras, this represents the mode that automatically calculates both aperture and shutter speed.

Raw. A preprocessed image, larger but containing much more information than a JPEG format. See *Format*.

Rule of Thirds. A principle of composition used to add a sense of balance and uniqueness to photographs by the off-center placement of the picture's main subject.

Selective focusing. The art of limiting depth of field so that only your subject is in sharp focus.

Self-timer. A feature that delays the moment when the camera takes the picture. A self-timer allows you to get into the picture yourself or to shoot without actually moving the camera, thus avoiding the camera-shake problem.

Short lens. See *Wide-angle lens*.

Shutter. A mechanism that controls how much light is allowed to get into the camera.

Shutter button. The button you press to take the picture.

Shutter Priority (S) mode. This mode automatically calculates aperture after you specify the shutter speed.

Shutter speed. How long the shutter is left open, or how long the camera takes to make the picture.

SLR. See *DSLR*.

Soft. Refers to the parts of photographs that are slightly blurry. This can be good (say, when creatively using a shallow depth of field) or not so good (when areas of an image are out of focus but should be sharp). This term also describes the diffused, gentler kind of light of a bright, overcast day and can refer to subtly beautiful colors (as opposed to vibrant hues).

Telephoto lens. A lens that magnifies your subject, enabling you to shoot subjects that are very far away, usually 70mm or above.

Tripod. Wise photographers often attach their camera to this three-legged stand to keep the camera steady while taking a picture, to make use of certain creative effects (such as a deep depth of field and to convey motion), and to fine-tune their compositions.

Tv. Stands for time value. Especially on SLR cameras, this is often used to indicate a Shutter Priority mode.

Underexposure. When the sensor doesn't receive enough light and the picture looks too dark.

Viewpoint. See *Point of view*.

Wide-angle lens. A lens that gives you a wide or sweeping view—usually under 35mm.

Wide open. Shooting at a lens's lowest *f*-stop number, such as *f*/2.8.

Zoom. A zoom lens provides more flexibility by allowing you to easily change the focal length (the amount of magnification) before you shoot.

CONTRIBUTING PHOTOGRAPHERS

The following members and instructors of BetterPhoto.com and participants in BetterPhoto's Masterpiece Membership program contributed a number of photos for this book. The rest were created by Jim and Kerry.

Mary Beth Aiello www.mary-beth-aiello-photography.com

Amalia Arriaga de Garcia www.betterphoto.com/Premium/default.aspx?id=17963&mp=V1

Stefania Barbier www.stefania-barbier.com

Margaret Barry www.betterphoto.com?pbarry

Stacey A. Bates www.betterphoto.com?sabates

Christopher J. Budny www.chrisbudny.com

Peter K. Burian www.peterkburian.com

Beverly A. Burke www.bevburkephotography.com

Kathleen T. Carr www.kathleencarr.com

Sarah A. Christian www.schristian-photography.com

Nancy de Flon www.fstopnancyphoto.com

Renee Doyle www.renee-doyle-photography.com

Susan Gallagher www.susan-gallagher-photography.com

Karol Grace www.threedogstudio.com

Debra Harder, DRH Images www.drhimages.com

Sonya L. Hatfield-Hall www.betterphoto.com?sonyasnaps

Susana Heide www.betterphoto.com?susana

Kristi A. Howson www.betterphoto.com?kristi

Wanda Judd www.wandajudd.com

Anna Krukowska www.betterphoto.com/Premium/default.aspx?id=288791&mp=V2

Jon M. Lamrouex www.jonmlamrouex.com

Linda Lester www.lindadlester.com

Deborah Lewinson www.newjerseyphotos.net

Katarina Mansson www.betterphoto.com/gallery/gallery.asp?memberID=175747

Greg McCroskery www.imagismphotos.com

Anne McKinnell www.betterphoto.com/Premium/default.aspx?id=294293&mp=V3

Leslie McLain www.betterphoto.com/gallery/gallery.asp?memberID=222331

Donna Rae Moratelli www.donnaraephotography.com

Rolan Narman www.rsnphoto.com

Kathe Nealon www.thephotodamsel.com

William Neill www.williamneill.com

Vik Orenstein www.vikorensteinphotography.com

Donna Pagakis www.betterphoto.com?donna

Becky J. Parkinson www.beckyparkinsonphotography.com

Debbie Payne www.betterphoto.com?dellen

Ibarionex Perello www.thecandidframe.com

Jacqueline Rogers www.petitclercphotography.com

Deborah Sandidge www.debsandidge.com

Lynn Sapadin www.lynnslookingglass.com

Carla Trefethen Saunders www.betterphoto.com?saunders

Fran Saunders www.betterphoto.com?franny

Leland N. Saunders www.lelandsaundersphotography.com

Rob Sheppard www.natureandphotography.com

Laurie Rubin Shupp www.betterphoto.com?lshupp

Doug Steakley www.douglassteakley.com

Chellie L. Stull www.betterphoto.com/Premium/default.aspx?id=277398&mp=V1

Oscar Suárez www.elsuarez.com

Tony Sweet www.tonysweet.com

Jim Zuckerman www.jimzuckerman.com

This sunrise photo of St. Augustine Beach, Florida, actually began the day before, during a scouting trip. It pays to check out things in advance, since trying to find a good location in the early-morning darkness can be frustrating. I chose a wide-angle view on the bluff above the beach and included the strong leading line of the pier, which takes the viewer into the scene. I positioned the main focal point—the rising sun—away from the middle of the composition. Such an off-center placement is usually more visually dynamic than a centered one.
↑ Photo © Kerry Drager.
1/45 sec. at *f*/16, ISO 200, 20mm lens

RESOURCES

SELECTED BIBLIOGRAPHY

Freeman, Michael. *The Photographer's Eye: Composition and Design for Better Digital Photos.* Focal Press, 2007. The basics of design—as well as light, color, and graphic elements—are covered in this book.

Frost, Lee. *Designing a Photograph: Visual Techniques for Making Your Photographs Work.* Amphoto Books, 2001. This unique book includes techniques, lessons, comparisons, and more—all related to composing a dynamic photo.

Miotke, Jim. *BetterPhoto Basics: The Absolute Beginner's Guide to Taking Photos Like a Pro.* Amphoto Books, 2010. The fundamentals are all here: exposure, composition, and light. You'll learn tips and tricks to improve your pictures right away, regardless of your camera.

Miotke, Jim. *The BetterPhoto Guide to Digital Photography.* Amphoto Books, 2005

Miotke, Jim. *The BetterPhoto Guide to Digital Nature Photography.* Amphoto Books, 2007

Miotke, Jim. *The BetterPhoto Guide to Photographing Children.* Amphoto Books, 2008. If you like the book you're holding right now, you won't want to miss this and the previous two titles listed, which are all part of the BetterPhoto Guide series.

Patterson, Freeman. *Photography and the Art of Seeing.* Key Porter Books, 2004. This acclaimed book covers design, composition, and creative vision and includes Patterson's superb photography.

Peterson, Bryan. *Learning to See Creatively: Design, Color & Composition in Photography.* Amphoto Books, 2003. This beautiful book covers the elements of design, expanding your vision, and the magic of light.

Sheppard, Rob. *The Magic of Digital Landscape Photography.* Lark, 2010. In this comprehensive guide, the author discusses the techniques, gear, and vision necessary to shoot striking nature images.

Tharp, Brenda. *Creative Nature & Outdoor Photography, Revised Edition.* Amphoto Books, 2010. The author shares her creative vision in regard to visual design, color, light, and composition.

Zuckerman, Jim. *Pro Secrets to Dramatic Digital Photos.* Lark, 2011. This inspiring book by a top stock photographer provides many insights and techniques for capturing extraordinary images.

Reflections always seem to grab the viewer's attention—whether from water, chrome, windows, whatever. In this case, the mirrored images jumped out, along with the surrounding designs. I chose a close-up view to emphasize the colors, patterns, and reflections.
← **Photo © Jim Miotke. 1/125 sec. at *f*/6.3, ISO 100, 28–135mm lens at 135mm**

BETTERPHOTO.COM

Even if Jim were not its founder and president, and Kerry were not a staffer and instructor, we would still vouch for this site as the best photography resource on the Web! BetterPhoto's mission is to help photographers feel free to be creative and improve their skills—and to have fun doing it. BetterPhoto, which launched in 1996, offers a top-notch online digital photography school (in which students get feedback from top pros), plus a photo contest, newsletters, websites, online galleries, and a variety of other resources for photographers.

MAGAZINES

Digital Photo

dpmag.com

A fine publication filled with tips, reviews, techniques, and buyer's guides.

Digital Photo Pro

digitalphotopro.com

Beautifully produced magazine that focuses on trends, photographer profiles, and techniques.

Outdoor Photographer

outdoorphotographer.com

An outstanding magazine covering the art and technique of scenic, wildlife, and travel photography.

Shutterbug

shutterbug.com

A well-stocked, well-edited magazine of shooting tips, techniques, and reviews of equipment and software.

Petersen's Photographic Digital Photography Guide

photographic.com

A quarterly magazine that features great tutorials and great photography.

Popular Photography

popphoto.com

Lots of reviews and news on camera gear and software, plus tips on photography and the digital darkroom.

Practical Photography

photoanswers.co.uk

A British publication with information, inspiration, and down-to-earth photographic advice.

CAMERA AND GEAR MANUFACTURERS

There are many quality manufacturers—far too many to list. Here, we concentrate on a few of our favorites.

Canon

canon.com

Jim shoots with Canon DSLRs and lenses.

Gitzo

gitzo.com

The maker of high-quality tripods that have long been the standard for many top pro shooters.

Lensbaby

lensbaby.com

Unique SLR camera lenses designed for creative selective focus.

LowePro

lowepro.com

A manufacturer of fine camera bags and photo backpacks of all shapes, types, and sizes.

Manfrotto

manfrotto.us

The manufacturer of a full line of excellent tripods that fit just about any budget.

Nikon

nikonusa.com

Kerry shoots with Nikon DSLRs and lenses.

Really Right Stuff

reallyrightstuff.com

An innovative designer of high-quality tripods, ball heads, and quick-release systems.

Think Tank Photo

thinktankphoto.com

The state-of-the-art maker of high-quality camera bags and photo backpacks.

CAMERA AND GEAR RETAILERS

There's nothing like a good camera shop for one-on-one service and for holding—in your hands!—that cool new camera model you've been considering. And it's ideal for buying a tripod, too: Just pack up your heaviest camera-and-lens combination and see how it works on the tripod that catches your eye. On the other hand, there's nothing like the convenience of an online store, and thankfully, there are many reputable outlets. Here are two that we like:

B&H Photo

bhphotovideo.com

The website of this retailer is huge, with just about every-thing you can imagine. B&H also operates a monster-sized superstore in New York City that you must see to believe.

Hunt's Photo & Video

huntsphotoandvideo.com

Besides a big online presence, this retailer also has a big brick-and-mortar store presence throughout much of New England.

Experimenting (often) and breaking the rules (when necessary for an artistic effect) are so important in the road to visual creativity. With this garden of flowers, I panned the camera with a slow shutter speed to give a sense of blurred motion. You can't always predict the results, so expect many outtakes when you use this technique of "painting" with motion. Expect a lot of creative fun, too!

↑ Photo © Jim Miotke. 1/13 sec. at *f*/9, ISO 100, 300mm lens

PHOTO SOFTWARE

Adobe Photoshop and Lightroom

www.adobe.com

Also in Adobe's fine line of image-editing programs, there's Photoshop's wonderful "little brother" (or "little sister"): Elements.

Nik Software

niksoftware.com

Established in 1995, Nik has become a leader in digital photographic filters and software technology.

INDEX

This collection of pine cones almost demanded a graphic-design treatment that emphasized the pattern. This meant zooming in tight, while also making sure to leave out any surrounding elements not only to prevent distractions but to give a sense that the pine-cone pattern extended beyond the borders.

↑ Photo © Jim Miotke. 1/8 sec. at *f*/40, ISO 50, 70–300mm lens at 250mm